DRAW COMICS
with Dick Giordano

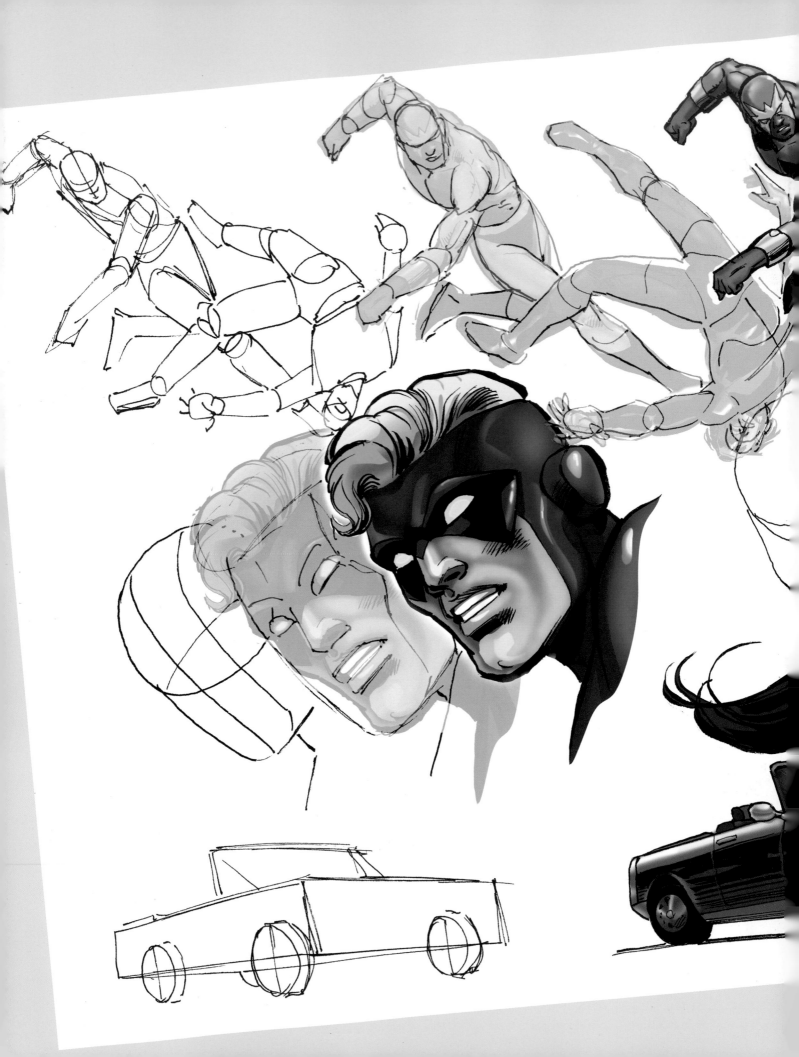

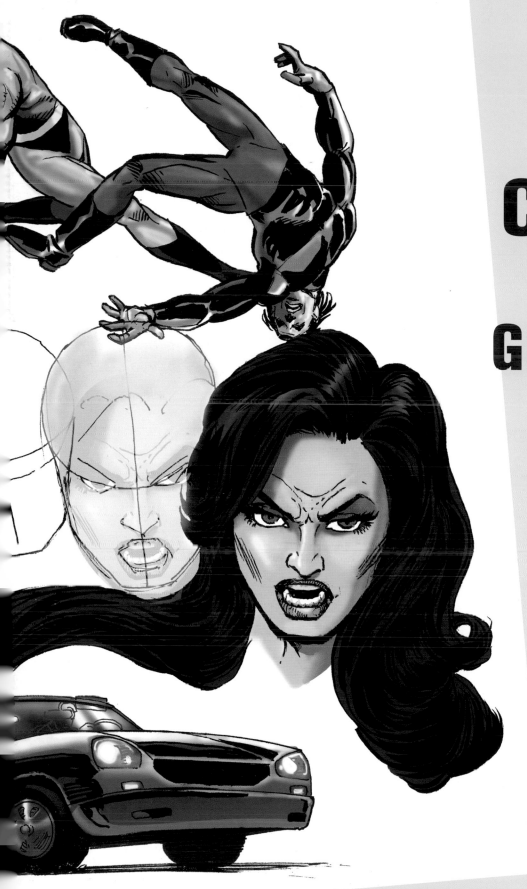

DRAW COMICS with **DICK** **GIORDANO**

IMPACT
CINCINNATI, OHIO
www.impact-books.com

DEDICATION

For Lisa Jo, Dawn Marie and Rich.
You enriched my life as children, and
I'm proud of you as adults.

ACKNOWLEDGMENTS

My gratitude goes to the people who helped make the long road of producing this book an easier and more exciting experience for me. They are:

- Pat Bastienne and Rob Jones, my studio mates.

- Bob Layton, Terry Austin and Brian Augustyn, who gave me free access to the work we had done together.

- David Micheline, Mary Skrenes, Mike Friedrich and Bill Pearson, my collaborators on some of the characters shown in this book.

- Pam Wissman, Gina Rath, Stefanie Laufersweiler and Amy Jeynes, my editors at IMPACT Books. A special thank you to Gina, who listened to all my hare-brained ideas and allowed me to include most of them.

- My old friend Sal Amendola: a special thank you for allowing me to reproduce the invaluable perspective instruction from six pages of his own manual. (It appears on pages 70-75 of chapter 3.) Sal, an instructor at the School of Visual Arts in New York City, is a recognized expert in perspective.

- Brad D. Nault, who provided the color for this book as well as the step-by-step instruction on pages 122-123.

fw
F+W PUBLICATIONS, INC.

09 08 07 06 05 5 4 3 2 1

Library of Congress Cataloging in Publication Data
Giordano, Dick.
 Draw comics with Dick Giordano / Dick Giordano
 p. cm
 Includes index.
 ISBN 1-58180-627-2 (pbk. : alk. paper)
 1. Cartooning--Technique. 2. Comic books, strips, etc.--Technique. I. Title

NC1764.G56 2005
741.5--dc22 2004026731

Editors: Gina Rath and Stefanie Laufersweiler
Production editor: Amy Jeynes
Designer: Wendy Dunning
Page layout artist: Jessica Schultz
Production coordinator: Mark Griffin

Artwork on pages 2–3, 12–13, 34–35, 68–69, 88–89, 104–105 and 122–123 colored by Brad D. Nault.

Perspective illustrations on pages 70–75 by Sal Amendola.

Excerpts from *Unforgiven* on pages 95–97 and 118–121 reprinted with permission from the American Bible Society.

METRIC CONVERSION CHART

To convert	to	multiply by
Inches	Centimeters	2.54
Centimeters	Inches	0.4
Feet	Centimeters	30.5
Centimeters	Feet	0.03
Yards	Meters	0.9
Meters	Yards	1.1
Sq. Inches	Sq. Centimeters	6.45
Sq. Centimeters	Sq. Inches	0.16
Sq. Feet	Sq. Meters	0.09
Sq. Meters	Sq. Feet	10.8
Sq. Yards	Sq. Meters	0.8
Sq. Meters	Sq. Yards	1.2
Pounds	Kilograms	0.45
Kilograms	Pounds	2.2
Ounces	Grams	28.3
Grams	Ounces	0.035

ABOUT THE AUTHOR

When one mentions legends of the comics industry, high on that list is Dick Giordano, active in the field since 1951. He has worn many hats during his career, among them artist, editor, administrator and teacher. He began working in the industry immediately after graduating from high school (The School of Industrial Arts in New York City) where, in addition to a full schedule of academic courses, he was also able to take a variety of commercial art courses, with art and academia splitting each school day evenly. After graduation he became an artist at the Jerry Iger Studio working on *Sheena* for Fiction House, then went on to work for various comics publishers including Charlton (where he became editor-in-chief in the 1960s), DC Comics, Marvel, Dell, American, Valiant, Treasure Chest and Junior Life. He has worked with such fellow comics legends as Neal Adams, John Byrne and George Perez, among countless others.

Giordano was an artist for DC's best-selling *Batman* series in the 1970s. He became vice president/editorial director for DC in 1980 and was the guiding force behind such award-winning series as Alan Moore's *Watchmen* and Frank Miller's *The Dark Knight Returns* in the 1980s. His creative vision raised the bar for creativity throughout the entire industry.

Giordano has also launched two successful advertising art companies: Continuity Associates with Neal Adams, and DIK-ART, Inc. Recent freelance projects include pencilling *Batman: The Dark Knight of the Round Table* and pencilling, inking and producing the covers for *Batman: Hollywood Knight* and the six-issue miniseries *The L.A.W.* for DC. He currently draws *The Phantom* for Egmont, a Swedish publisher. He is on the Disbursement Committee for ACTOR (A Commitment To Our Roots), the first federally chartered, not-for-profit organization dedicated to helping comics industry veterans in need. With creative partners Bob Layton and David Micheline he recently formed Future Comics, for which he contributes his artistic talents as well as the administrative duties of a principal.

A biography entitled *Dick Giordano: Changing Comics, One Day at a Time* by Michael Eury (TwoMorrows Publishing, 2003) features never-before-seen artwork by the artist, his personal reflections, an index of his published work and comments from famous co-creators. For more information, visit www.twomorrows.com/books/giordano.html.

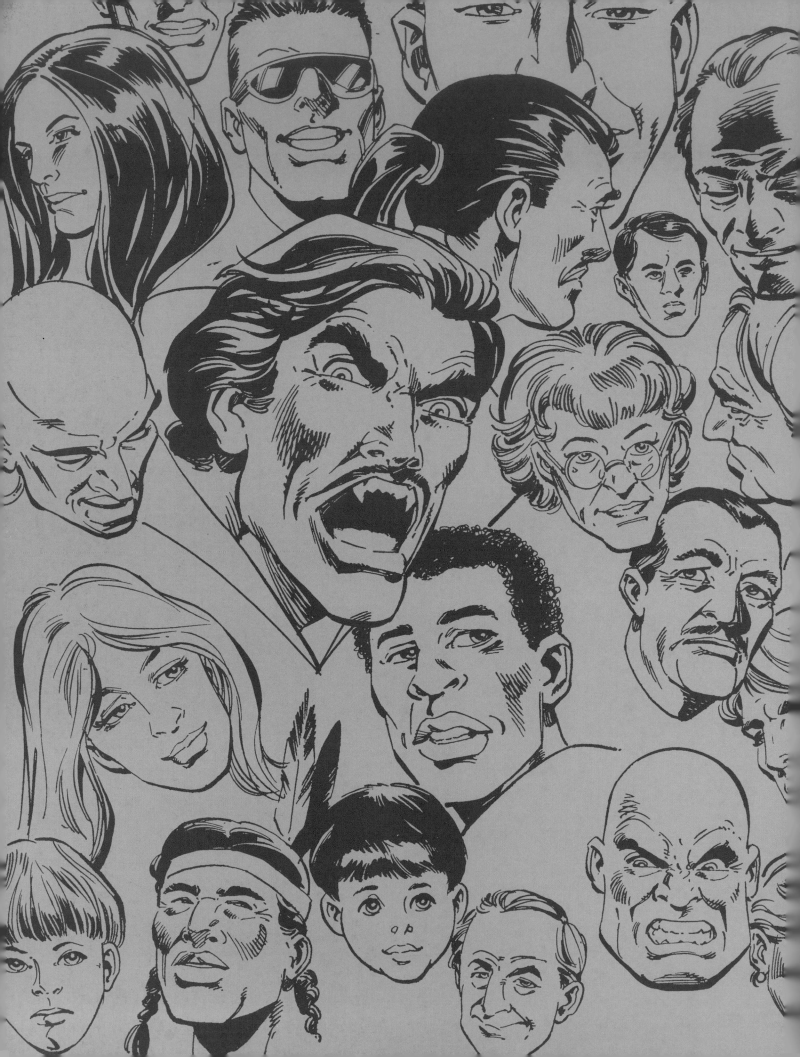

TABLE OF CONTENTS

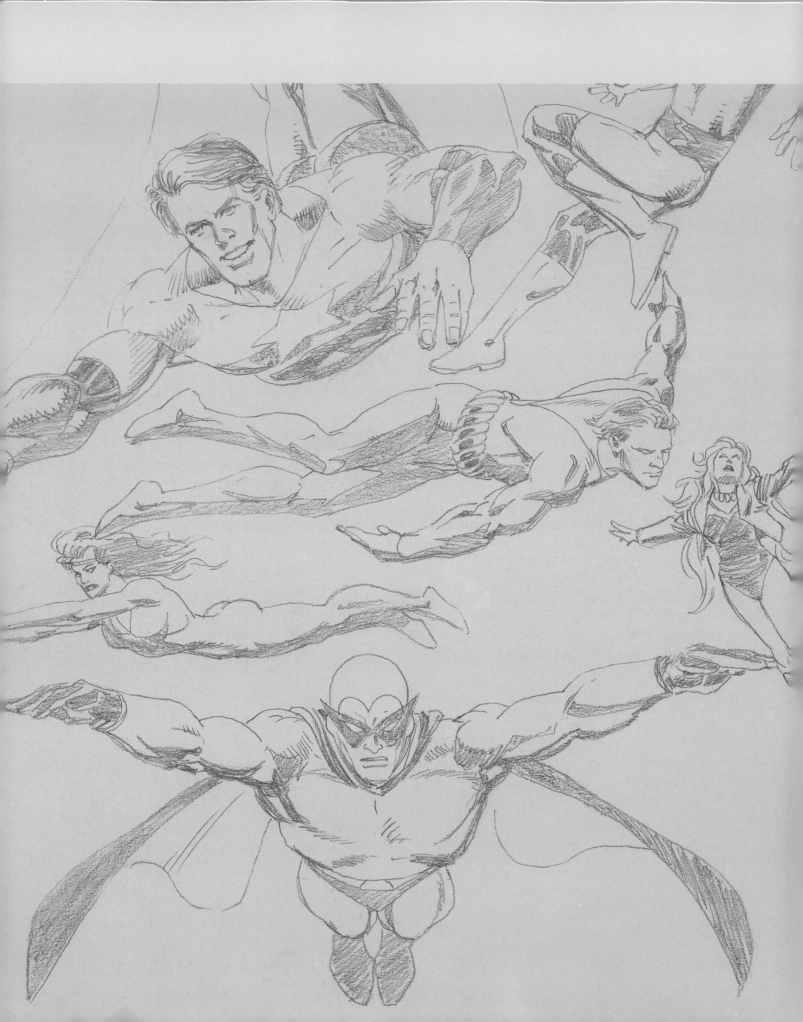

INTRODUCTION

Someone once said that all art is problem solving; the more art problems you learn to solve, the better an artist you will become.

While I believe that's true, I must caution you that any artist who learns to solve, say, 423 art problems will not necessarily be on the same level as every other artist who has reached that plateau—but he or she will be better than before!

The purpose of this book is to help budding comic artists solve some of the fundamental drawing problems that every artist—not just comic artists—needs to solve in order to build the foundations necessary to become a competent professional artist. Now, to keep the record straight, if you are a beginner you can't expect to reach a professional level after just these 128 pages. However, I believe that if you diligently work through these pages, you will discover whether or not you have the right stuff and want to continue learning. I've been a professional for over fifty years and I'm still learning. I like to think that I'm still a work in progress!

As its title states, this book is about learning how to draw comics. While the information contained herein is designed to attain that specific goal, it will also help you to learn how to draw for other fields (animation, illustration, storyboards, etc.) or just for your own pleasure. Drawing is drawing.

And finally, I do not profess that the drawing instructions contained in this book are the best way or the right way to do it. They are merely my way. Some of the techniques I learned in school I still use, and they are demonstrated in this volume. Others I've developed on my own, either by doing or by observing what others did. I encourage you to build upon and experiment with the information you learn here.

So, with that in mind, read on, draw, and enjoy!

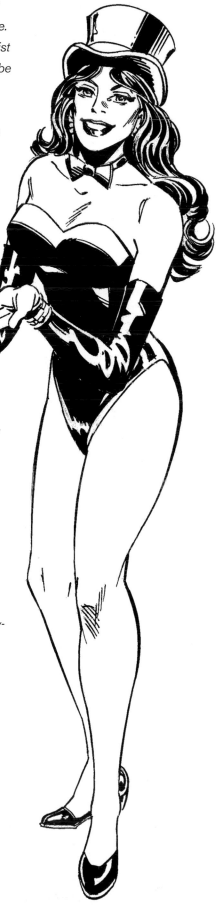

WHAT YOU'LL NEED

Art supplies aren't cheap, but compared to the cost of tools for other trades, they are relatively inexpensive. It doesn't pay to shop for art supplies by price alone. Good tools pay off in better and faster results. The pencilling and inking tools listed here by brand aren't the only brands that will produce good results; they are simply the brands I use. Experiment to discover what works best for you.

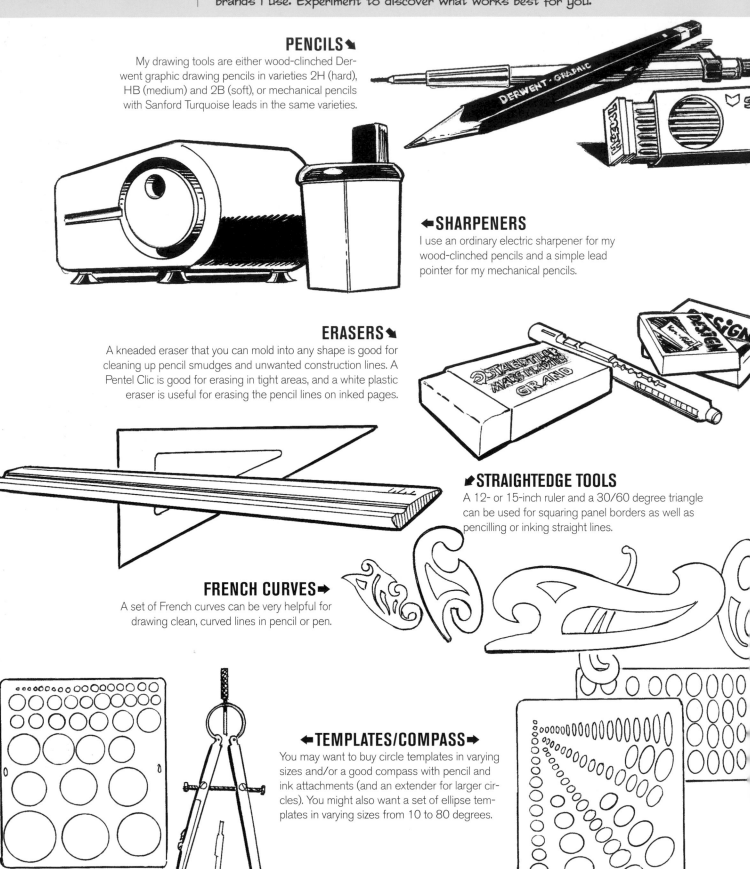

PENCILS

My drawing tools are either wood-clinched Derwent graphic drawing pencils in varieties 2H (hard), HB (medium) and 2B (soft), or mechanical pencils with Sanford Turquoise leads in the same varieties.

SHARPENERS

I use an ordinary electric sharpener for my wood-clinched pencils and a simple lead pointer for my mechanical pencils.

ERASERS

A kneaded eraser that you can mold into any shape is good for cleaning up pencil smudges and unwanted construction lines. A Pentel Clic is good for erasing in tight areas, and a white plastic eraser is useful for erasing the pencil lines on inked pages.

STRAIGHTEDGE TOOLS

A 12- or 15-inch ruler and a 30/60 degree triangle can be used for squaring panel borders as well as pencilling or inking straight lines.

FRENCH CURVES

A set of French curves can be very helpful for drawing clean, curved lines in pencil or pen.

TEMPLATES/COMPASS

You may want to buy circle templates in varying sizes and/or a good compass with pencil and ink attachments (and an extender for larger circles). You might also want a set of ellipse templates in varying sizes from 10 to 80 degrees.

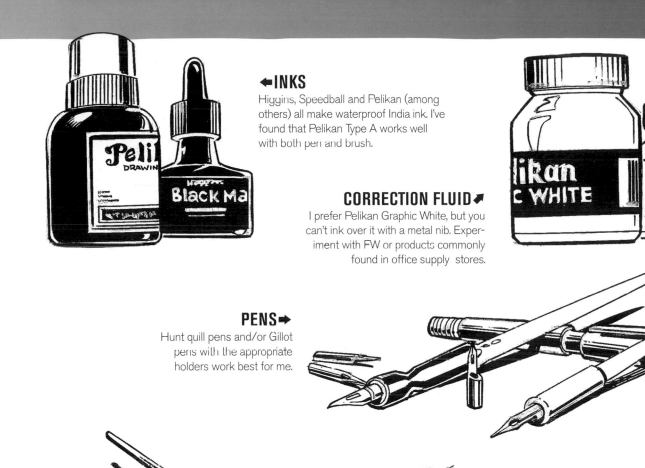

◄INKS

Higgins, Speedball and Pelikan (among others) all make waterproof India ink. I've found that Pelikan Type A works well with both pen and brush.

CORRECTION FLUID ◄

I prefer Pelikan Graphic White, but you can't ink over it with a metal nib. Experiment with FW or products commonly found in office supply stores.

PENS ➡

Hunt quill pens and/or Gillot pens with the appropriate holders work best for me.

◄BRUSHES

I use pointed round watercolor brushes. I'm currently using no. 2 and no. 4 rounds from the Raphaël Series 8404. The no. 2 round, the smaller brush, is easier to control when working within tight areas. I often tout the virtues of kolinsky red sable, but brushes made of synthetic fibers seem to achieve decent results at one-third to one-half the cost. Longevity, however, is limited.

DRAWING SURFACE ◄

Any good bristol board with at least some rag content will do. Bristol board is available in rough and smooth finishes and in 1-, 2- or 3-ply thickness. It is sold in pads or in larger 30" x 22" sheets and can be bought pre-ruled in non print blue by Blue Line Pro.

features
NOSE and EARS

Getting these features wrong can ruin an otherwise perfect drawing, so make sure you practice plenty!

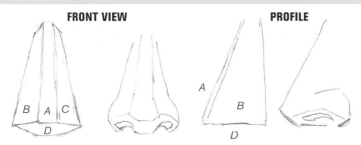

FRONT VIEW PROFILE

Every nose has one frontal plane (A) two side planes (B, C) and a bottom plane (D). To draw the nose from any angle, simply draw these planes in perspective and add the details. Not all planes will show from every angle.

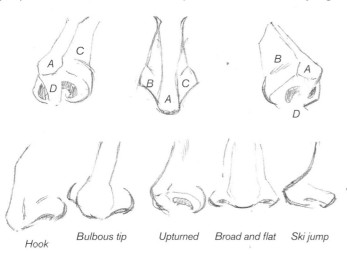

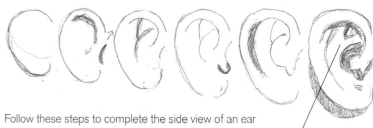

Follow these steps to complete the side view of an ear by drawing in the bold lines in the sequence shown.

Every ear has a "Y" shape in it.

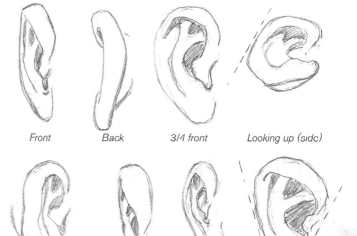

Hook *Bulbous tip* *Upturned* *Broad and flat* *Ski jump*

Noses vary greatly in size and shape among individuals. The leading edge of the nose is partially nasal bone (top) and the balance (bottom half) is cartilage. This combo allows for a wide variety of nose shapes.

Front *Back* *3/4 front* *Looking up (side)*

3/4 back *Looking down (front)* *Looking up (front)* *Looking down (side)*

Here are different views of the same ear.

HAIR

To get hair right, remember that each hair is attached to the skull somewhere, and each is affected by gravity (it wants to fall to the ground).

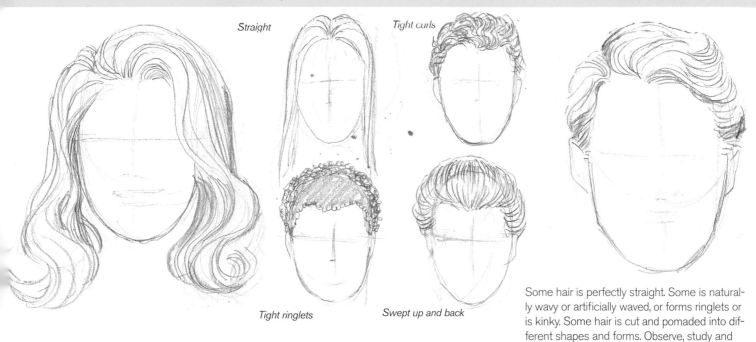

Straight *Tight curls*

Tight ringlets *Swept up and back*

Some hair is perfectly straight. Some is naturally wavy or artificially waved, or forms ringlets or is kinky. Some hair is cut and pomaded into different shapes and forms. Observe, study and memorize.

head views
FRONT VIEW

There are differences between males and females, but not in the preliminary drawing steps you use to get to the finished drawing. The differences are in the details. After more than fifty years in the business, I still always use these layout methods (which I learned in school) for drawing heads.

1 Draw a circle and then add the "jaw" at the bottom, forming an egg shape.

2 Bisect the egg-shape both vertically and horizontally.

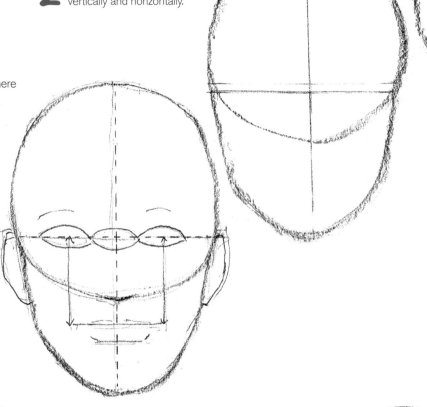

3 Lightly block in areas where features will be located: eyes on the horizontal middle line (spaced an eye's width apart); the bottom of the nose located halfway between the eye line and the bottom of the jaw; the lips located about halfway between the nose and the jaw, and end left and right at points directly below the center of each eye; ears extend from the eye line to the nose line. General locations of features may vary somewhat from character to character.

4 Add the features and head details.

Females are likely to have:
- fuller, more voluptuous lips
- slightly larger eyes
- more pronounced eyelids

Males are likely to have:
- more angular lines defining the head shape
- a slightly longer chin

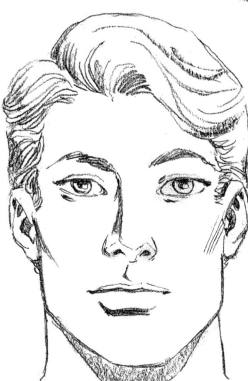

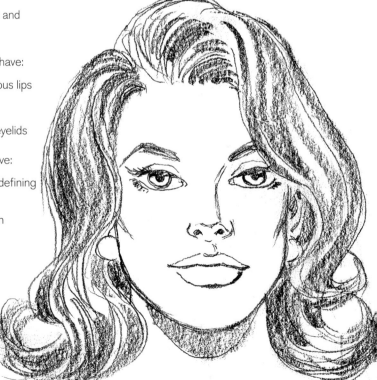

head views
PROFILE

The profile is probably the easiest view of the human head to draw: only one eye, one ear and one nose plane to deal with! In addition, part of the outline of the head also forms the features of the head. However, because of this simplicity, it is also the most boring view.

1 Draw a circle and add a "jaw" line appropriate for a profile. It will be triangular in shape.

2 Bisect the shape in the middle horizontally.

3 Lightly block in the features: eyes on the horizontal middle line; ear extending from the eye line to the nose line; nose on a line halfway between the eye line and the bottom of the jaw; upper and bottom lips over and under a line halfway between nose line and jaw.

4 Add the features and head details.

Males are more likely to have:

- a slight indent in forehead

- a more angular nose

- a bolder, more pronounced chin

Females are more likely to have:

- a nose that is rounder at the bridge root

- thicker lips

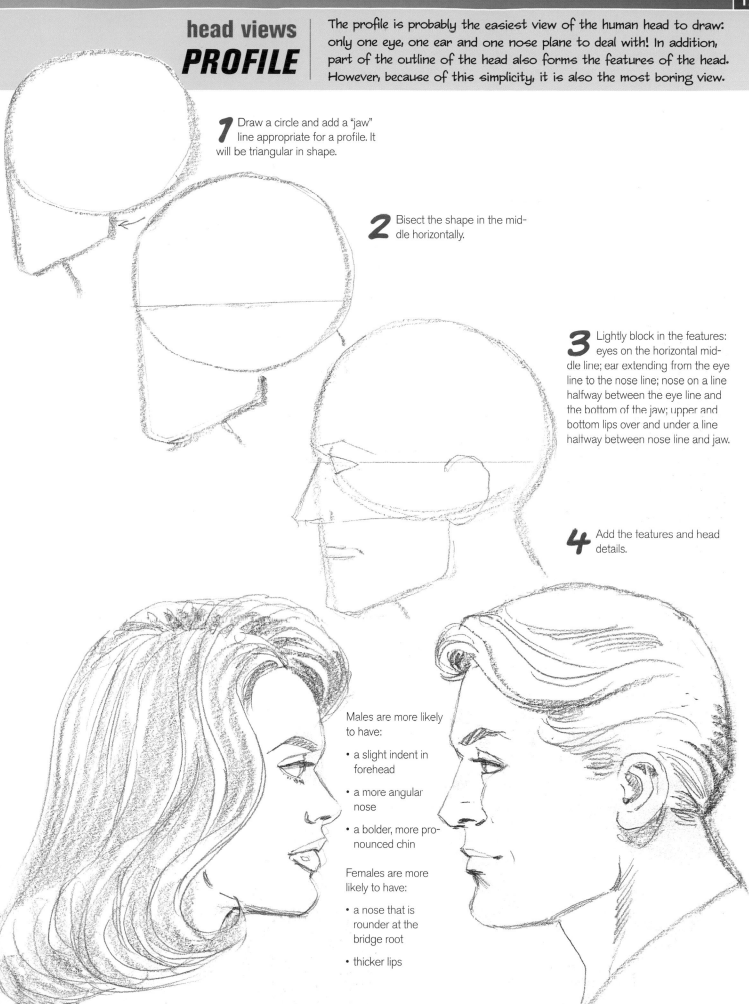

head views
3/4 FRONT VIEW

A 3/4 view is any view from an almost-front view to an almost-profile view. The same wide variety can be found in the 3/4 back view (see next page).

1 Draw a circle and add a "jaw" line appropriate for this 3/4 front view.

2 Bisect this form both horizontally and vertically. The vertical line determines the view of the head. Add plane (A) that forms the dividing point between the front and the side of the head.

A

3 Block in features using proportion formulas defined in the previous step-by-step instructions. Note that eyes and lips need to curve around the head and are foreshortened. For this view, it is helpful to block in side planes on the head and nose to keep you aware of the dimensional view of the head.

4 Add the features and head details.

The male neck tends to be thicker.

A female's contours tend to be smoother, her chin shorter and the jaw somewhat less defined.

head views
3/4 REAR VIEW

This is a somewhat limiting but necessary view of the human head. The visibility of the features is limited by this angle, making it difficult to show emotion or expression. Again, the 3/4 rear view can vary from an almost-rear view to an almost-profile view.

1 Draw a circle and then a "jaw" similar in shape to the profile, but narrower.

Narrow

2 Bisect the shape horizontally. I like to add a plane line (A) representing the far side of the jaw to guide me toward the view I've chosen.

A

3 Lightly block in a plane line (B) that will show where the side of the head meets the front. Location of the features is identical to the profile's but you will not be able to see the full eye, nose or lips.

B

4 Add the features and head details.

SIMMS LIBRARY
ALBUQUERQUE ACADEMY

foreshortening
BIRD'S-EYE VIEW

Your characters won't always be at the reader's eye level. For this reason, it is important to learn how to draw foreshortened views of the head. Foreshortening is a method of drawing that makes what you're drawing appear to be moving toward or away from you. We'll begin with a bird's-eye view: looking down at a character. We'll use the a modified version of the circle/draw sketch used for the standard views.

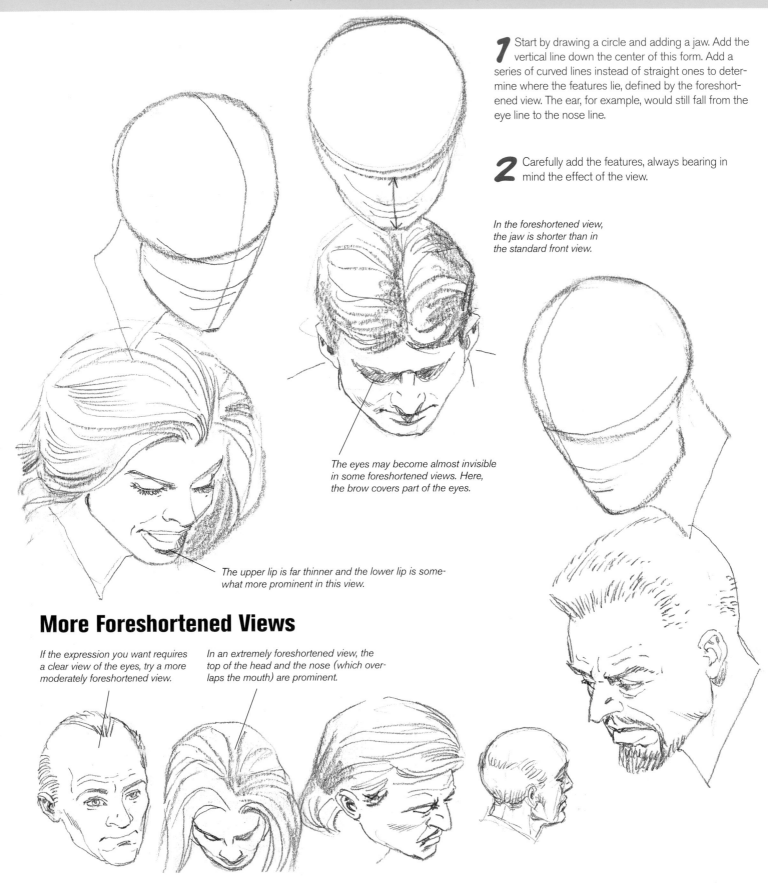

1 Start by drawing a circle and adding a jaw. Add the vertical line down the center of this form. Add a series of curved lines instead of straight ones to determine where the features lie, defined by the foreshortened view. The ear, for example, would still fall from the eye line to the nose line.

2 Carefully add the features, always bearing in mind the effect of the view.

In the foreshortened view, the jaw is shorter than in the standard front view.

The eyes may become almost invisible in some foreshortened views. Here, the brow covers part of the eyes.

The upper lip is far thinner and the lower lip is somewhat more prominent in this view.

More Foreshortened Views

If the expression you want requires a clear view of the eyes, try a more moderately foreshortened view.

In an extremely foreshortened view, the top of the head and the nose (which overlaps the mouth) are prominent.

foreshortening
WORM'S-EYE VIEW

Let's try the more difficult worm's-eye view, in which we're looking up at a character. This angle is somewhat superior to the bird's-eye angle in that it allows a clearer view of all the facial features, making varying expressions possible.

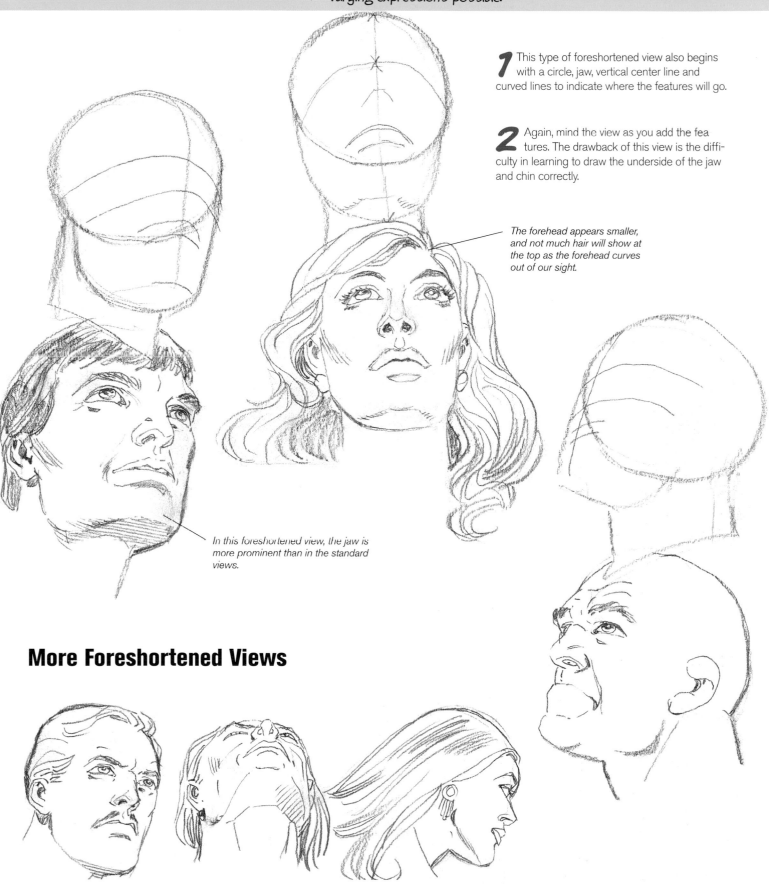

1 This type of foreshortened view also begins with a circle, jaw, vertical center line and curved lines to indicate where the features will go.

2 Again, mind the view as you add the features. The drawback of this view is the difficulty in learning to draw the underside of the jaw and chin correctly.

The forehead appears smaller, and not much hair will show at the top as the forehead curves out of our sight.

In this foreshortened view, the jaw is more prominent than in the standard views.

More Foreshortened Views

EXPRESSING EMOTION

Follow the old stage actor's creed: Always play to the back row. Make sure your reader knows what your characters are saying, thinking and feeling by their expressions and body language. Whether subtle or over-the-top, your character's emotions should always be apparent.

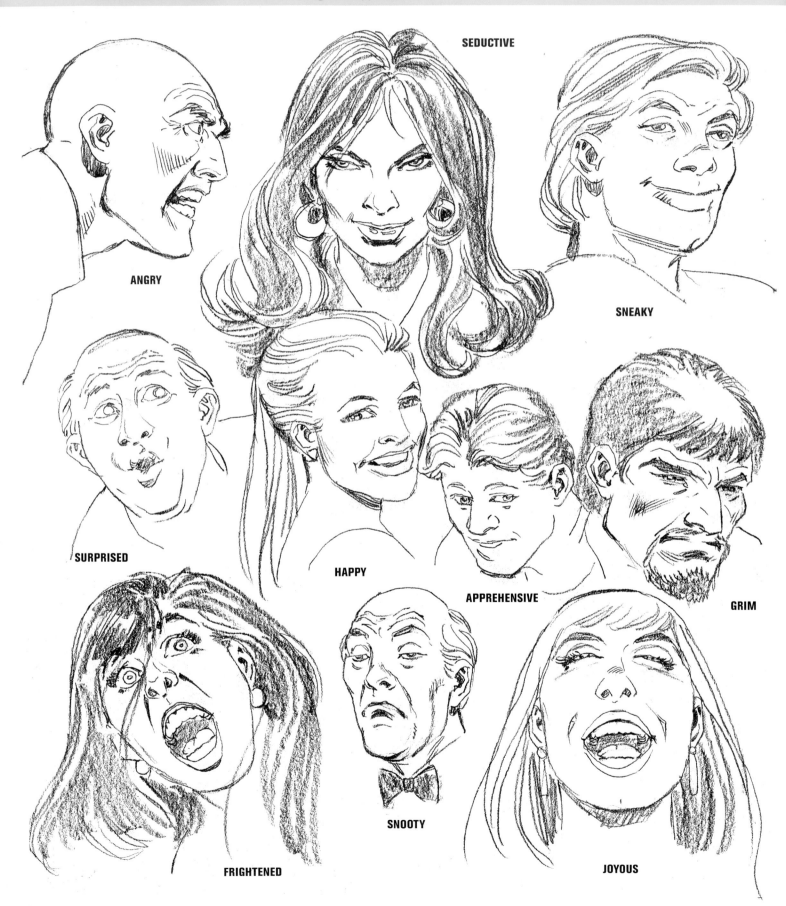

SEDUCTIVE

ANGRY

SNEAKY

SURPRISED

HAPPY

APPREHENSIVE

GRIM

SNOOTY

FRIGHTENED

JOYOUS

CHARACTER DESIGN

Design characters only after you know something about their personalities and what they do. For the characters shown here, which I designed for Future Comics, I was given text that provided back story and story functions for each of them. Some are lead characters, but most play supporting roles.

As the artist you must also anticipate what kind of situations your characters will be involved in so that you can design a character that will be recognizable from any view, in any circumstance.

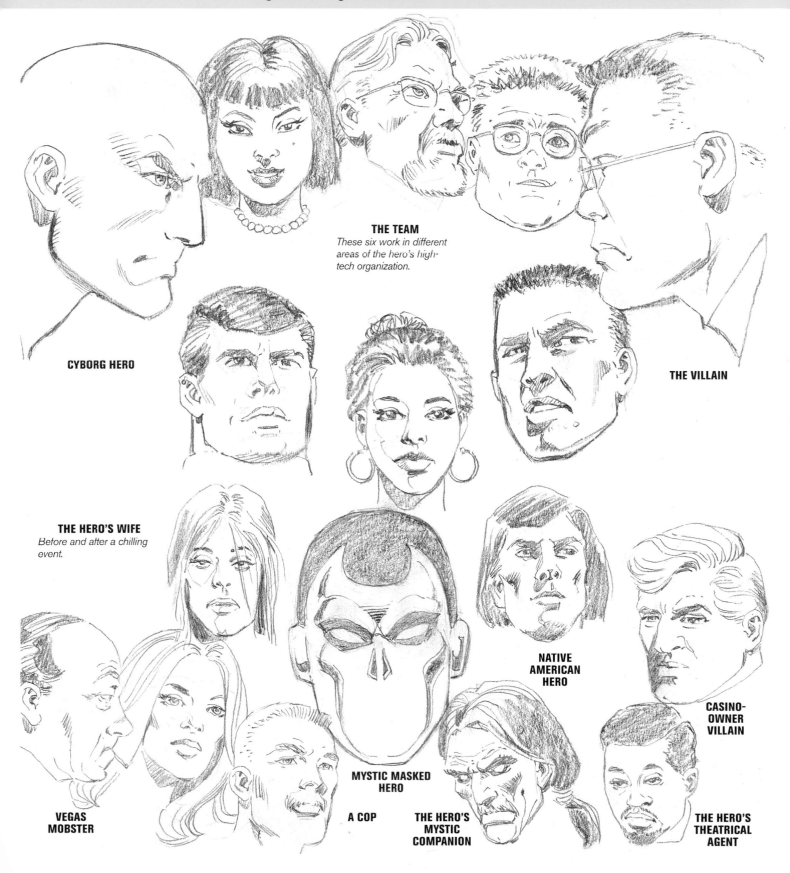

THE TEAM
These six work in different areas of the hero's high-tech organization.

CYBORG HERO

THE VILLAIN

THE HERO'S WIFE
Before and after a chilling event.

NATIVE AMERICAN HERO

CASINO-OWNER VILLAIN

MYSTIC MASKED HERO

VEGAS MOBSTER

A COP

THE HERO'S MYSTIC COMPANION

THE HERO'S THEATRICAL AGENT

head types
MALE HEROES

In real life, heroes come in many shapes and sizes. However, the shorthand language of comics usually requires that its heroes be instantly recognizable as such. Most superheroes will have most or all of the handsome, Greek god-like attributes mentioned below. Others might have only some of these attributes, and sometimes a very different real-world appearance is desired.

Ultimately, if you take the time to find out who your hero is and what he does, what he looks like will suggest itself.

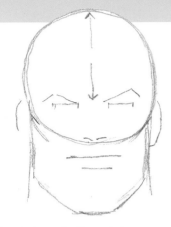

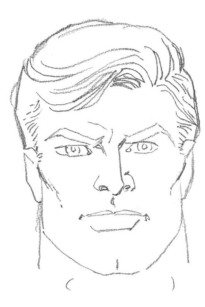

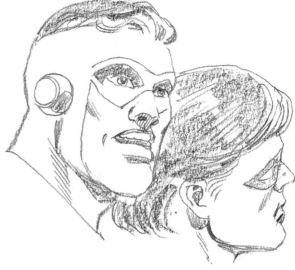

Key attributes for the male hero:

- High forehead (shows intelligence)
- High cheekbones (good bone structure)
- Narrowed eyes (implies sense of purpose)
- Broad jaw and neck (indicates strength)
- Firm, straight, broad mouth, not too full
- Arched eyebrows

Discard any of these attributes at your own risk! Cleft optional!

More Heroes

⬇ THE GUNSLINGER
Slimmer, craggier, weather-beaten, but gives the impression that he's able to take care of himself.

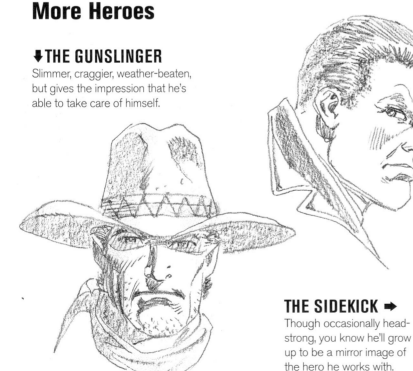

⬅ THE PRIVATE EYE
Has to look smart and tough. He's sexy (babes love him) and has good friends… and dangerous enemies! He doesn't smoke … anymore.

THE SIDEKICK ➡
Though occasionally head-strong, you know he'll grow up to be a mirror image of the hero he works with.

⬆ THE ADVENTURER
Competent with a number of the tools of his trade, he often gets into the kind of trouble that requires derring-do.

head types
MALE VILLAINS

Most of the time, villains should look like bad guys. Yes, that's a cliche, but it's good for the reader to be able to easily distinguish the bad guys from the good guys. Even when a character you didn't suspect is outed as the villain, he suddenly looks like a bad guy!

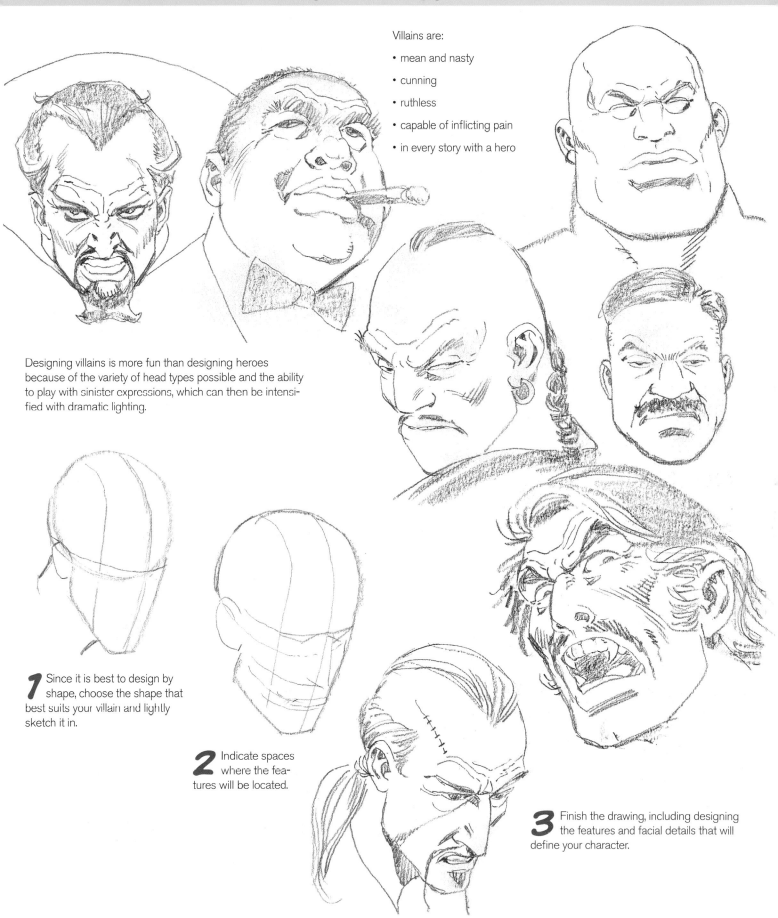

Villains are:

- mean and nasty
- cunning
- ruthless
- capable of inflicting pain
- in every story with a hero

Designing villains is more fun than designing heroes because of the variety of head types possible and the ability to play with sinister expressions, which can then be intensified with dramatic lighting.

1 Since it is best to design by shape, choose the shape that best suits your villain and lightly sketch it in.

2 Indicate spaces where the features will be located.

3 Finish the drawing, including designing the features and facial details that will define your character.

head types
FEMALE HEROES

Of course the female hero has to be pretty. Beautiful even! But more importantly, she has to look like she's a confident individual who can take care of herself in any situation. She can be emotional and intellectual at the same time. She's never a damsel in distress, or just a brainless, brawnless babe. She's a hero!

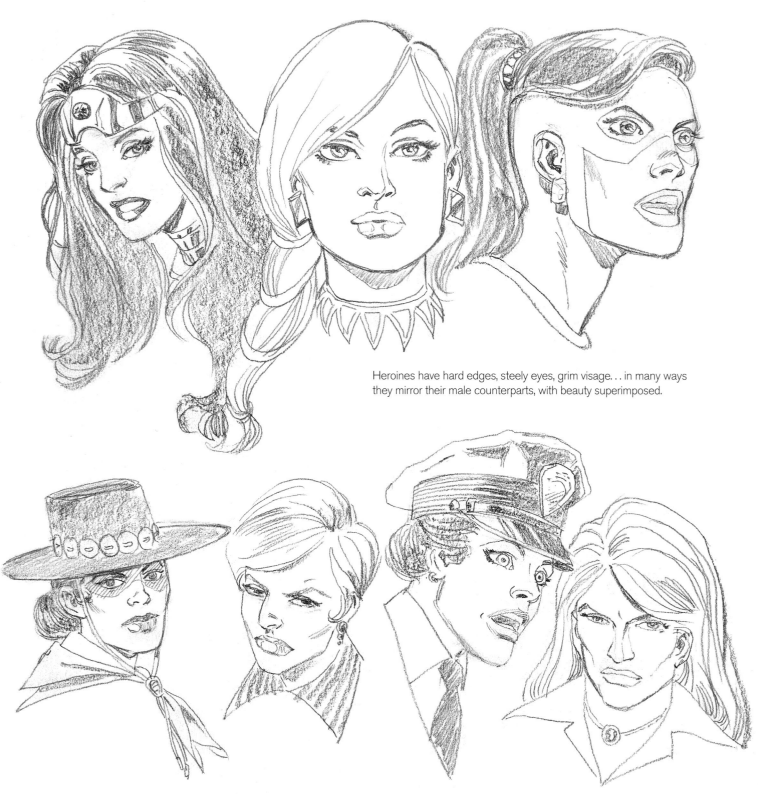

Heroines have hard edges, steely eyes, grim visage. . . in many ways they mirror their male counterparts, with beauty superimposed.

Beautiful heroines don't have to be cookie-cutter. You can design a number of heads that are different from each other, yet share certain physical qualities that identify them as female heroes—and also just happen to be gorgeous.

head types
FEMALE VILLAINS

Everybody loves a bad girl, an evil woman–a villain who is female! Designing female villains has always been great fun for me. Of course, not every female villain can look like a dragon lady. The storyline must dictate what she should look like. Her look should match who she is.

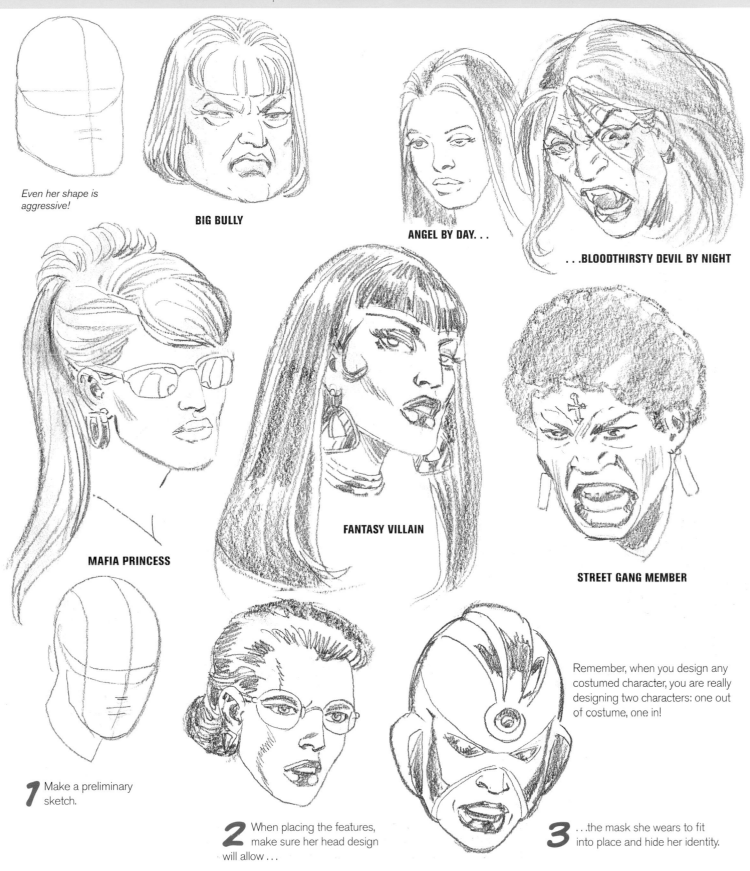

Even her shape is aggressive!

BIG BULLY

ANGEL BY DAY. . .

. . .BLOODTHIRSTY DEVIL BY NIGHT

MAFIA PRINCESS

FANTASY VILLAIN

STREET GANG MEMBER

1 Make a preliminary sketch.

2 When placing the features, make sure her head design will allow . . .

3 . . .the mask she wears to fit into place and hide her identity.

Remember, when you design any costumed character, you are really designing two characters: one out of costume, one in!

head types
THUGS

Thugs provide muscle, firepower, ruthless violence and other special services for "the Boss." In this era of high technology, thugs are not as numerous and are being replaced by techno-geeks who perform their dirty work from behind a computer.

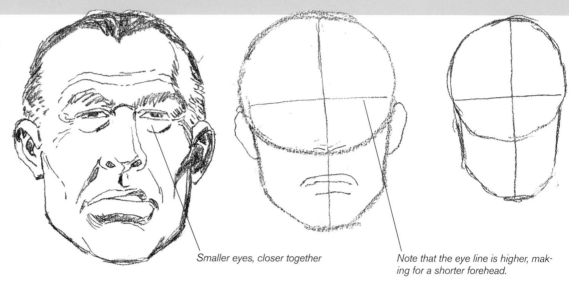

This is more or less the standard-issue thug: heavy on muscle, light on wit. He is fast becoming an endangered species in today's comics, where computer hackers threaten to a new level of danger.

Smaller eyes, closer together

Note that the eye line is higher, making for a shorter forehead.

Newer Breeds: The Modern Henchmen

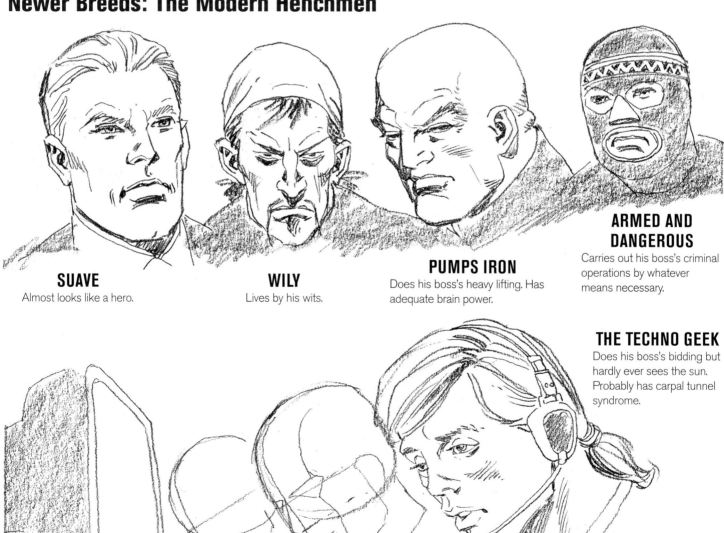

SUAVE
Almost looks like a hero.

WILY
Lives by his wits.

PUMPS IRON
Does his boss's heavy lifting. Has adequate brain power.

ARMED AND DANGEROUS
Carries out his boss's criminal operations by whatever means necessary.

THE TECHNO GEEK
Does his boss's bidding but hardly ever sees the sun. Probably has carpal tunnel syndrome.

head types
YOUNG PEOPLE

Changes in the shape, size and proportions of the human head are apparent from infancy through the teen years. Chubby cheeks, a small nose and chin and a shorter neck are the hallmarks of an infant or toddler. These specific features change drastically with age as a person nears adulthood.

The face of a baby is quite small in proportion to the rest of the head, taking up one-half of the head rather than the standard three-quarters on older people. Start with a square for each view, front and profile. Then reduce the width of the front-view square by approximately one-sixth. Divide this resulting rectangle and the profile square in half both vertically and horizontally. Then divide the lower half of both into four equal parts.

When placing the features, note that:

- The eyes fall well below the horizontal halfway line.

- The eyes are very large and are more than an eye's width apart.

- The upper lip is fuller and protrudes somewhat.

- The bridge of the nose is concave.

- The jowls obscure the neck in the front view; the profile reveals a chubby nape.

Note the changes that occur over time: the more-defined features, the lengthening of the neck and the changing proportions of the features relative to the size of the head. By age 16–18, the head takes on adult proportions.

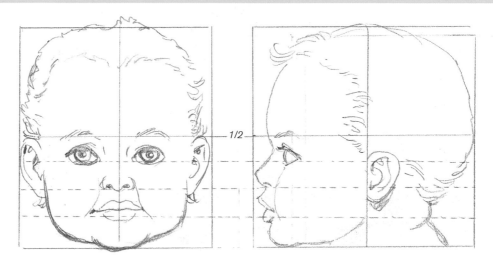

1/2

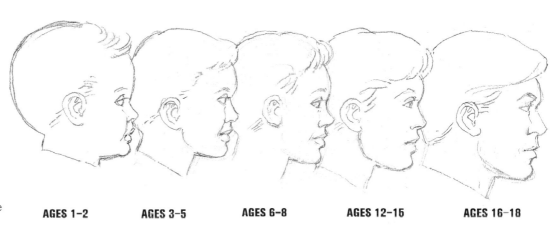

AGES 1–2 **AGES 3–5** **AGES 6–8** **AGES 12–15** **AGES 16–18**

More Kids

ethnic traits
ASIANS

Asian heads are generally characterized by higher cheekbones; narrower eyes somewhat slanted upward; dark eyes; dark, generally straight hair; slightly prominent teeth; broader, flatter noses; and somewhat weaker chins. These are all generalities, of course; exceptions are often apparent as they are in all of the head types we've studied here.

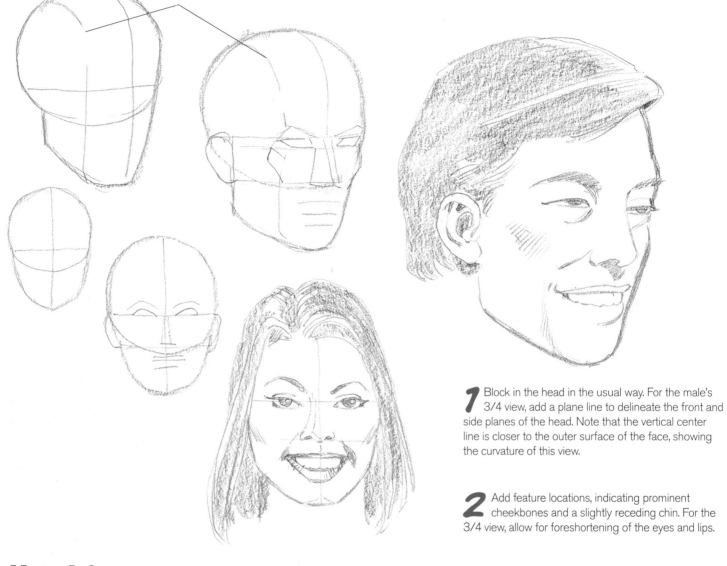

Plane lines

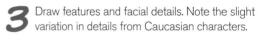

1 Block in the head in the usual way. For the male's 3/4 view, add a plane line to delineate the front and side planes of the head. Note that the vertical center line is closer to the outer surface of the face, showing the curvature of this view.

2 Add feature locations, indicating prominent cheekbones and a slightly receding chin. For the 3/4 view, allow for foreshortening of the eyes and lips.

3 Draw features and facial details. Note the slight variation in details from Caucasian characters.

More Asians

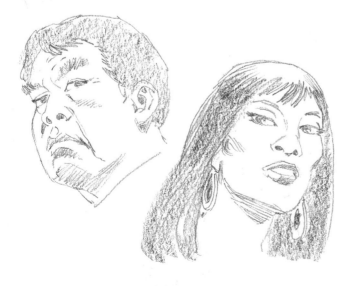

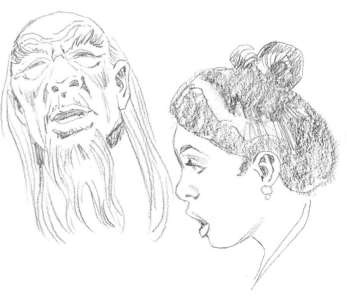

ethnic traits
AFRICAN-AMERICANS

Some generalities you may find useful when drawing African-Americans: somewhat prominent cheekbones; a flat nose that's broader at the nostrils; wider, fuller lips; smaller ears; dark eyes; dark, curly or wavy hair; and somewhat prominent teeth. Again, these are generalities, and some or none may apply to a given individual.

1 Block in the head in the usual way. The male is nearly a full front view, so the side plane will be narrow. The female's construction lines indicate we're looking up at her.

2 Rough in the feature locations, being careful to maintain consistency in showing the angle of the head.

3 Draw the features and facial details, again minding the angle of the head.

Always accentuate the differences in the facial details and head shapes that make each character unique.

More African-Americans

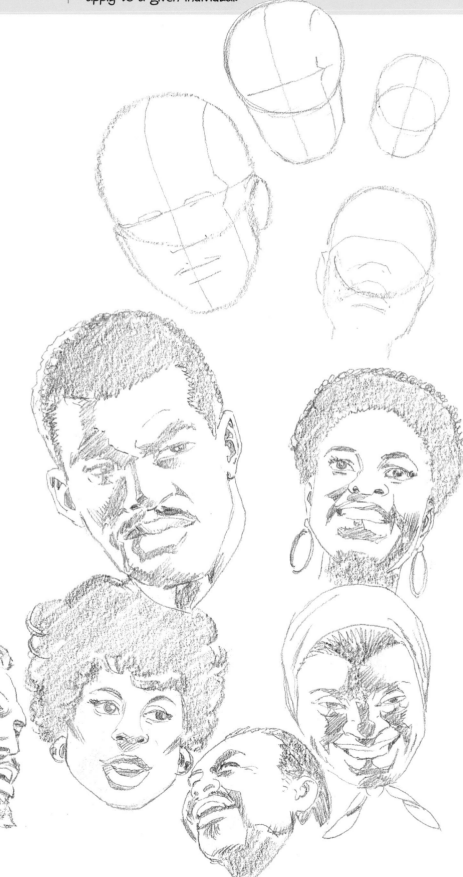

age effects
OLDER WOMEN

Everyone ages differently, but sagging and wrinkled skin, drooping eyelids, longer earlobes, a longer, more bulbous nose and deep, permanent laugh lines will strike all to some degree as they age. The following drawings are an extreme case, encompassing all the signs of aging listed above. Omit or reduce some of these signs and you'll find a much younger woman.

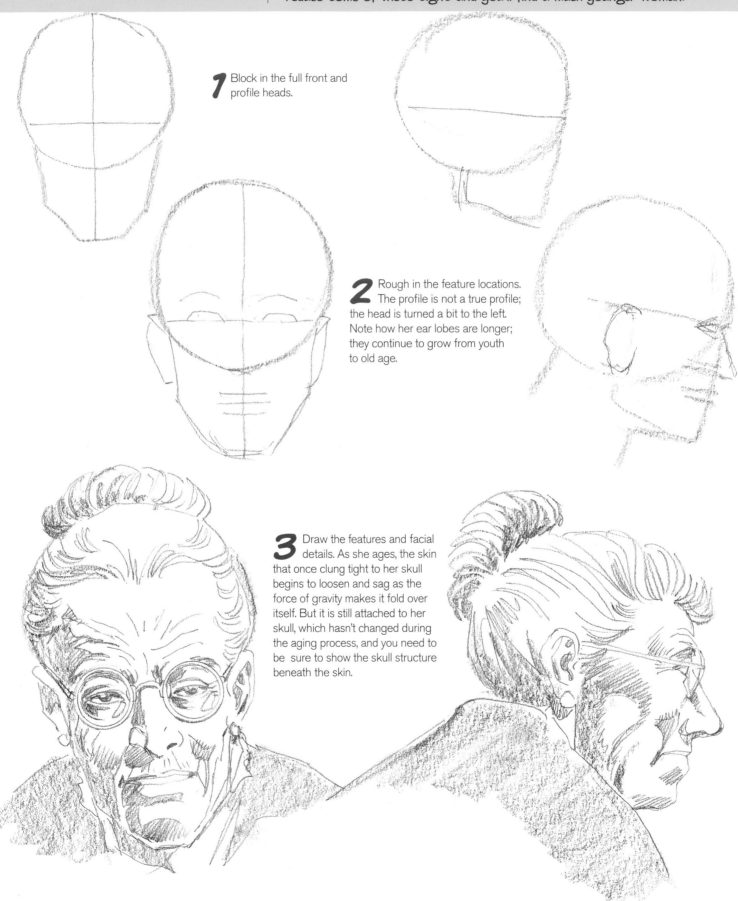

1 Block in the full front and profile heads.

2 Rough in the feature locations. The profile is not a true profile; the head is turned a bit to the left. Note how her ear lobes are longer; they continue to grow from youth to old age.

3 Draw the features and facial details. As she ages, the skin that once clung tight to her skull begins to loosen and sag as the force of gravity makes it fold over itself. But it is still attached to her skull, which hasn't changed during the aging process, and you need to be sure to show the skull structure beneath the skin.

age effects
OLDER MEN

Men age pretty much like women—the skin sags and wrinkles, eyelids droop, and so forth. But if you add facial hair, the head takes on an elegance that transcends the "old man" label.

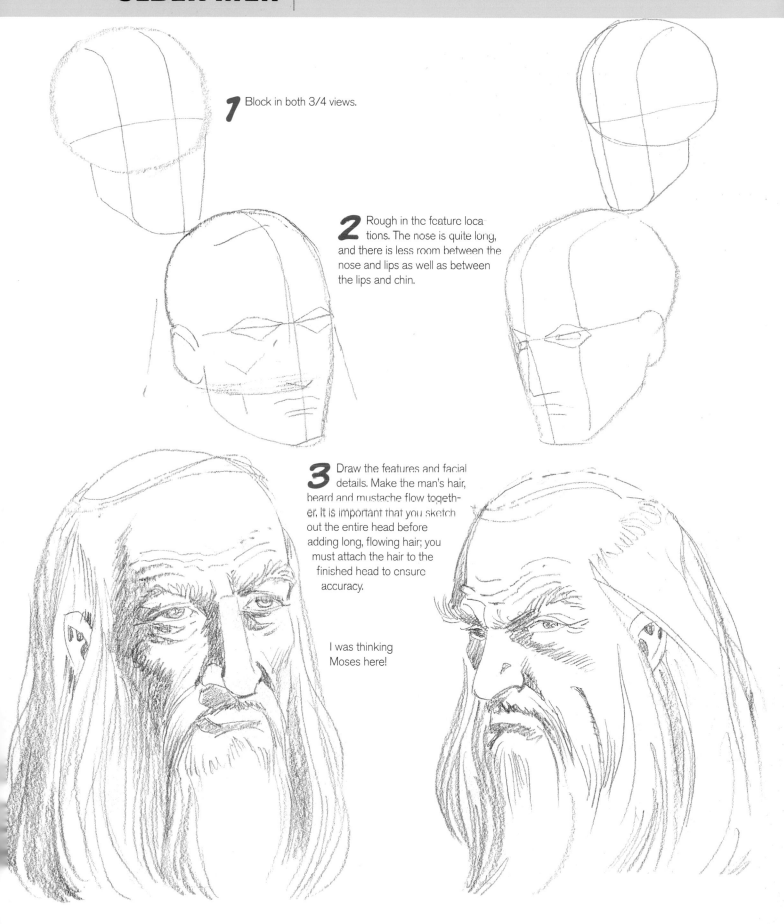

1 Block in both 3/4 views.

2 Rough in the feature locations. The nose is quite long, and there is less room between the nose and lips as well as between the lips and chin.

3 Draw the features and facial details. Make the man's hair, beard and mustache flow together. It is important that you sketch out the entire head before adding long, flowing hair; you must attach the hair to the finished head to ensure accuracy.

I was thinking Moses here!

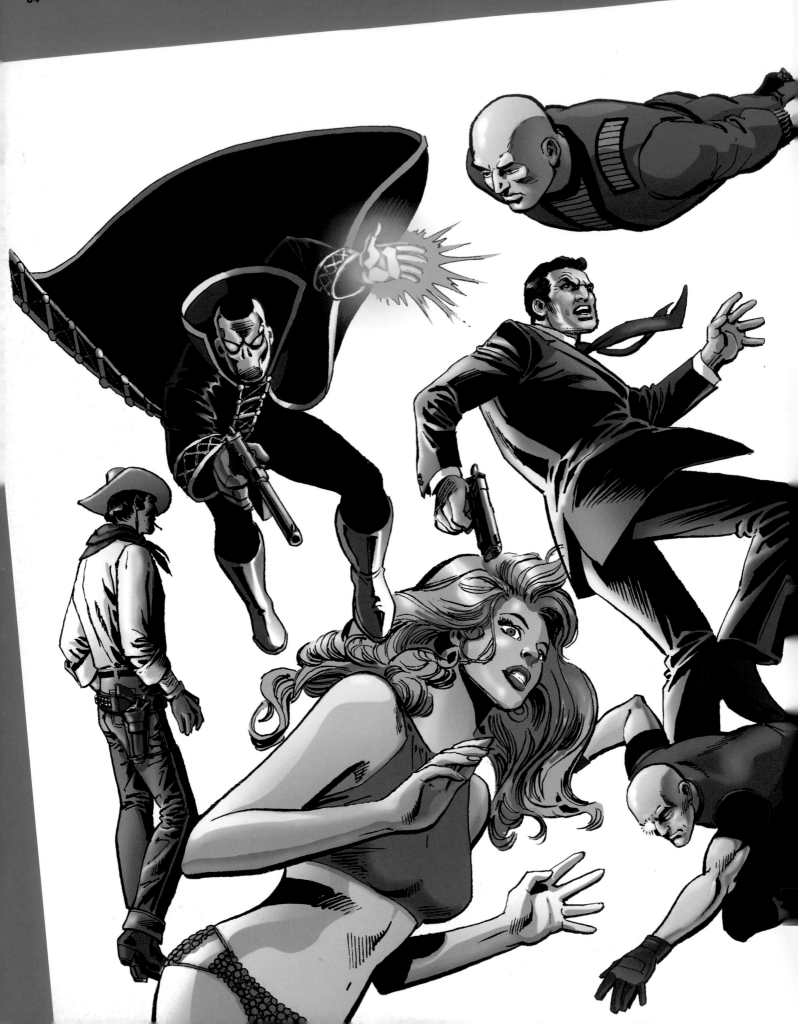

CHAPTER TWO
DRAWING FIGURES

The human figure in motion or at rest is an object of beauty. The aspiring comic book artist must take the time to learn the foundation and drawing techniques necessary to render expressive and credible figures. Good figure drawing is at the very heart of every comic-book story. Artists with the greatest ability to draw action and physical conflict in a realistic and dramatic fashion are most in demand.

We will not have the space here to convey all the information you must have to succeed. Drawing from photos or from life can fill in some of the gaps, and anatomy books are readily available in bookstores or art store websites.

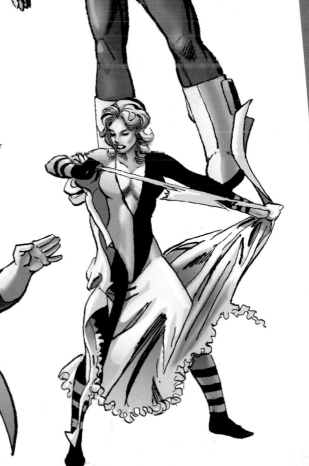

figure basics
PROPORTIONS FOR ADULTS

Getting the proportions right is crucial to good figure drawing. After you determine the height of your character, divide the space between the top of the head and the heels of the feet into equal areas, and use these divisions as a guide for placing various body parts.

The ideal proportion for a comic-book adult is 8 heads tall, modified from the real-life proportion of 7 1/2 heads tall. Most superheroes are drawn at a larger-than-life 8 1/2 to 9 heads tall. Space out the body parts over the larger area, but maintain the same head size.

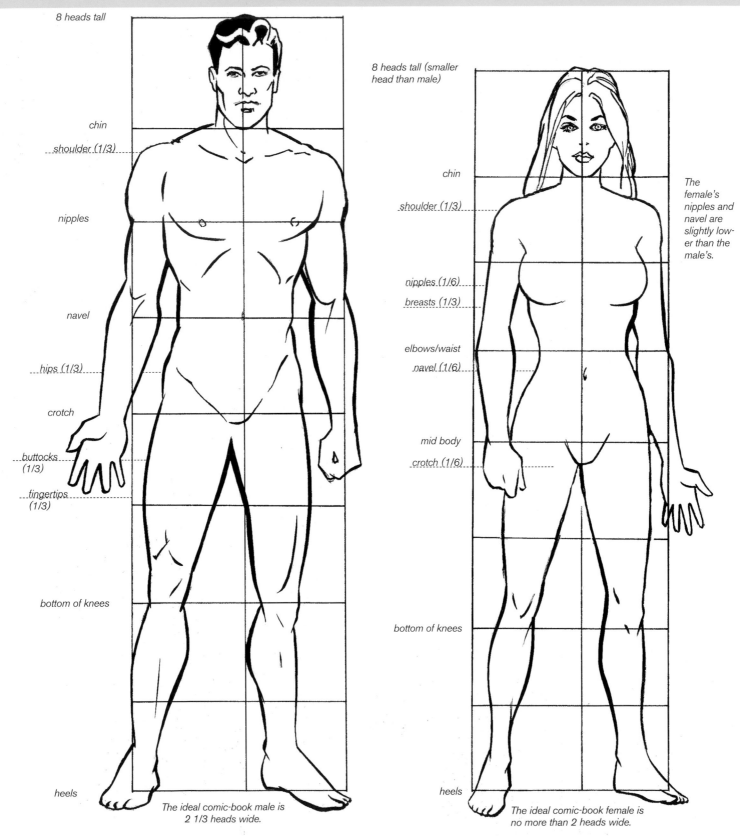

8 heads tall

chin

shoulder (1/3)

nipples

navel

hips (1/3)

crotch

buttocks (1/3)

fingertips (1/3)

bottom of knees

heels

The ideal comic-book male is 2 1/3 heads wide.

8 heads tall (smaller head than male)

chin

shoulder (1/3)

nipples (1/6)

breasts (1/3)

elbows/waist

navel (1/6)

mid body

crotch (1/6)

bottom of knees

heels

The female's nipples and navel are slightly lower than the male's.

The ideal comic-book female is no more than 2 heads wide.

figure basics
PROPORTIONS FOR CHILDREN

The proportional scales on this page more or less presume that the child will eventually grow to be the ideal 8-heads-high adult. From infancy to about the age of 15 (when adult proportions are almost reached), a child's shoulders will be narrow, the head larger in proportion to the body, and the features smaller in proportion to the head. The proportions change from year to year and vary from child to child. You may wish to deviate somewhat for different characters.

WHICH FIGURE WILL GROW TALLER?

Even though these figures share the same body shape, the one on the left still has more growing to do. Why? Because the body grows in relation to the head size. The bigger the head, the more the rest of the body will need to eventually grow to catch up.

15-YEAR-OLD

7 1/2 heads tall

chin

bottom of chest

just below navel

crotch

above knees

below knees

heels

The ideal 15-year-old in comic books shares proportions with "real-life" 7 1/2-heads-high adults.

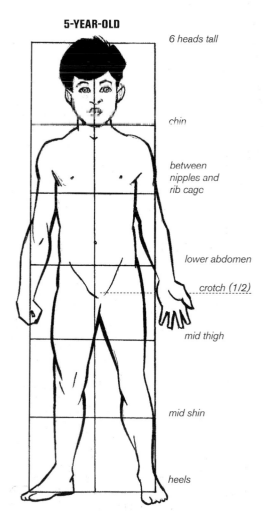

5-YEAR-OLD

6 heads tall

chin

between nipples and rib cage

lower abdomen

crotch (1/2)

mid thigh

mid shin

heels

figure basics
CONSTRUCTING FIGURES

Did you ever draw one figure beautifully, then miss the mark entirely on the next one you drew? Chances are, both were accidents—the result of drawing a figure without first constructing it. I cannot stress enough the importance of developing a basic figure construction process that allows you to attain consistency.

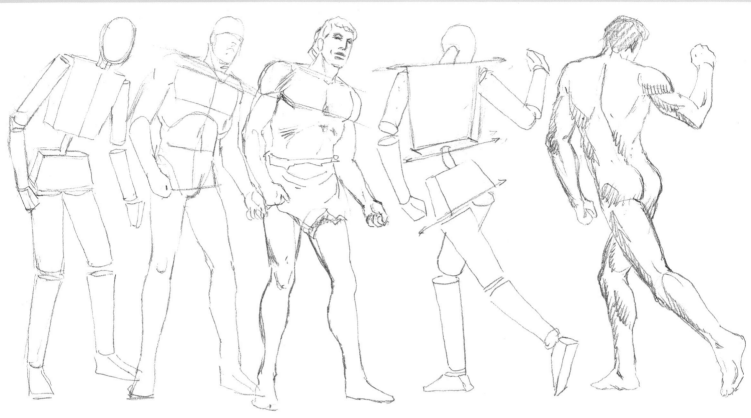

1 Draw a mannequin-like figure consisting of basic geometric shapes, indicating proportions and body movement.

2 Begin the process of completing the figure by blocking in rounder lines that connect the individual shapes together.

3 Finish the drawing by adding details and shading to indicate form and light direction.

After some practice, you may be able to skip a step—just don't abandon the entire process!

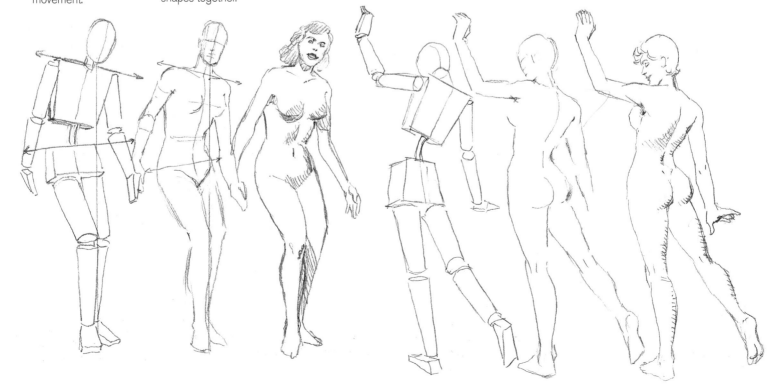

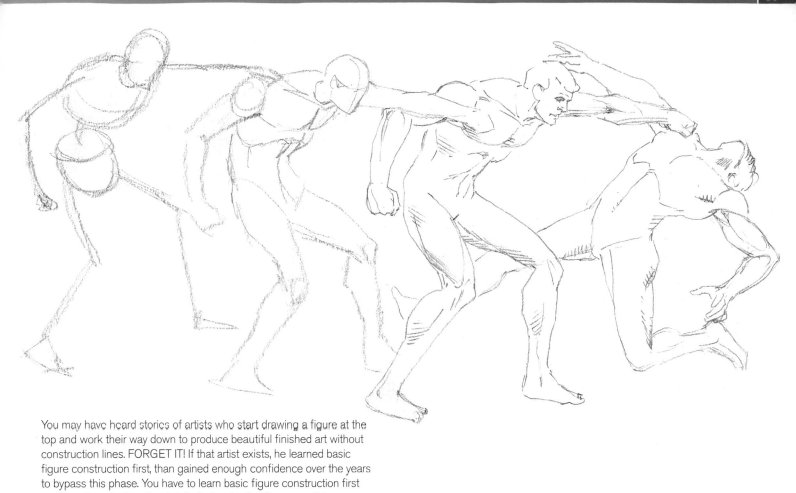

You may have heard stories of artists who start drawing a figure at the top and work their way down to produce beautiful finished art without construction lines. FORGET IT! If that artist exists, he learned basic figure construction first, than gained enough confidence over the years to bypass this phase. You have to learn basic figure construction first and then how to draw the details that make the figure credible.

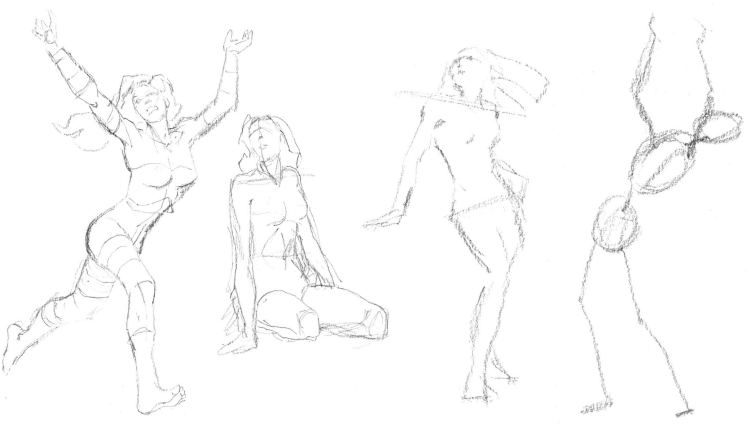

Loosely sketch the figure, accenting by darkening/thickening the main action lines and indicating form.

Sketch the form by keeping your pencil constantly moving, looking for shapes and body attitude.

Use only a few lines to lay down a very basic shape, with directional lines to show body attitude.

OTHER APPROACHES
Try combining elements of several different figure construction methods.

figure basics
HANDS

The hand is one of the most mobile and expressive parts of the human body. It is capable great movement, expressing emotion and acting as a reflection of its owner's persona. Hands are next in importance to the face since they play a part in every picture you draw.

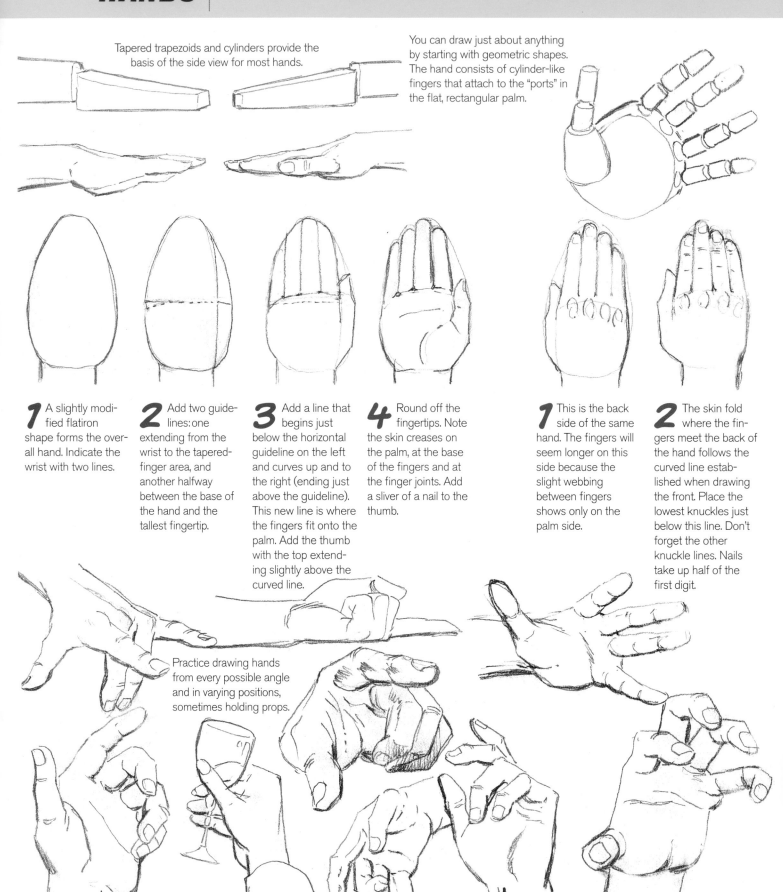

Tapered trapezoids and cylinders provide the basis of the side view for most hands.

You can draw just about anything by starting with geometric shapes. The hand consists of cylinder-like fingers that attach to the "ports" in the flat, rectangular palm.

1 A slightly modified flatiron shape forms the overall hand. Indicate the wrist with two lines.

2 Add two guidelines: one extending from the wrist to the tapered-finger area, and another halfway between the base of the hand and the tallest fingertip.

3 Add a line that begins just below the horizontal guideline on the left and curves up and to the right (ending just above the guideline). This new line is where the fingers fit onto the palm. Add the thumb with the top extending slightly above the curved line.

4 Round off the fingertips. Note the skin creases on the palm, at the base of the fingers and at the finger joints. Add a sliver of a nail to the thumb.

1 This is the back side of the same hand. The fingers will seem longer on this side because the slight webbing between fingers shows only on the palm side.

2 The skin fold where the fingers meet the back of the hand follows the curved line established when drawing the front. Place the lowest knuckles just below this line. Don't forget the other knuckle lines. Nails take up half of the first digit.

Practice drawing hands from every possible angle and in varying positions, sometimes holding props.

figure basics
FEET

Feet may not be as expressive as hands, but you still must know how to draw them. While hands, like heads, are mostly drawn uncovered, the feet you draw will be covered most of the time, so you need to learn to draw shoes as well.

1 Lay in the basic shape.

2 Add toes and ankle bones.

3 "Build" the shoe over the foot so it looks truc to form.

When drawing the contours of the foot, don't forget the ankle bones. The inside bone appears higher than the bone on the outer side.

I know an artist who chooses compositions that intentionally omit showing feet because he doesn't feel he draws them well enough. Don't let that be you! Practice drawing feet (covered and uncovered)—and hands, for that matter—from both life and photos.

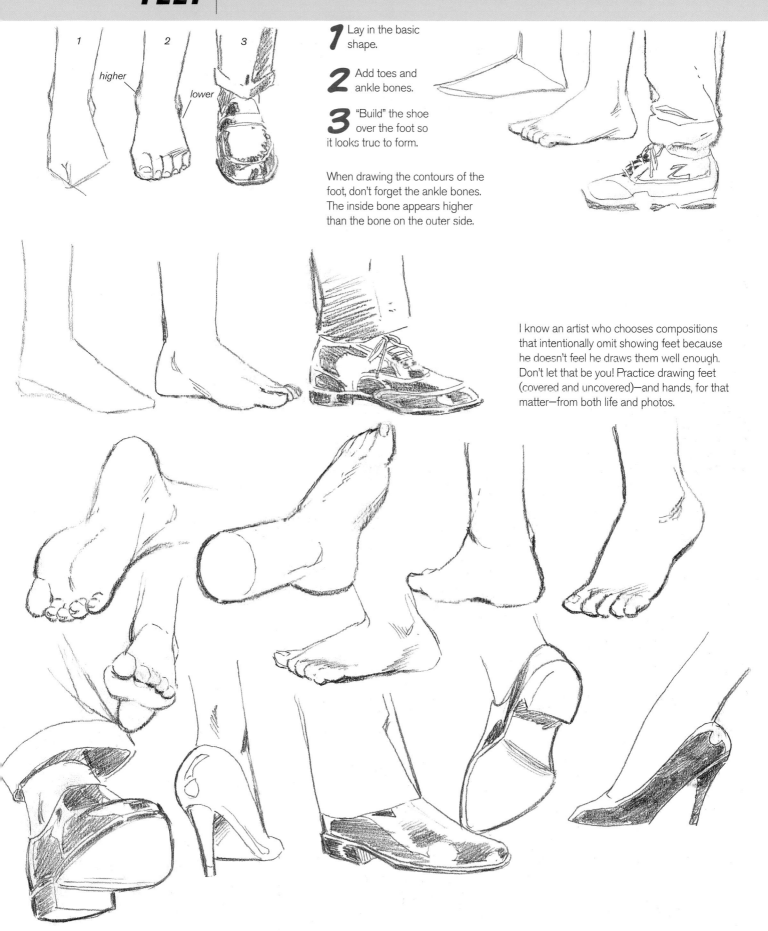

figures in motion
THE ART OF ACTION

I always strive for the graceful action figure. I draw the action as though it were ballet. For me it removes some of the onus of violence. This holds true even with figures that are *not* moving violently.

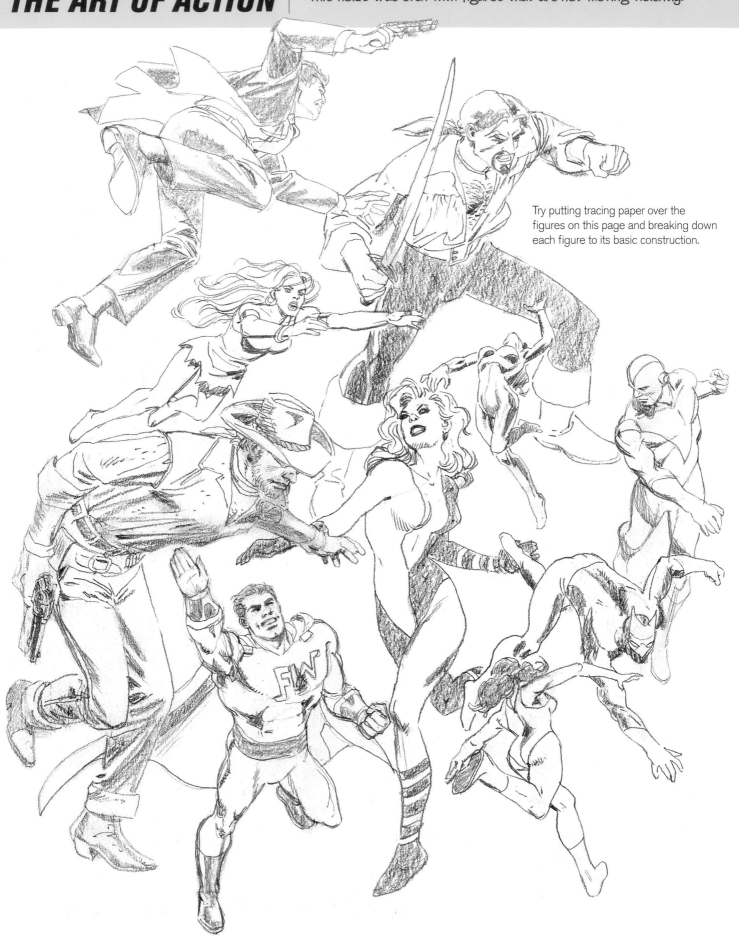

Try putting tracing paper over the figures on this page and breaking down each figure to its basic construction.

figures in motion
WALKING

It seems simple enough: put one foot in front of the other, then repeat. However, there are often things to be learned by *how* a character walks.

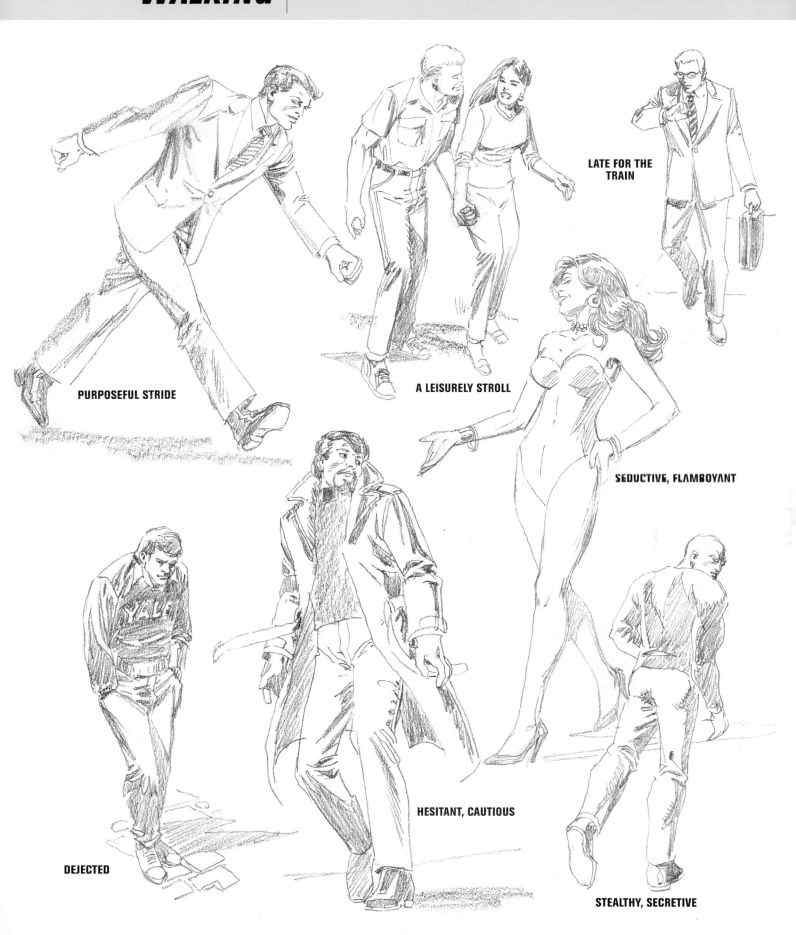

PURPOSEFUL STRIDE

A LEISURELY STROLL

LATE FOR THE TRAIN

SEDUCTIVE, FLAMBOYANT

DEJECTED

HESITANT, CAUTIOUS

STEALTHY, SECRETIVE

figures in motion
RUNNING

In walking or running, the body must slant forward as the first step is taken. Balance is caught by the front foot as the rear foot provides the forward thrust. As the speed of the forward movement increases, the body must slant forward at a greater angle to maintain balance. Arms and legs move in opposition.

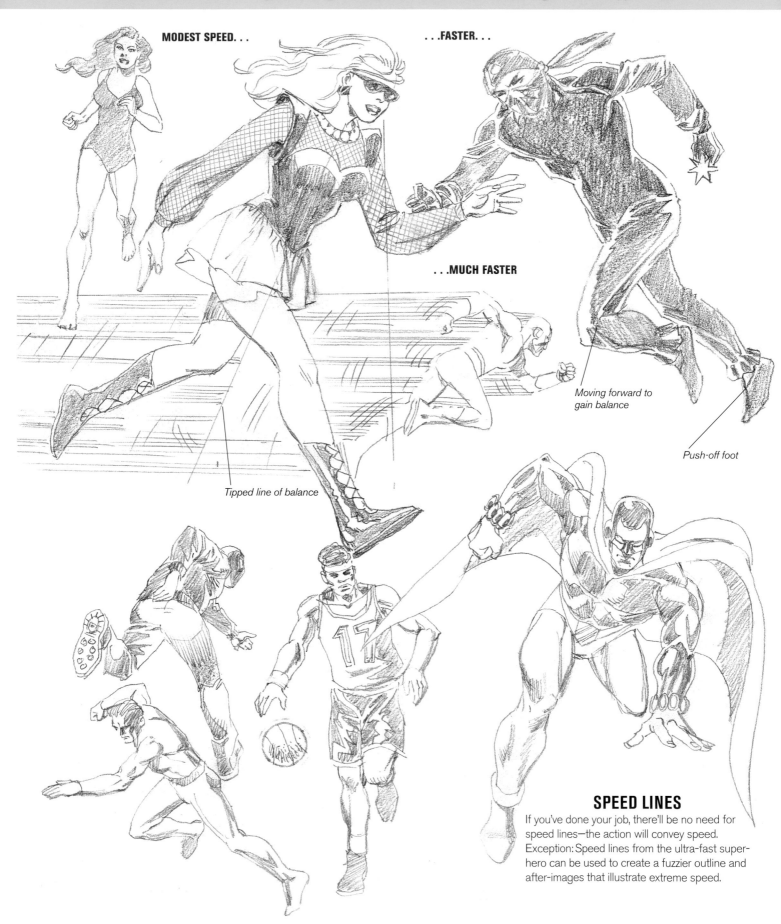

MODEST SPEED. . .

. . .FASTER. . .

. . .MUCH FASTER

Moving forward to gain balance

Push-off foot

Tipped line of balance

SPEED LINES

If you've done your job, there'll be no need for speed lines—the action will convey speed. Exception: Speed lines from the ultra-fast superhero can be used to create a fuzzier outline and after-images that illustrate extreme speed.

figures in motion
JUMPING

Jumping is an action that many anatomy books give short shrift to. Perhaps that is because it can appear to be a second cousin to running and falling. There are four basic ways to jump: Up, down, over or across.

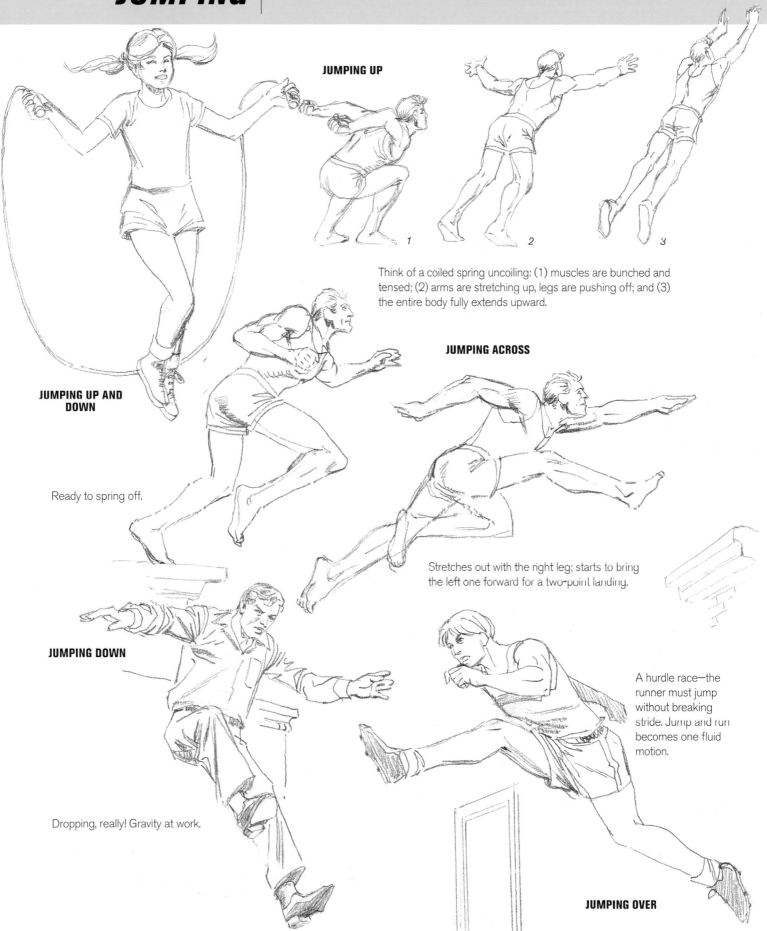

JUMPING UP

1　　*2*　　*3*

Think of a coiled spring uncoiling: (1) muscles are bunched and tensed; (2) arms are stretching up, legs are pushing off; and (3) the entire body fully extends upward.

JUMPING ACROSS

JUMPING UP AND DOWN

Ready to spring off.

Stretches out with the right leg; starts to bring the left one forward for a two-point landing.

JUMPING DOWN

Dropping, really! Gravity at work.

A hurdle race—the runner must jump without breaking stride. Jump and run becomes one fluid motion.

JUMPING OVER

figures in motion
FLYING

Not every superhero flies, but many readers wish they all did! They *love* flying shots. The heroes that don't fly per se generally have other lofty means of transport: a rope or web to swing on, magical powers that allow them to levitate, super-speed or wind currents to float on.

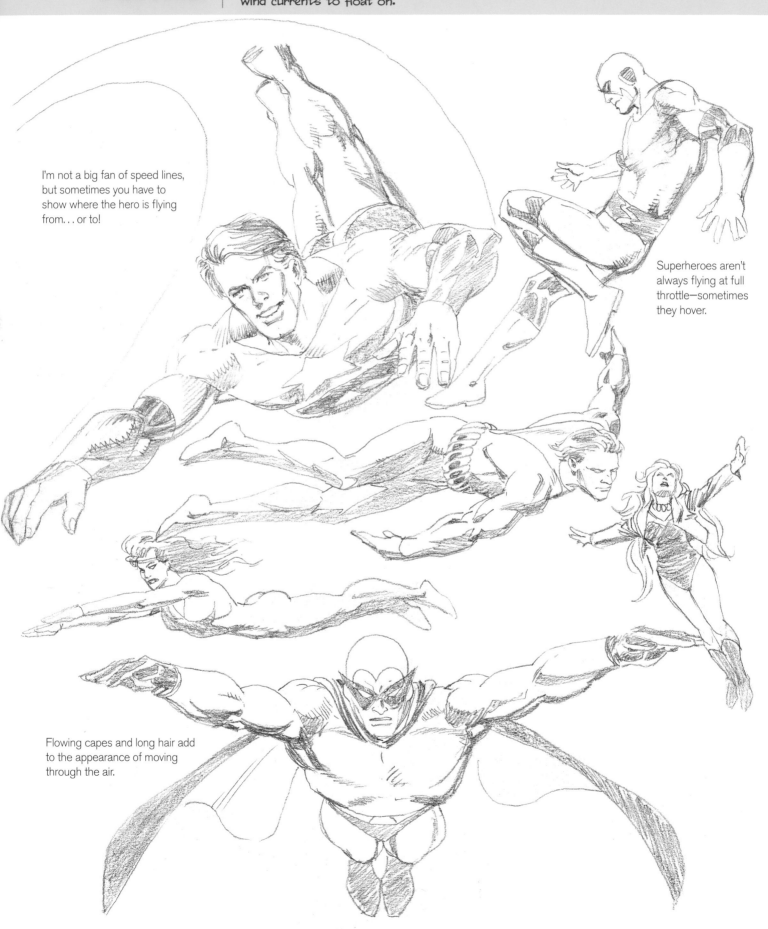

I'm not a big fan of speed lines, but sometimes you have to show where the hero is flying from... or to!

Superheroes aren't always flying at full throttle—sometimes they hover.

Flowing capes and long hair add to the appearance of moving through the air.

figures in motion
FALLING

When drawing this action, first determine whether the fall is controlled (diving from a high place into water) or uncontrolled (pushed off a building). The dynamics are quite different.

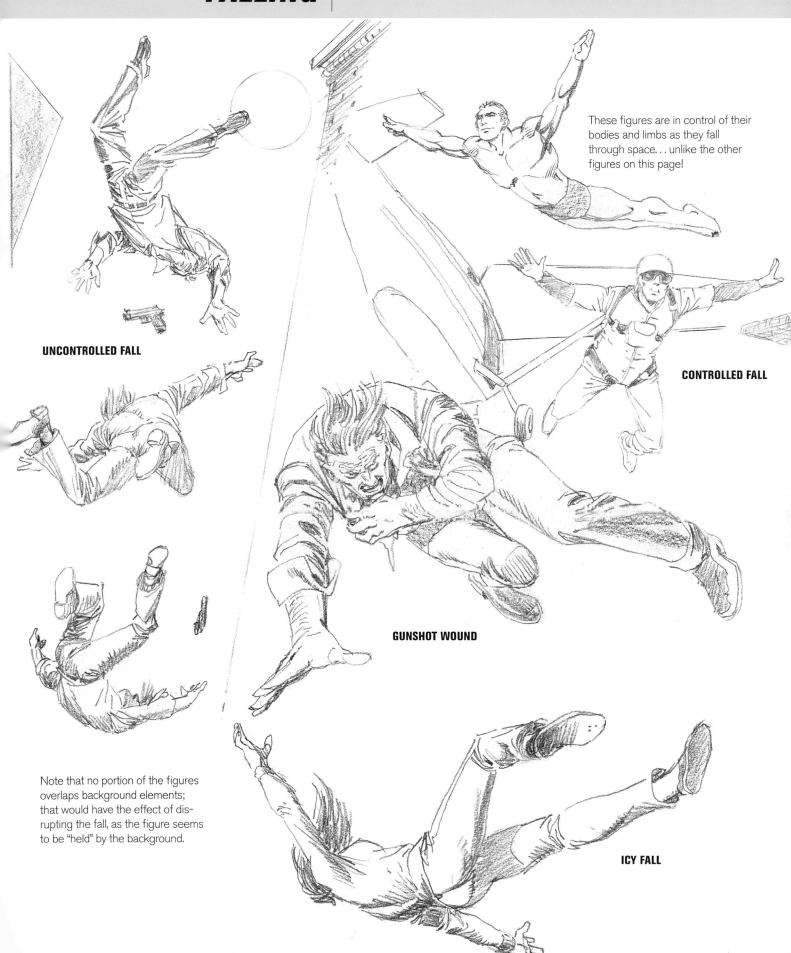

UNCONTROLLED FALL

These figures are in control of their bodies and limbs as they fall through space... unlike the other figures on this page!

CONTROLLED FALL

GUNSHOT WOUND

ICY FALL

Note that no portion of the figures overlaps background elements; that would have the effect of disrupting the fall, as the figure seems to be "held" by the background.

figures in motion
FIGHTING

Comic book characters fight a lot, and you need to work overtime to learn how to draw those fights in a believable fashion. Shown here are hand-to-hand combat moves between non-powered characters. Fights between superheroes and super villains are a whole other issue, as are fights involving weaponry.

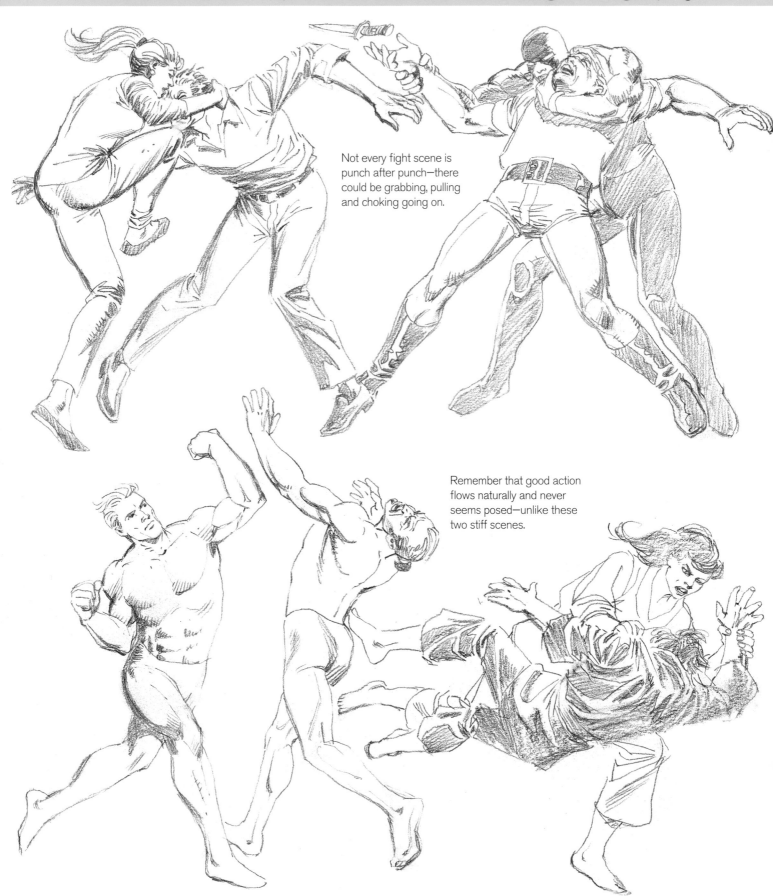

Not every fight scene is punch after punch—there could be grabbing, pulling and choking going on.

Remember that good action flows naturally and never seems posed—unlike these two stiff scenes.

figures in motion
PUNCHING

The good old-fashioned fist fight is a mainstay even in today's comics. Here are a few ways to finish off the bad guys. Try not to develop a bunch of stock shots; make each drawing unique.

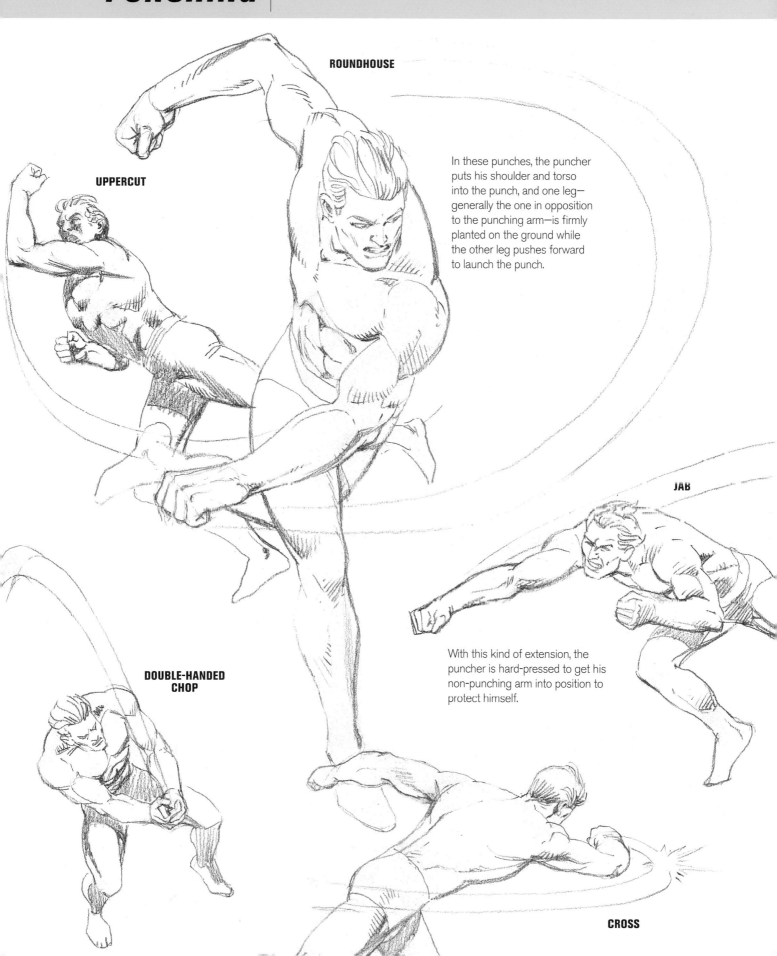

ROUNDHOUSE

UPPERCUT

In these punches, the puncher puts his shoulder and torso into the punch, and one leg—generally the one in opposition to the punching arm—is firmly planted on the ground while the other leg pushes forward to launch the punch.

JAB

With this kind of extension, the puncher is hard-pressed to get his non-punching arm into position to protect himself.

DOUBLE-HANDED CHOP

CROSS

figures in motion
KICKING

When one thinks of kicking in hand-to-hand combat, the images that commonly spring to mind are of the kicks used by martial artists. I'm no exception; most of these drawings are martial-arts inspired.

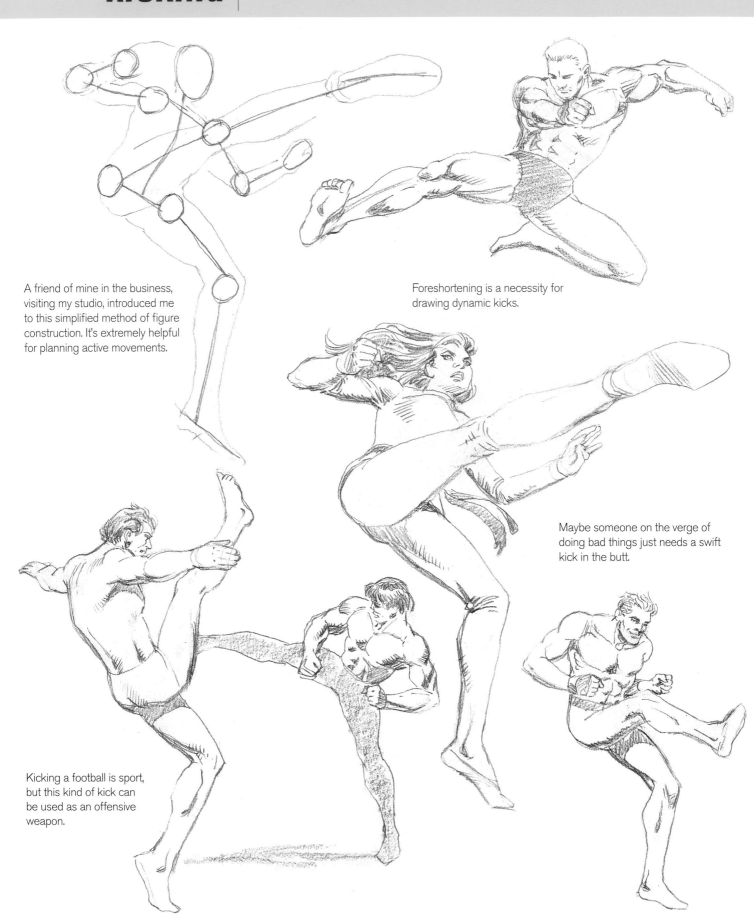

A friend of mine in the business, visiting my studio, introduced me to this simplified method of figure construction. It's extremely helpful for planning active movements.

Foreshortening is a necessity for drawing dynamic kicks.

Maybe someone on the verge of doing bad things just needs a swift kick in the butt.

Kicking a football is sport, but this kind of kick can be used as an offensive weapon.

figures in motion
RECOILING

Action and reaction. . . remembering this simple law of physics will serve you well in drawing hand-to-hand combat. The recoil, or reaction, of the combatant who is hit is directly related to the action of the combatant who does the hitting. The angle of attack and the force of the blow directly influence that reaction. The figures shown here are reacting to the punches or kicks delivered on previous pages.

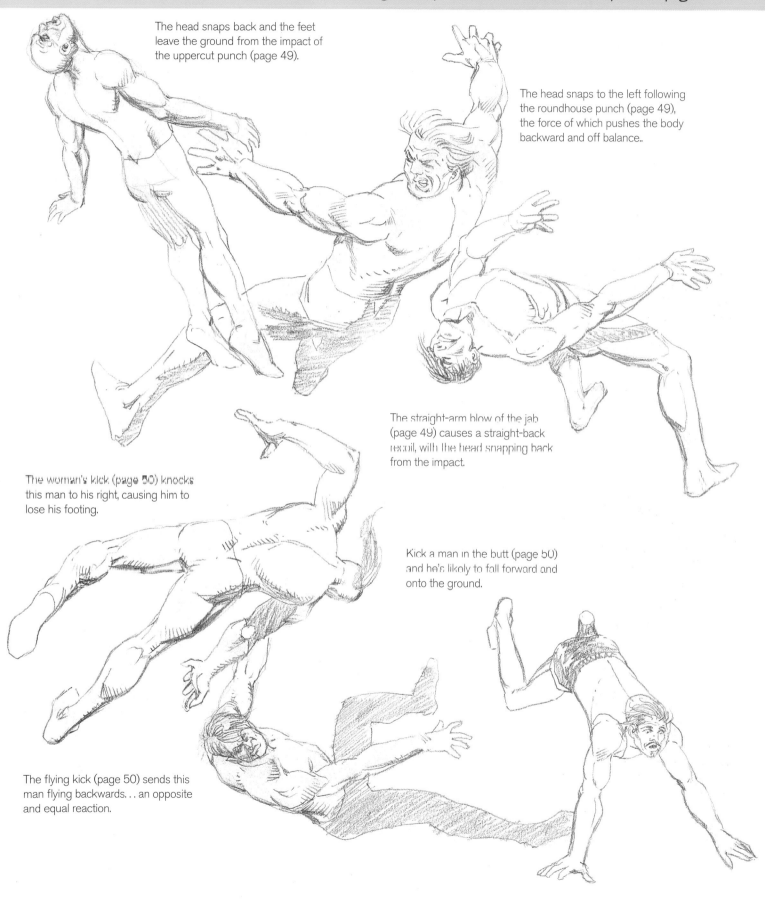

The head snaps back and the feet leave the ground from the impact of the uppercut punch (page 49).

The head snaps to the left following the roundhouse punch (page 49), the force of which pushes the body backward and off balance..

The straight-arm blow of the jab (page 49) causes a straight-back recoil, with the head snapping back from the impact.

The woman's kick (page 50) knocks this man to his right, causing him to lose his footing.

Kick a man in the butt (page 50) and he's likely to fall forward and onto the ground.

The flying kick (page 50) sends this man flying backwards. . . an opposite and equal reaction.

figure types
VARIOUS MALES

In the course of drawing a comic book story, you may be called upon to create a variety of characters (some just background people) that aren't hero figure types to fill out a story.

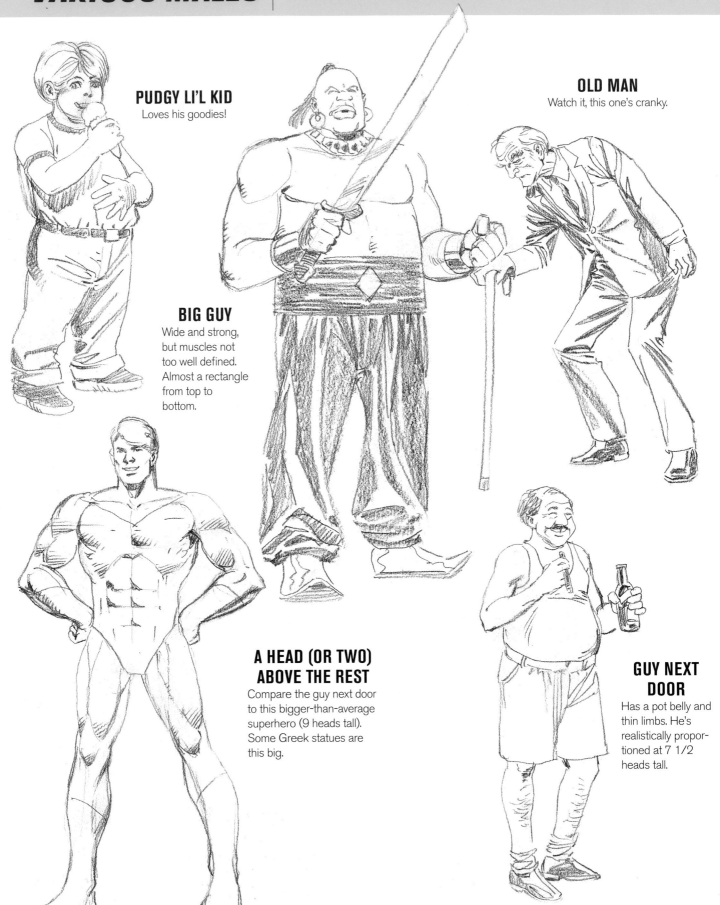

PUDGY LI'L KID
Loves his goodies!

BIG GUY
Wide and strong, but muscles not too well defined. Almost a rectangle from top to bottom.

OLD MAN
Watch it, this one's cranky.

A HEAD (OR TWO) ABOVE THE REST
Compare the guy next door to this bigger-than-average superhero (9 heads tall). Some Greek statues are this big.

GUY NEXT DOOR
Has a pot belly and thin limbs. He's realistically proportioned at 7 1/2 heads tall.

figure types
VARIOUS FEMALES

Women make up a large portion of the population in comics. Many of the mostly male readers focus on the more attractive women in the heroic fantasy milieu in which most comic stories occur. But as an artist you should learn to draw a variety of real-world females—most of whom are not supermodels.

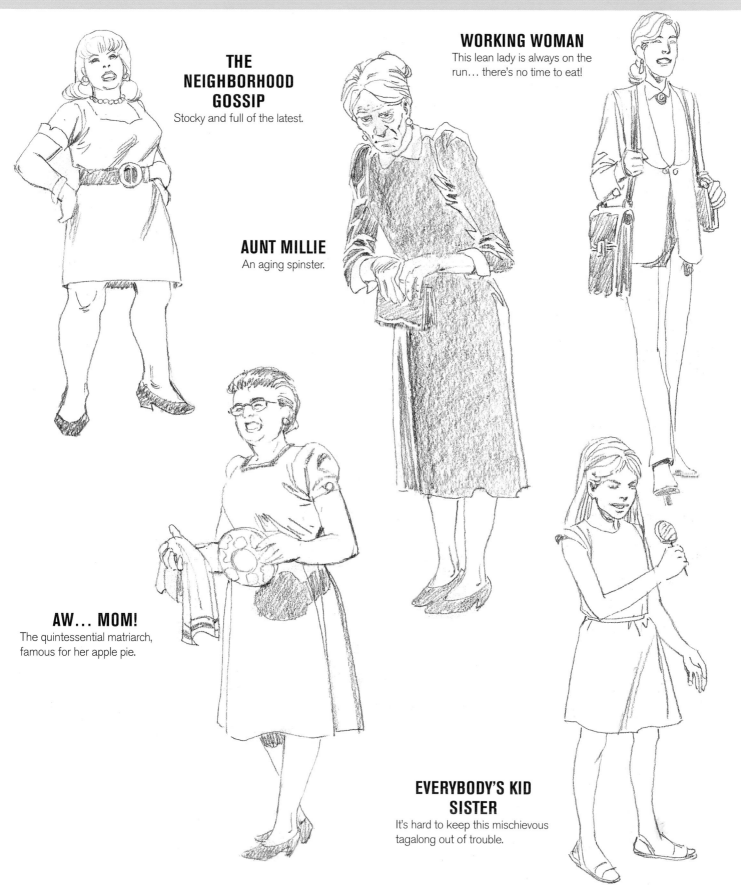

THE NEIGHBORHOOD GOSSIP
Stocky and full of the latest.

AUNT MILLIE
An aging spinster.

WORKING WOMAN
This lean lady is always on the run… there's no time to eat!

AW… MOM!
The quintessential matriarch, famous for her apple pie.

EVERYBODY'S KID SISTER
It's hard to keep this mischievous tagalong out of trouble.

figure basics
FORESHORTENING

It would be difficult to draw a figure for a comic book story that did not have at least some part of the body in a foreshortened view—appearing as though it is coming toward or moving away from the reader. When drawing this way, it helps to imagine your figure in a box.

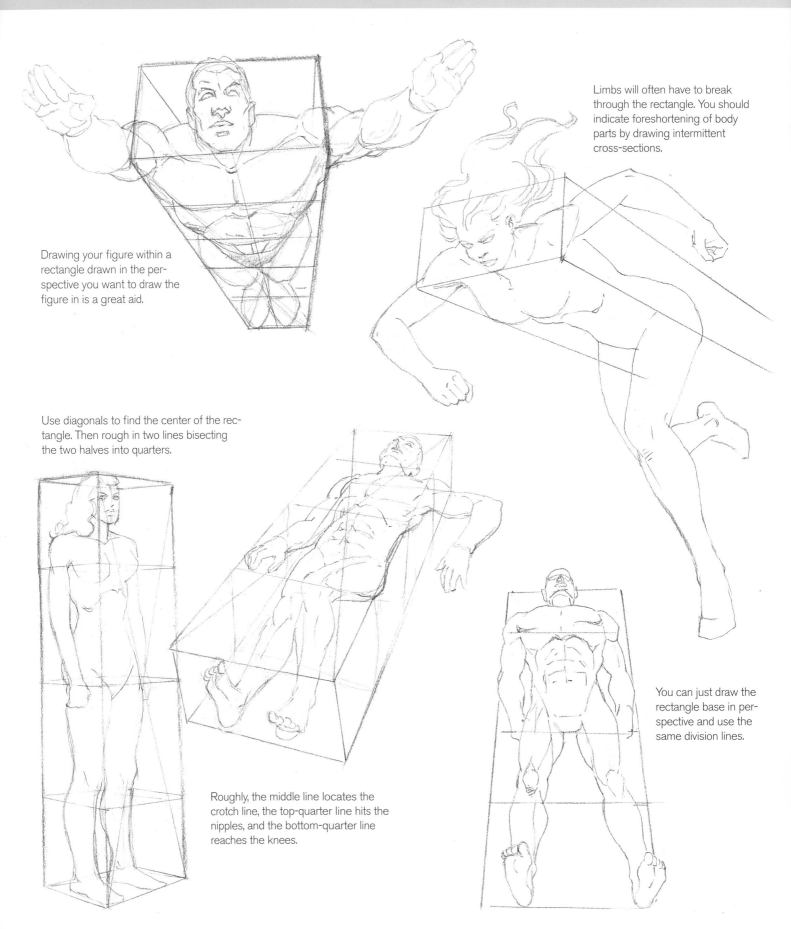

Limbs will often have to break through the rectangle. You should indicate foreshortening of body parts by drawing intermittent cross-sections.

Drawing your figure within a rectangle drawn in the perspective you want to draw the figure in is a great aid.

Use diagonals to find the center of the rectangle. Then rough in two lines bisecting the two halves into quarters.

You can just draw the rectangle base in perspective and use the same division lines.

Roughly, the middle line locates the crotch line, the top-quarter line hits the nipples, and the bottom-quarter line reaches the knees.

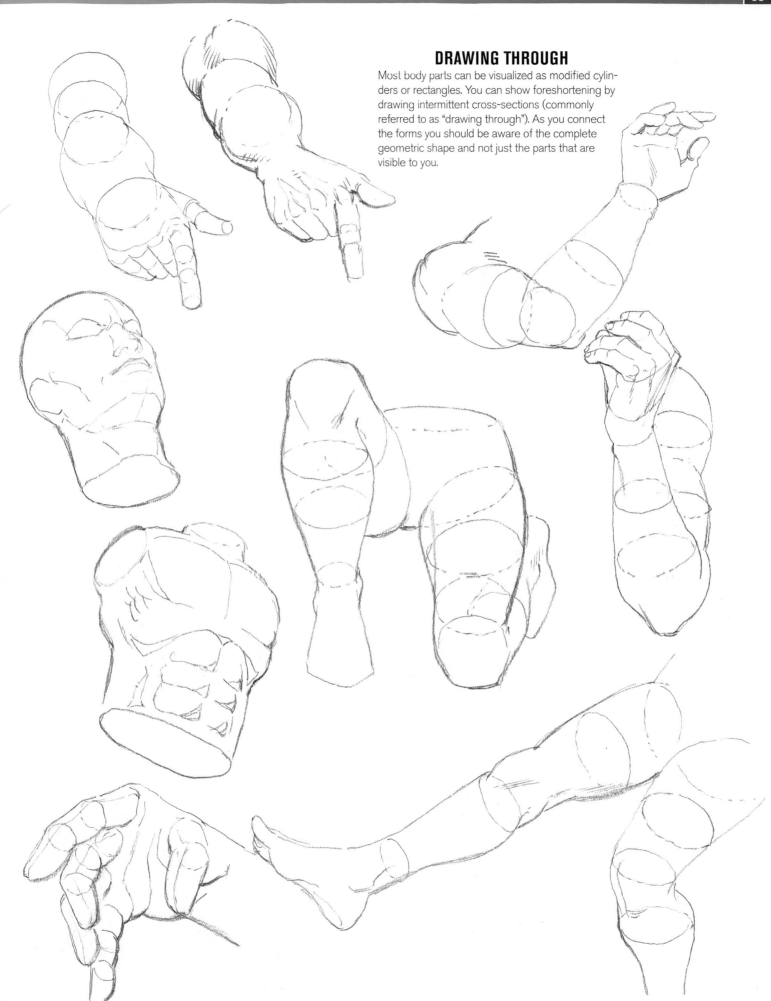

DRAWING THROUGH

Most body parts can be visualized as modified cylinders or rectangles. You can show foreshortening by drawing intermittent cross-sections (commonly referred to as "drawing through"). As you connect the forms you should be aware of the complete geometric shape and not just the parts that are visible to you.

figure basics
COSTUMES

As a comic book artist, you have to be ready to draw and costume a wide variety of characters who must be instantly recognizable and look the part of the role they play. Here again, form follows function. Decide *who* your characters are and dress them accordingly. Cliches that work can be employed. The guy with the white hat is still the hero!

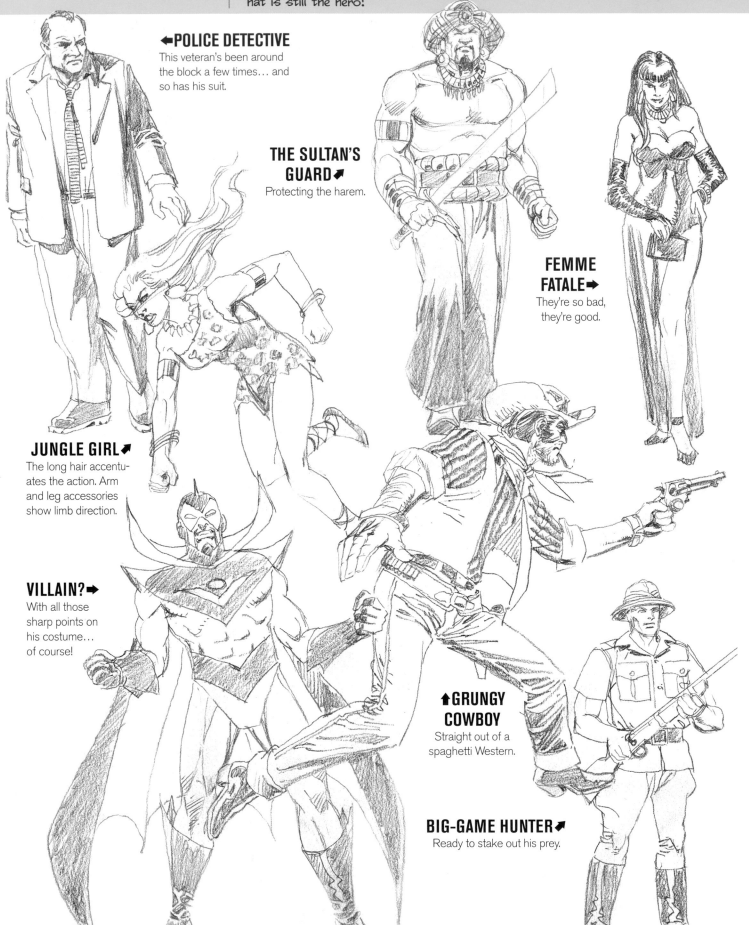

◄POLICE DETECTIVE
This veteran's been around the block a few times… and so has his suit.

THE SULTAN'S GUARD➤
Protecting the harem.

FEMME FATALE➤
They're so bad, they're good.

JUNGLE GIRL➤
The long hair accentuates the action. Arm and leg accessories show limb direction.

VILLAIN?➤
With all those sharp points on his costume… of course!

↑GRUNGY COWBOY
Straight out of a spaghetti Western.

BIG-GAME HUNTER◄
Ready to stake out his prey.

More Costumes

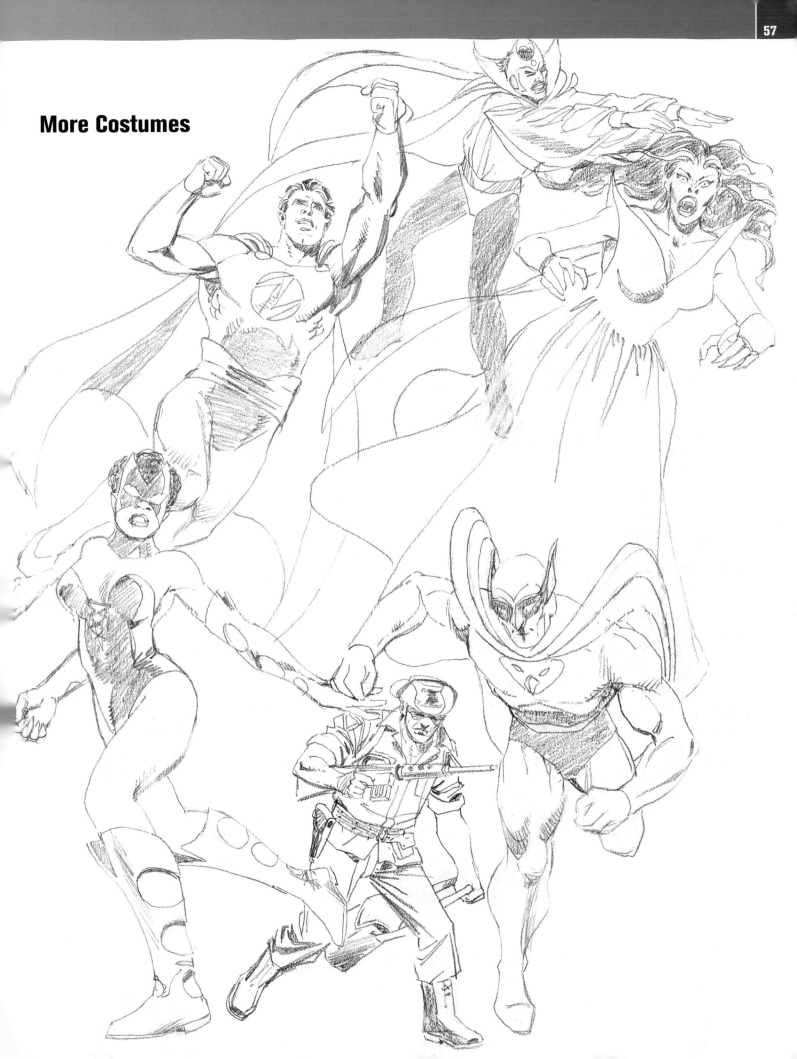

figure types
MALE HEROES

Heroes come in several varieties: Costumed or not; superpowered or sans powers; lean or bulky; masterful with weaponry or skilled with the fist; or any combination of the above.

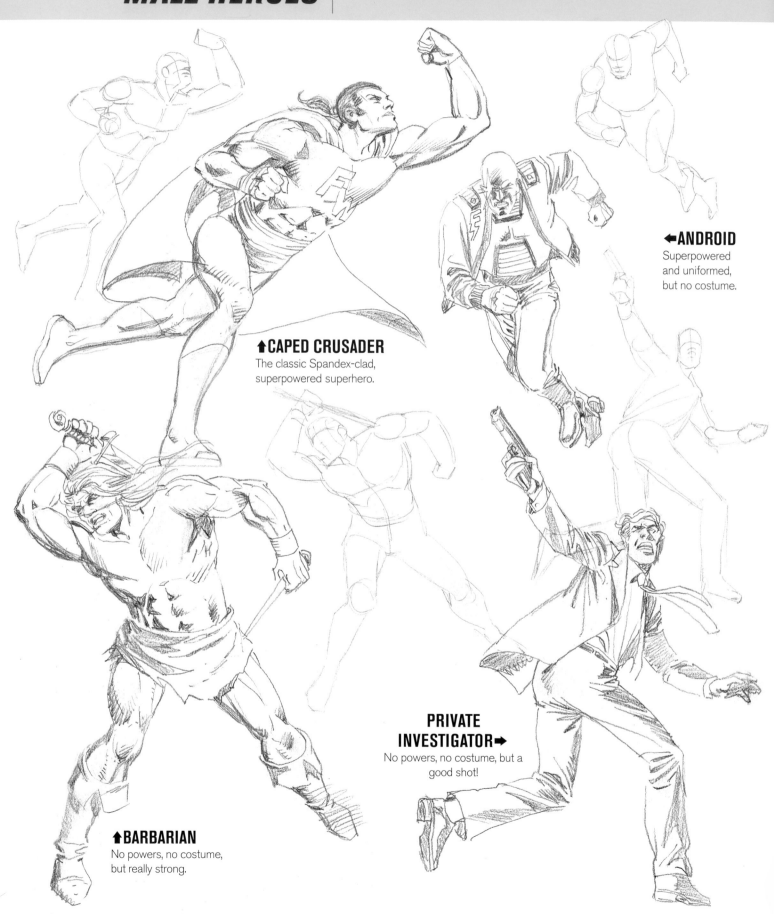

◀ANDROID
Superpowered and uniformed, but no costume.

⬆CAPED CRUSADER
The classic Spandex-clad, superpowered superhero.

PRIVATE INVESTIGATOR➡
No powers, no costume, but a good shot!

⬆BARBARIAN
No powers, no costume, but really strong.

figure types
MALE VILLAINS

Drama requires the presence of conflict. There must be villains for the heroes to battle. Villains are a varied lot. Some don masks and costumes; some sport street clothes. Some have superpowers, while others rely on rented muscle and firepower. All are committed to making the hero's cause a futile one.

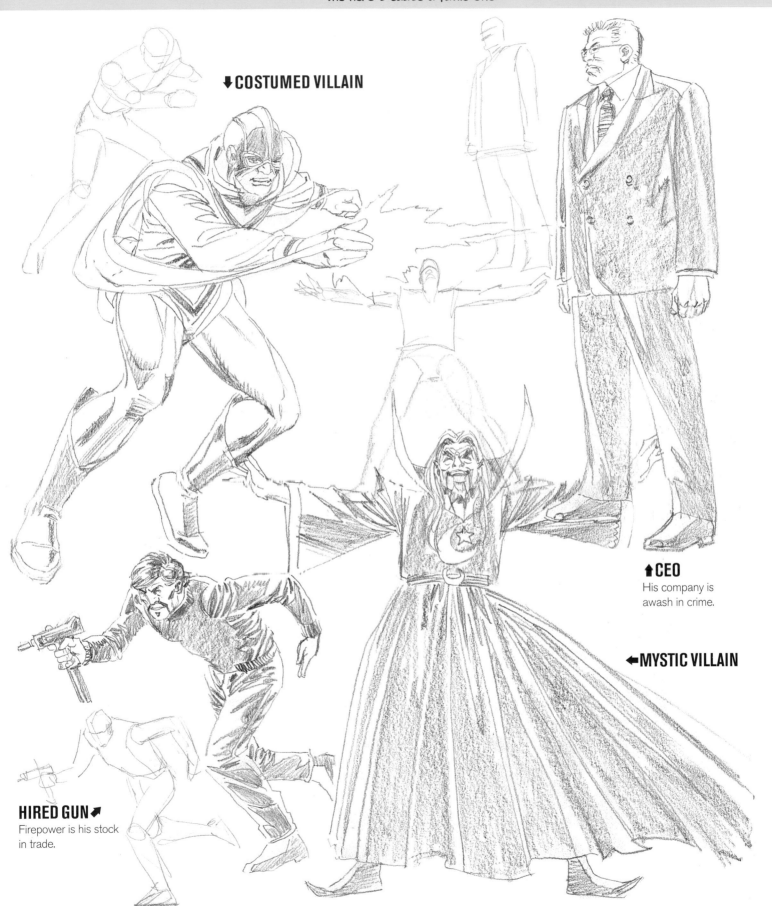

↓COSTUMED VILLAIN

↑CEO
His company is awash in crime.

←MYSTIC VILLAIN

HIRED GUN↗
Firepower is his stock in trade.

figure types
FEMALE HEROES

Must a heroine be beautiful, with a perfectly proportioned, sexy body? Not in real life, but in the world of comics, these women typically (if unrealistically) have it all.

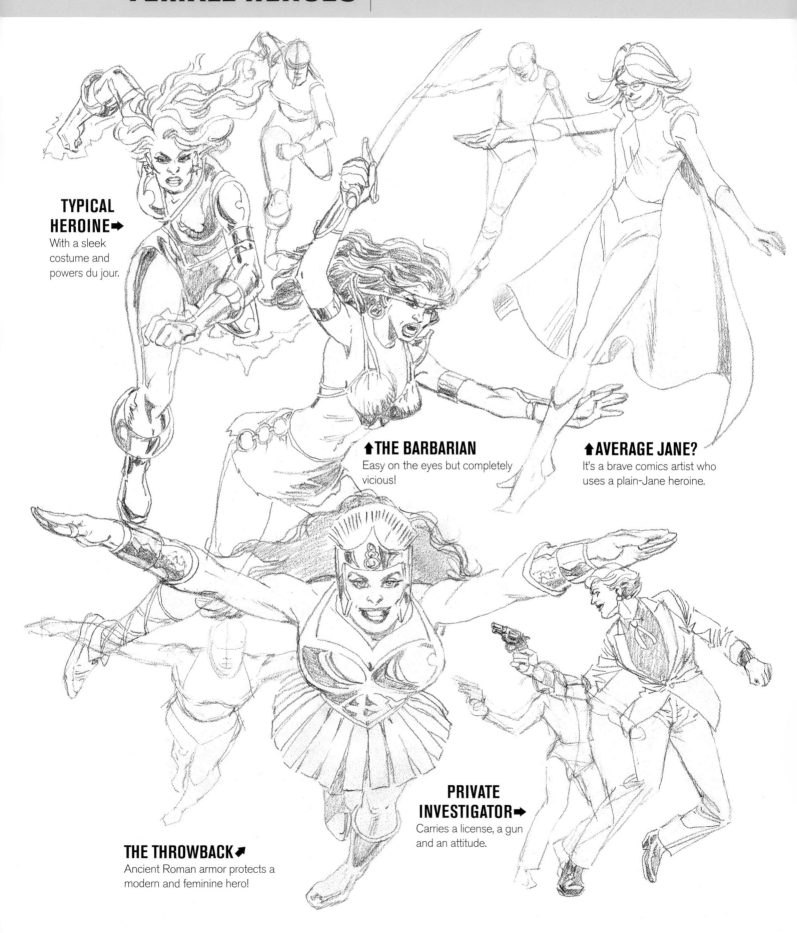

TYPICAL HEROINE➡
With a sleek costume and powers du jour.

⬆THE BARBARIAN
Easy on the eyes but completely vicious!

⬆AVERAGE JANE?
It's a brave comics artist who uses a plain-Jane heroine.

THE THROWBACK↖
Ancient Roman armor protects a modern and feminine hero!

PRIVATE INVESTIGATOR➡
Carries a license, a gun and an attitude.

figure types
FEMALE VILLAINS

In days gone by, villains were often identified by their appearance as well as their deeds. Today black (evil) and white (good) have been replaced with varying shades of gray, making it difficult to tell the good guys from the bad guys. Often, you can't tell the female villains from the heroes without a scorecard.

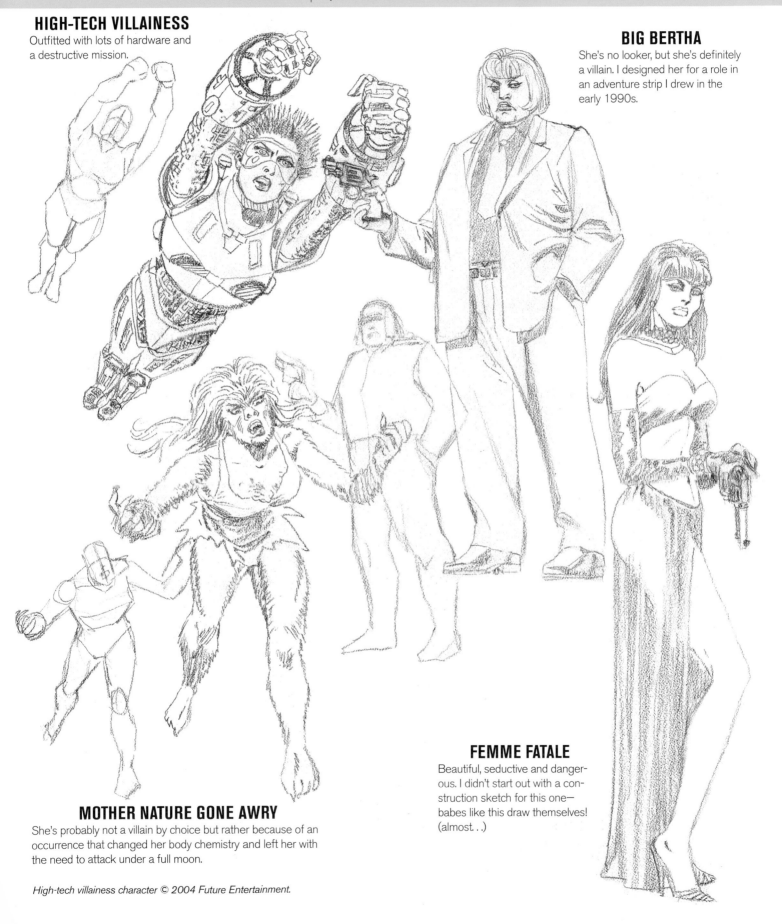

HIGH-TECH VILLAINESS
Outfitted with lots of hardware and a destructive mission.

BIG BERTHA
She's no looker, but she's definitely a villain. I designed her for a role in an adventure strip I drew in the early 1990s.

MOTHER NATURE GONE AWRY
She's probably not a villain by choice but rather because of an occurrence that changed her body chemistry and left her with the need to attack under a full moon.

FEMME FATALE
Beautiful, seductive and dangerous. I didn't start out with a construction sketch for this one—babes like this draw themselves! (almost. . .)

High-tech villainess character © 2004 Future Entertainment.

figure types
THUGS

From the first comic books to today's, we've seen villains hire thugs, body guards and gangsters to help them accomplish their illegal activities. As time passed, the original muscle-bound-but-dim thug gave way to a new, more sophisticated version—one who could use his brain as well as his brawn while attracting a minimal amount of attention.

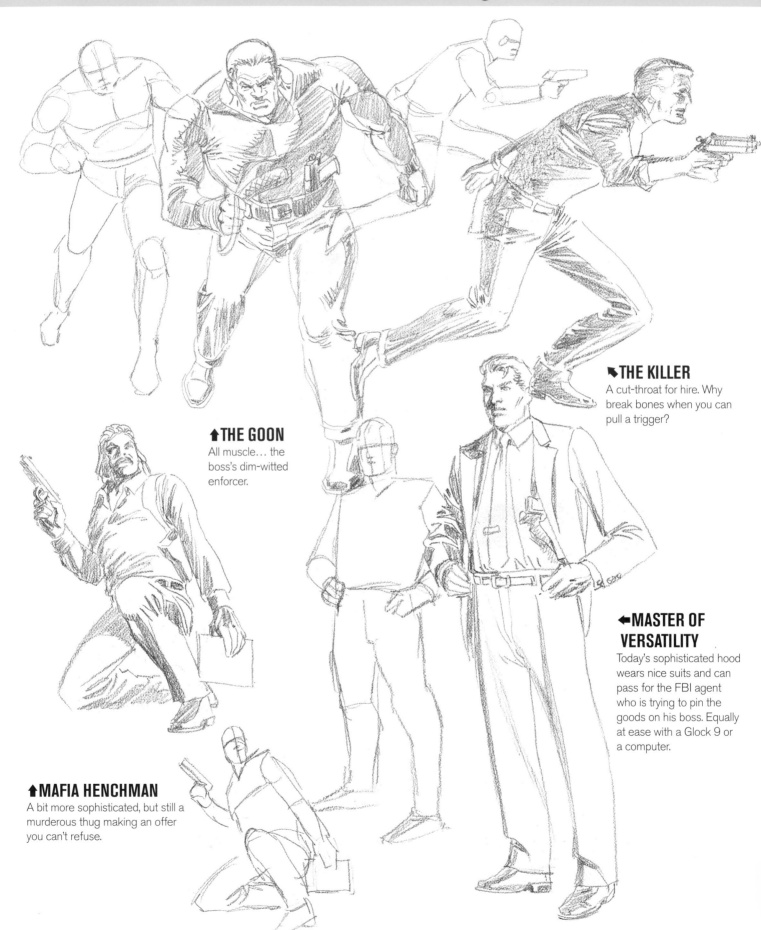

THE KILLER
A cut-throat for hire. Why break bones when you can pull a trigger?

THE GOON
All muscle… the boss's dim-witted enforcer.

MASTER OF VERSATILITY
Today's sophisticated hood wears nice suits and can pass for the FBI agent who is trying to pin the goods on his boss. Equally at ease with a Glock 9 or a computer.

MAFIA HENCHMAN
A bit more sophisticated, but still a murderous thug making an offer you can't refuse.

figure types
SEXY WOMEN

Some people say *all* the women I draw are sexy. Not so! Only *some* of them are sexy, like the ones below. Of course, sexiness, like beauty, is in the eyes of the beholder—so maybe these gals don't do it for you, but they are on my A-list.

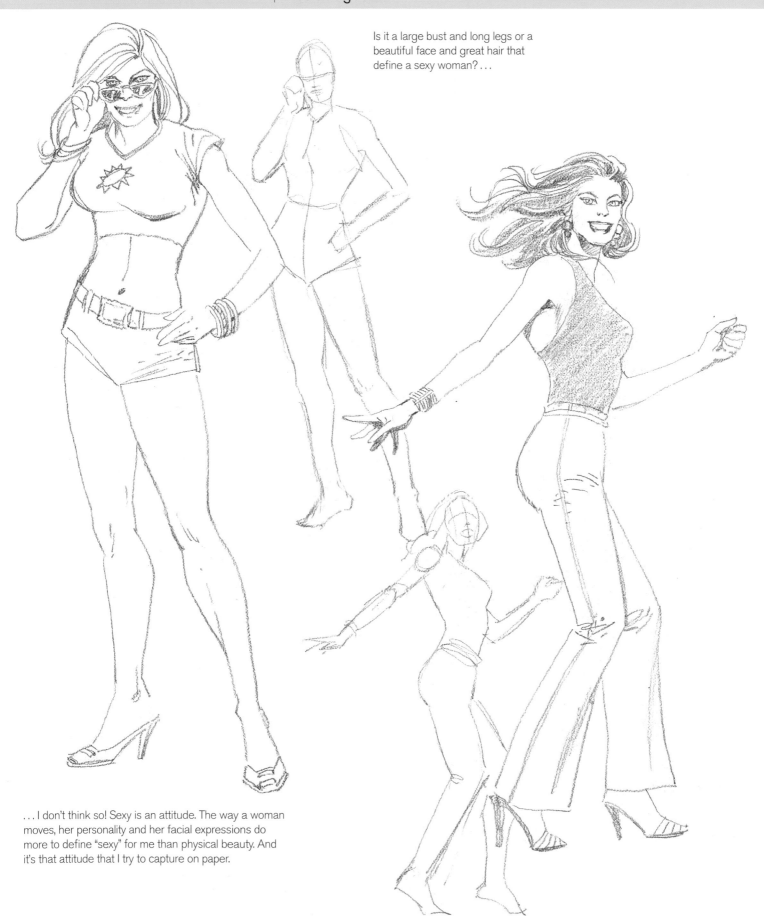

Is it a large bust and long legs or a beautiful face and great hair that define a sexy woman?...

...I don't think so! Sexy is an attitude. The way a woman moves, her personality and her facial expressions do more to define "sexy" for me than physical beauty. And it's that attitude that I try to capture on paper.

figure types
KIDS

Kids can be fun to draw, but they rarely appear in any meaningful role in today's popular comics. From infancy to about age 15 (when he attains near-adult proportions), a child's shoulders will be narrow, his head larger in proportion to his body and his features smaller in proportion to his head.

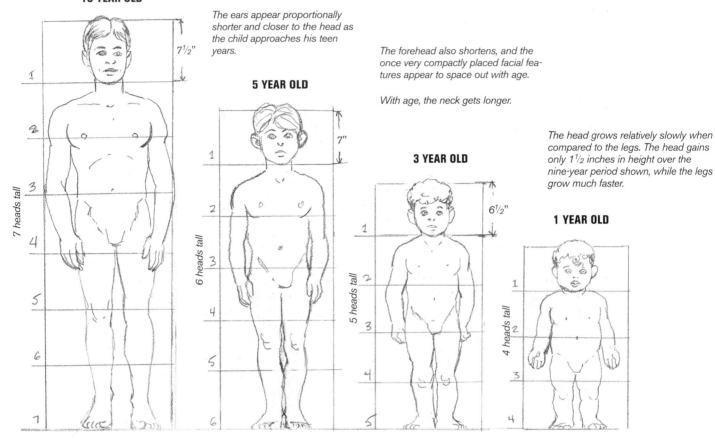

10 YEAR OLD

7½"

7 heads tall

1 2 3 4 5 6 7

The ears appear proportionally shorter and closer to the head as the child approaches his teen years.

5 YEAR OLD

7"

6 heads tall

1 2 3 4 5 6

The forehead also shortens, and the once very compactly placed facial features appear to space out with age.

With age, the neck gets longer.

3 YEAR OLD

6½"

5 heads tall

1 2 3 4 5

The head grows relatively slowly when compared to the legs. The head gains only 1½ inches in height over the nine-year period shown, while the legs grow much faster.

1 YEAR OLD

4 heads tall

1 2 3 4

Keep in mind that children are rounder than adults. It helps to draw their features and muscle definition slightly indistinct.

figure types
MUTATED CHARACTERS

Comic books (and classic fiction) are fertile ground for characters that, in certain circumstances, transform from one being into another. Think the Incredible Hulk. When drawing these characters, think about what triggers their transformations.

A lab experiment-turned-accident causes the usually tame Dr. Jekyll to spontaneously erupt into the monstrous Mr. Hyde. Variations on this classic tale have thrilled audiences for decades.

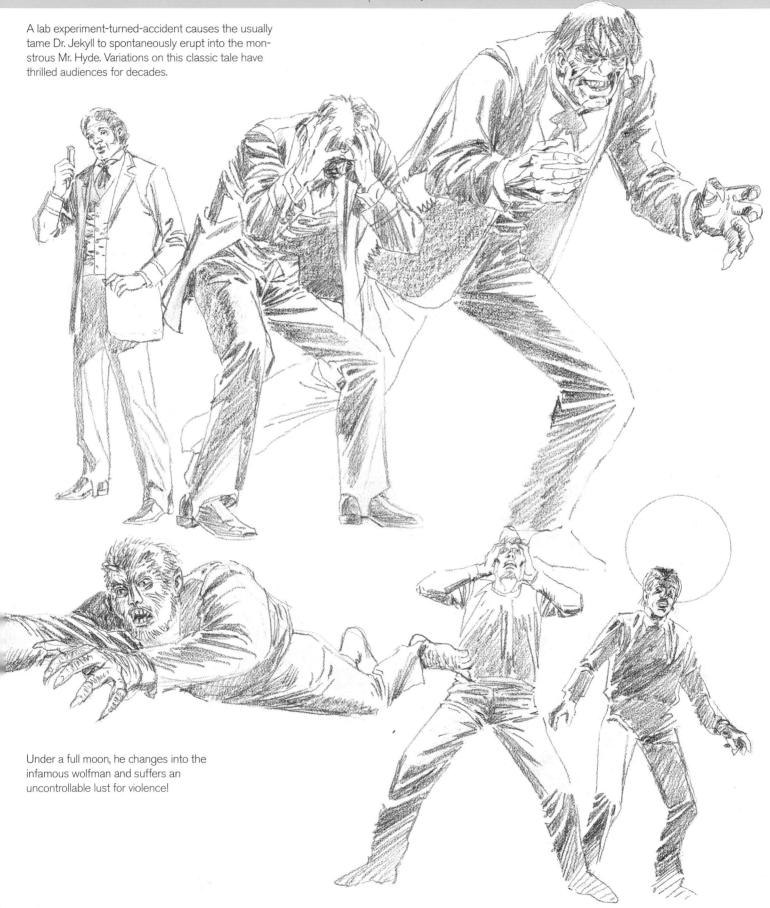

Under a full moon, he changes into the infamous wolfman and suffers an uncontrollable lust for violence!

figure types
OLDER WOMEN

Some women age differently from others, but once they reach a certain age, Mother Nature takes her toll and body changes become inevitable. Though perhaps still lively, the women on this page have begun to show their age.

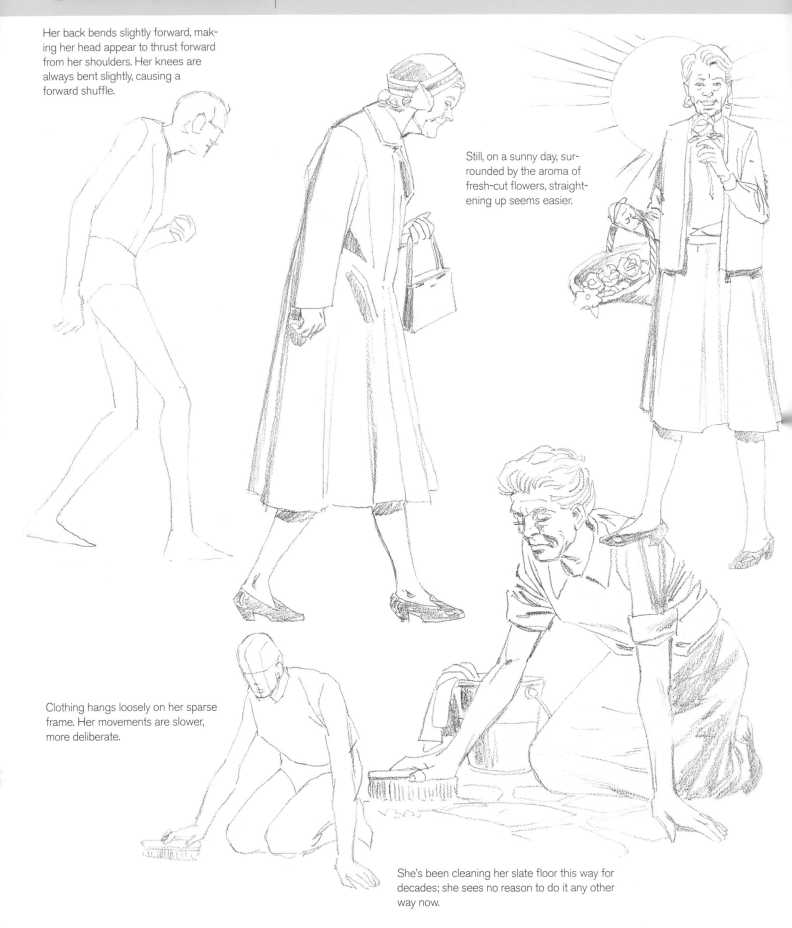

Her back bends slightly forward, making her head appear to thrust forward from her shoulders. Her knees are always bent slightly, causing a forward shuffle.

Still, on a sunny day, surrounded by the aroma of fresh-cut flowers, straightening up seems easier.

Clothing hangs loosely on her sparse frame. Her movements are slower, more deliberate.

She's been cleaning her slate floor this way for decades; she sees no reason to do it any other way now.

figure types
OLDER MEN

Men age at approximately the same pace as women, but wrinkling of the skin on their faces is often more pronounced and deeper. This is particularly true of men who have spent a lot of time in the sun.

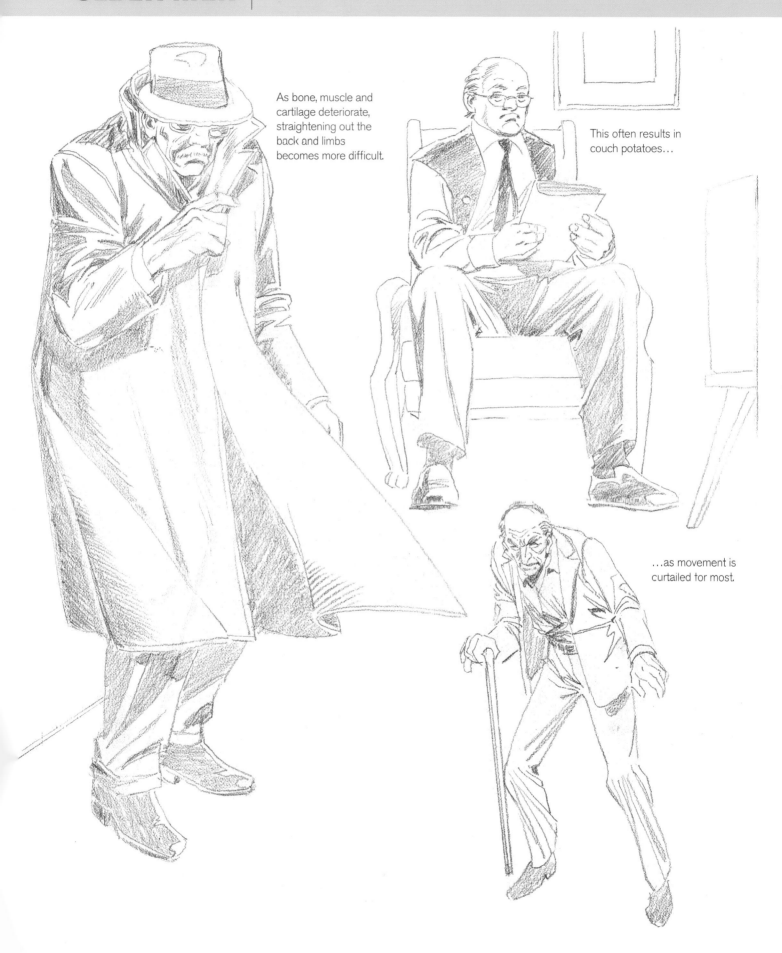

As bone, muscle and cartilage deteriorate, straightening out the back and limbs becomes more difficult.

This often results in couch potatoes…

…as movement is curtailed for most.

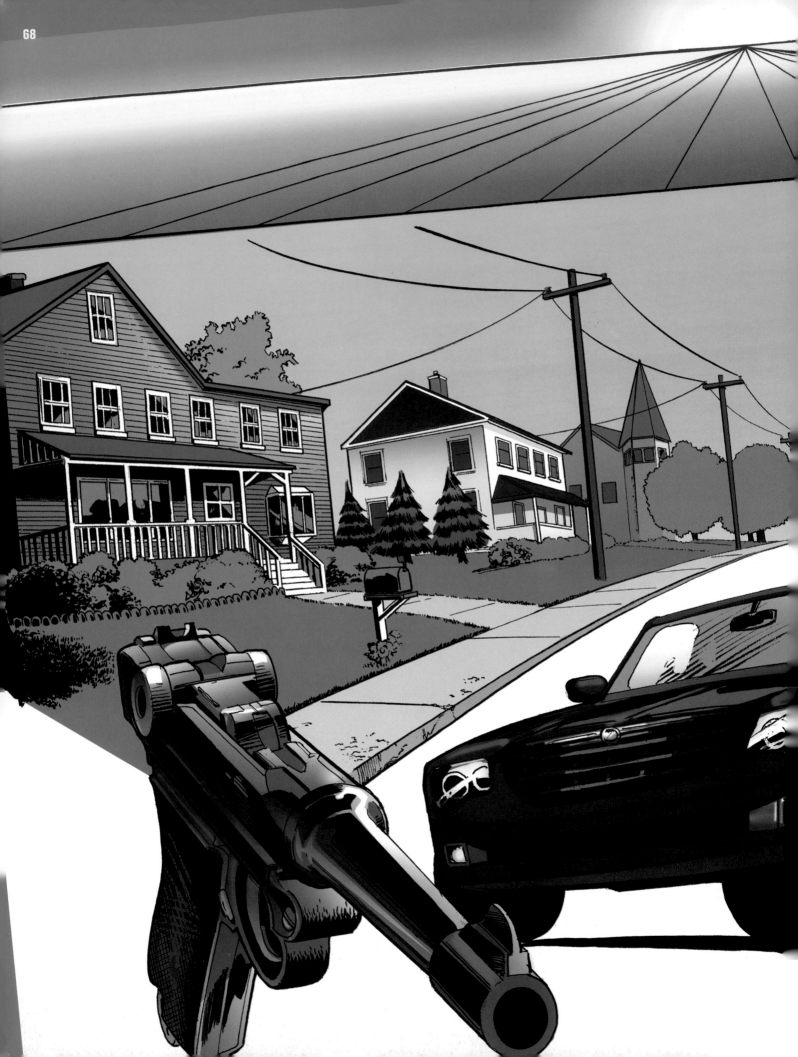

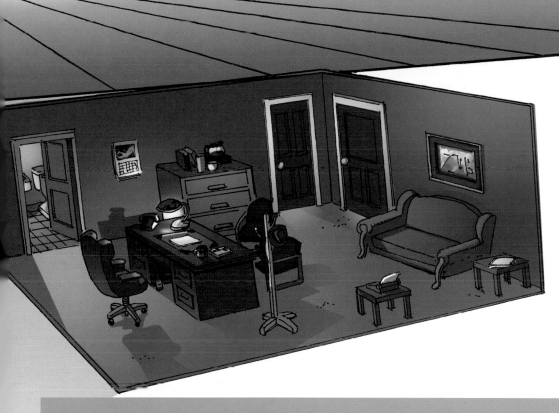

CHAPTER THREE
DRAWING SURROUNDINGS

Just an ordinary line, right? Wrong!

This is perhaps the most important line in just about every picture you draw. It's the horizon line—the perceived line where the sky meets the earth. The horizon line is often not physically seen in your drawing—but it is there nevertheless, and it affects everything in your drawing. The horizon line is where some vanishing points live, and together they are the heart and soul of perspective—an essential discipline of art.

In addition to perspective, in this chapter we will also be talking about drawing backgrounds and "hardware" (vehicles and weaponry). Both are affected by the laws of perspective, which I hope will be made clear enough for you to use effectively.

perspective basics
DRAWING LINES

To draw things in perspective, it's important that you know how to correctly draw the necessary lines. Freehanding them without using the proper tools (and using them properly!) is just plain dangerous.

BEFORE DRAWING ANY LINES. . .

. . . make sure your paper is secured properly to your drawing board. Follow these tips:

- Tape down the corners. *Never* tape the sides; this will almost guarantee that the paper will not be completely flat on the drawing board.

- Do not place the paper exactly on the side edge of the drawing board, and do not let tape go over the side edge of the board.

- Keep the drawing surface taped only when plotting perspective, or when ruling horizontal or vertical lines. When doing other drawing, you need to be able to vary the position of the paper as you draw.

FOR VERTICAL LINES

All vertical lines should be drawn with a triangle as it rides upon the top edge of the T-square. Control the T-square and triangle with your non-drawing hand. When making vertical lines, never use a ruler or a T-square as a substitute for a triangle. The lines will *not* be vertical.

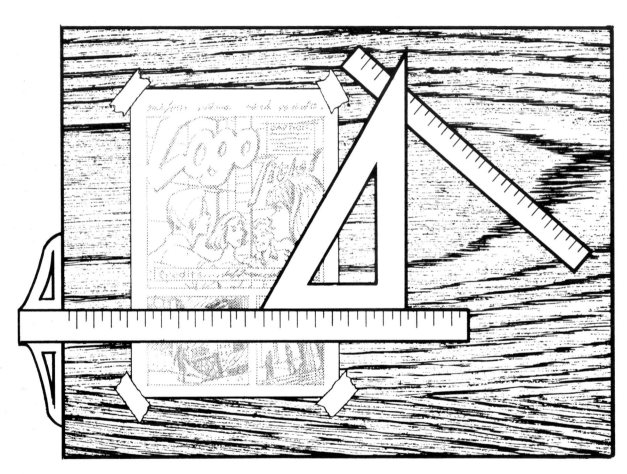

FOR HORIZONTAL LINES

Use a T-square to draw all horizontal lines. If you are right handed, the T-square "head" rides on the left edge of your drawing board. If you are left handed, it rides on the right edge. Control the T-square with your non-drawing hand. Your other hand will then be free to draw comfortably.

DON'T DO THIS!

Never draw on the bottom edge of a straightedge tool. For one thing, you'll end up running your hand and drawing tool under or into your other arm. Also, you risk losing control—if your straightedge slips, your line will be crooked. Yet another reason: Your lines may not be consistent with lines drawn exclusively via the top edge of the straightedge.

FOR OBLIQUE LINES

It's best to use the ruler to draw all oblique lines—those lines that are neither horizontal nor vertical. It's okay to use a triangle to draw oblique lines; but it's best to stick with the ruler. If you must use the T-square to draw oblique lines, turn the T-square upside down (so that its surface is flush with your drawing surface).

perspective basics
TYPES OF PERSPECTIVE

There are three basic types of perspective. Learn how each type is constructed and get familiar with the terminology.

↓1-POINT PERSPECTIVE

All lines of the object are horizontal or vertical, except for those that converge "into" the picture plane, toward one dot that has been placed more or less on the center of the H.L.

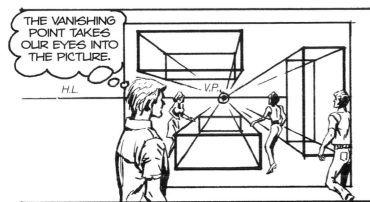

THE VANISHING POINT TAKES OUR EYES INTO THE PICTURE.

H.L. V.P.

<div style="border:1px solid">

TERMS TO KNOW

Picture Plane—Any shape area within which the picture is drawn.

Horizon Line (H.L.)—The horizontal line that represents the viewer's eye level. The picture plane may be placed anywhere in relation to the H.L., but there is only one H.L. per picture.

Vanishing Point (V.P.)—One, two, or any number of "dots" placed on the H.L., on a vertical extension of the V.P., or, in the case of 3-point perspective, on the center-of-vision line. All objects within the picture plane converge at or diminish in size toward these "dots."

Center-of-Vision Line (C.V.L.)—A vertical line through the center of the H.L.

</div>

2-POINT PERSPECTIVE→

Two points on the H.L.—one to the left of the picture plane, the other to the right—to which all non-vertical lines go.

SPACING OF V.P.S

To avoid optical distortion, place at least one of the two V.P.s at least twice the distance outside the picture plane as the height of the picture plane. At least, be certain to avoid creating true right angles (90 degrees) or "sharper" (more acute) angles in drawings of actual right-angle objects. Corners may more comfortably approach 90 degrees in 3-point perspective (with closer V.P.s on the right and left), but they still should *not* become 90 degrees or less within the picture plane.

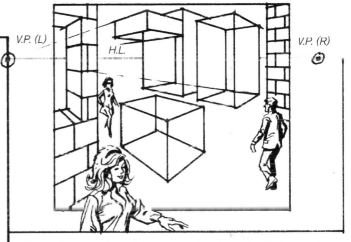

V.P. (L) H.L. V.P. (R)

The farther away the subject is from the viewer, the farther apart the V.P.s should be spaced in relation to the picture plane.

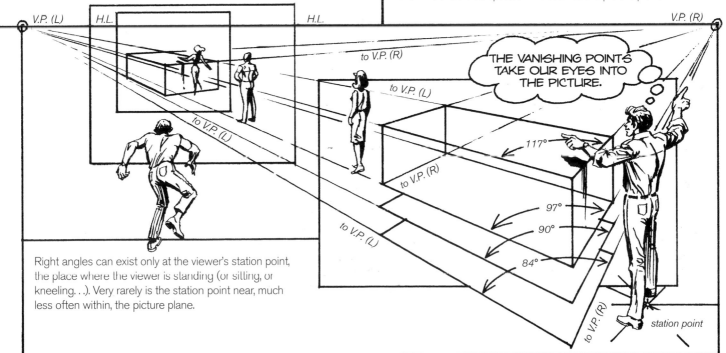

V.P. (L) H.L. H.L.

to V.P. (R)
to V.P. (L)
to V.P. (L)

V.P. (R)

THE VANISHING POINTS TAKE OUR EYES INTO THE PICTURE.

to V.P. (R)
to V.P. (L)

117°
97°
90°
84°

to V.P. (R)

station point

Right angles can exist only at the viewer's station point, the place where the viewer is standing (or sitting, or kneeling. . .). Very rarely is the station point near, much less often within, the picture plane.

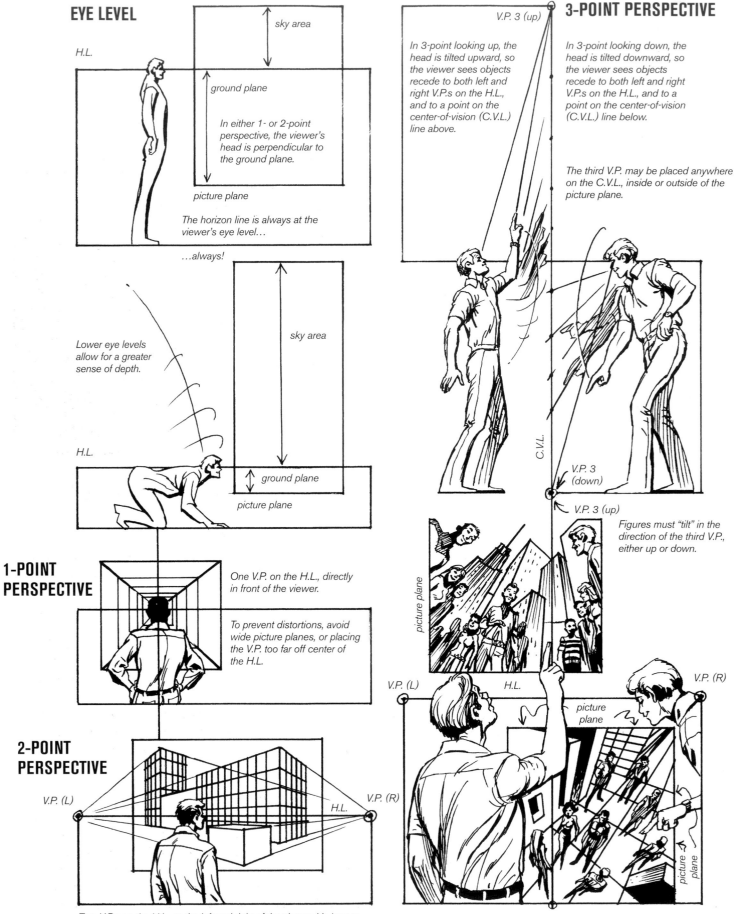

EYE LEVEL

H.L.

sky area

ground plane

In either 1- or 2-point perspective, the viewer's head is perpendicular to the ground plane.

picture plane

The horizon line is always at the viewer's eye level…

…always!

Lower eye levels allow for a greater sense of depth.

H.L.

sky area

ground plane

picture plane

1-POINT PERSPECTIVE

One V.P. on the H.L., directly in front of the viewer.

To prevent distortions, avoid wide picture planes, or placing the V.P. too far off center of the H.L.

2-POINT PERSPECTIVE

V.P. (L) H.L. V.P. (R)

Two V.P.s on the H.L., to the left and right of the viewer. It's best to keep both V.P.s outside of the picture plane.

3-POINT PERSPECTIVE

V.P. 3 (up)

In 3-point looking up, the head is tilted upward, so the viewer sees objects recede to both left and right V.P.s on the H.L., and to a point on the center-of-vision (C.V.L.) line above.

In 3-point looking down, the head is tilted downward, so the viewer sees objects recede to both left and right V.P.s on the H.L., and to a point on the center-of-vision (C.V.L.) line below.

The third V.P. may be placed anywhere on the C.V.L., inside or outside of the picture plane.

C.V.L.

V.P. 3 (down)

V.P. 3 (up)

Figures must "tilt" in the direction of the third V.P., either up or down.

picture plane

V.P. (L) H.L. V.P. (R)

picture plane

picture plane

perspective basics
DRAWING 1-POINT AND 2-POINT

There are differences in how you approach drawing objects vs. rooms in both 1-point and 2-point perspective. It all depends on whether you are looking at the outside of a box (an object) or the inside of a box (a room).

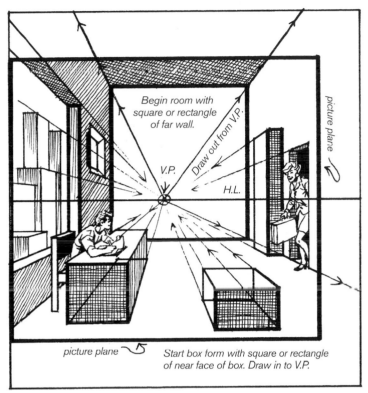

Begin room with square or rectangle of far wall.

Draw out from V.P.

V.P.

H.L.

picture plane

picture plane

Start box form with square or rectangle of near face of box. Draw in to V.P.

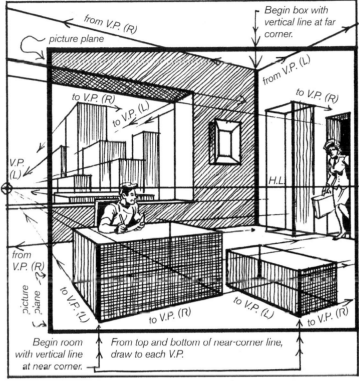

from V.P. (R)

picture plane

Begin box with vertical line at far corner.

from V.P. (L)

to V.P. (R)

to V.P. (L)

to V.P. (R)

V.P. (L)

H.L.

from V.P. (R)

picture plane

to V.P. (L)

to V.P. (R)

to V.P. (L)

to V.P. (R)

Begin room with vertical line at near corner.

From top and bottom of near-corner line, draw to each V.P.

1-Point Objects

Draw a square or rectangle of any size anywhere in your picture plane. This represents the front plane (or face) of a box (a building, desk, etc.). From all four corners of that shape, draw oblique lines toward one vanishing point on the horizon line. Decide how deep in space you want the box to be. At that place, draw horizontal and vertical lines so that all of the corners will be on the oblique lines.

1-Point Room

First draw the far wall (a rectangle or square). Then draw the oblique lines from the vanishing point on the horizon line toward the four corners. Since we don't see the wall behind us, draw these oblique lines to the edges of the picture plane. We tend to not notice ceilings, so you can leave it outside of the picture plane.

Avoid making the picture plane too wide. The picture will become increasingly distorted as the lines, shapes and forms get closer to the sides of the picture plane.

2-Point Objects

You almost always start with the vertical line that represents the nearest corner of the box (object). The line may be any height (even extending outside the picture plane). From the top and bottom of that line, draw oblique lines toward the right and left vanishing points.

Decide how deep in space you want each plane of that box to be. At these points, draw two more vertical lines to span the oblique lines that converge toward each V.P. From the tops and bottoms of each of those two new vertical lines, draw oblique lines toward the appropriate V.P.s. Where those oblique lines cross when heading toward the opposite V.P.s, draw a fourth vertical. This last line represents the farthest corner of the box.

2-Point Room

Begin by drawing the vertical line that represents the far corner of the box (room). From the top and bottom of that vertical line, draw oblique lines *from* the two V.P.s (rather than *toward* them). Since, in 2-point perspective, we tend to see only two walls of the room, we draw the oblique lines all the way to the edges of the picture plane. Most of the time you can omit the ceiling lines if seeing the ceiling is not necessary.

perspective basics
DRAWING 3-POINT

Perspective is all about point of view. Look at the buildings on this page as they are, and the buildings appear to be towering above you. But turn this page upside down and it will seem like you're looking down on those same buildings! Turned sideways, it's also still 3-point perspective.

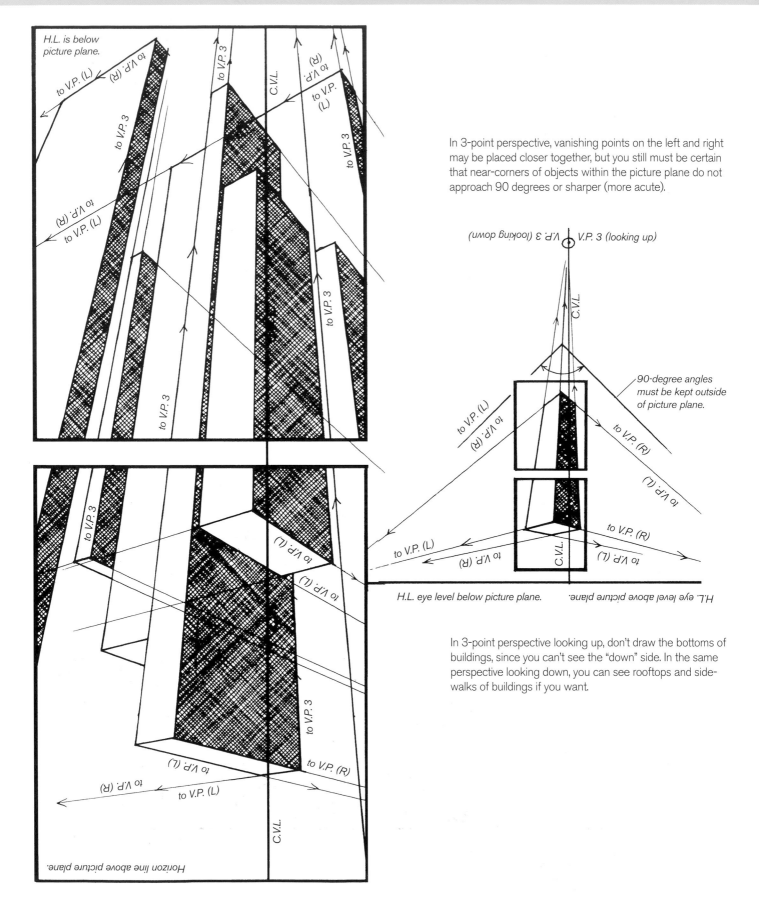

In 3-point perspective, vanishing points on the left and right may be placed closer together, but you still must be certain that near-corners of objects within the picture plane do not approach 90 degrees or sharper (more acute).

90-degree angles must be kept outside of picture plane.

In 3-point perspective looking up, don't draw the bottoms of buildings, since you can't see the "down" side. In the same perspective looking down, you can see rooftops and side-walks of buildings if you want.

H.L. eye level below picture plane.

There is nothing intrinsically wrong with the top drawing, but the bottom drawing creates depth and space, and a larger, more intimate environment. Drawings like the latter also tend to be more interesting to execute and look at.

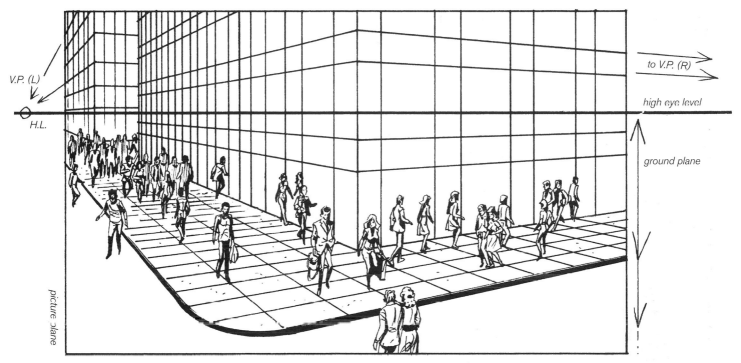

V.P. (L)

H.L.

to V.P. (R)

high eye level

ground plane

picture plane

The higher placement of the eye level (horizon line) tends to force a "down-shot" view. Higher eye levels are more appropriate for indoor scenes, where the viewer's field of vision tends to already be narrower and closer. They are also useful when you want to draw figures from the waist up or chest up, or for close-ups.

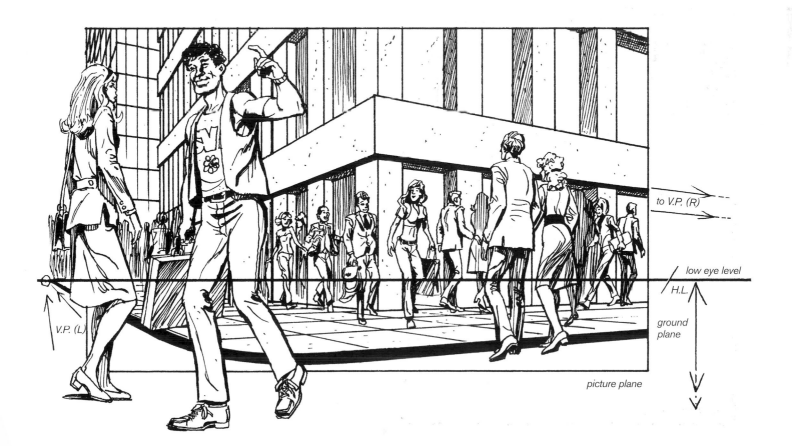

to V.P. (R)

low eye level

H.L.

ground plane

V.P. (L)

picture plane

backgrounds
DRAWING SETTINGS

Your characters have to be located *somewhere*. I often draw a stage set with two walls, like the ones shown on the next two pages, before starting work on my story. I may "wing it" on very short sequences, but in most circumstances, I feel it is essential for me to know where every element of the environment is located. Not only will knowing where each element is located help me move my characters through the environment, it also gives me ideas for compositions.

DETECTIVE'S OFFICE

An environment like this office should contain clues to the personality that occupies the space. Details like the hat rack with the holstered gun not only provide a sense of depth to the picture, they tell you something about the occupant of the room. A quick glance at the desk tells you that this P.I. drinks and smokes.

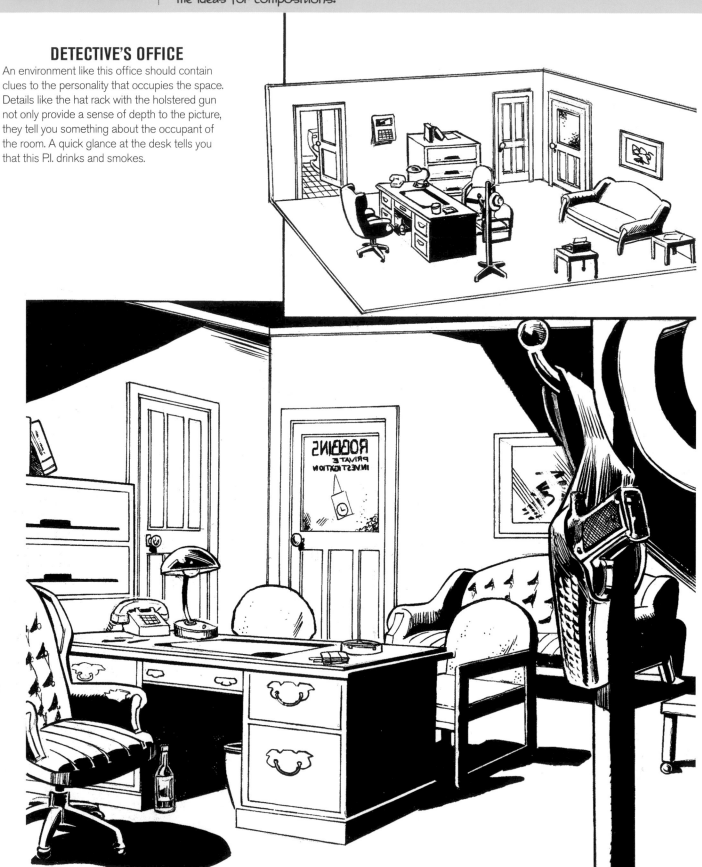

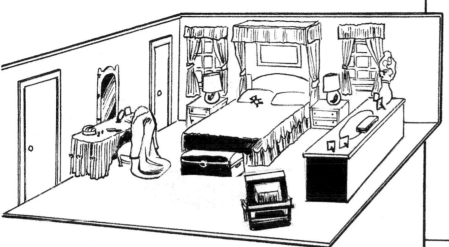

WOMAN'S BEDROOM

What can we assume about this woman from her bedroom? She's fairly neat (except for her makeup table); she falls asleep watching television; and she's fairly young (still has a teddy bear). She's quite comfortable amidst female trappings. And, since there are no shades or blinds on her windows, she isn't too concerned about her privacy; perhaps she lives in a desolate (or seemingly safe) area or on an upper floor in a high-rise.

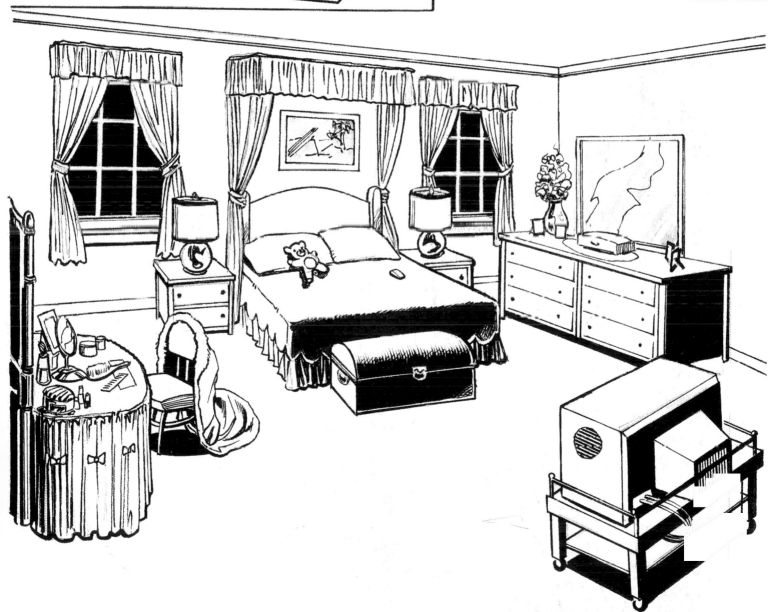

backgrounds
PLACING PEOPLE

Good rules of perspective must be observed to fit figure and background together. The rules that govern straight-line perspective also govern the figures placed in that environment.

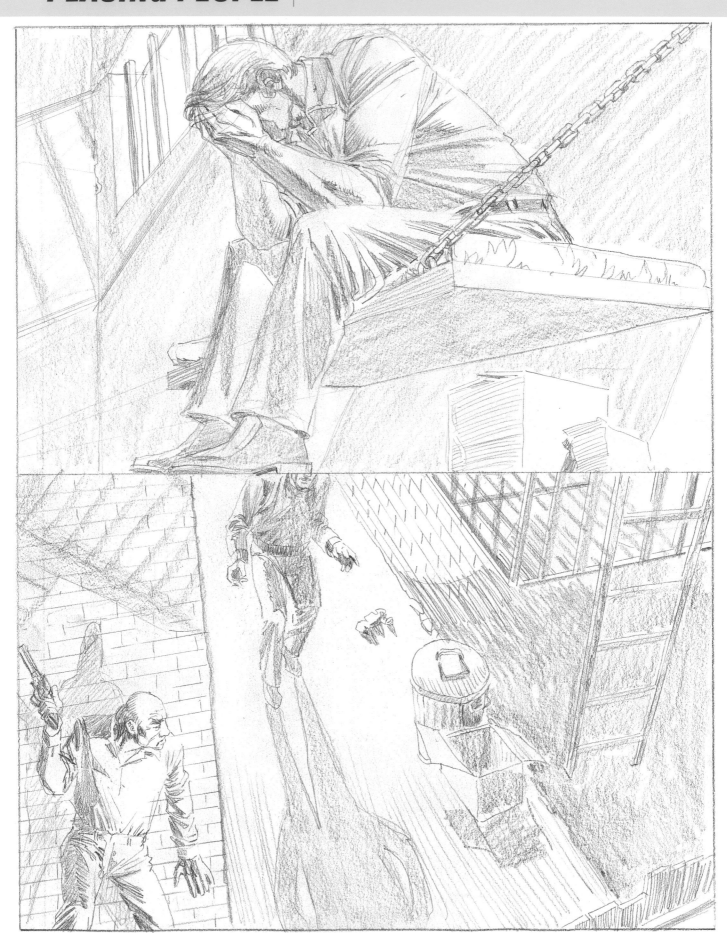

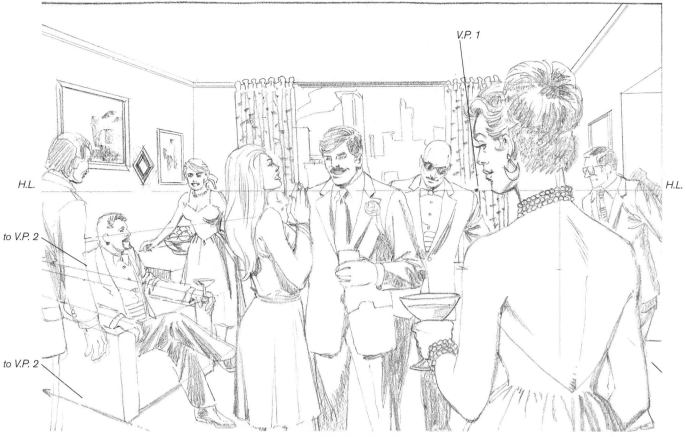

CROWDED ROOM

Here is a simple and effective way to place people in a scene and ensure they will all appear to be standing on the same floor: Draw the horizon line (H.L.) and place like figures in such a way that the same part of their body rests on the horizon line. In this example, the chin of each woman rests on the horizon line, as do the shoulders of each man. The first vanishing point (V.P. 1) is visible on the horizon line; the second vanishing point (V.P. 2) goes off the page, but it, too, is on the horizon line. Of course, you must make adjustments for varying figure heights and seated figures.

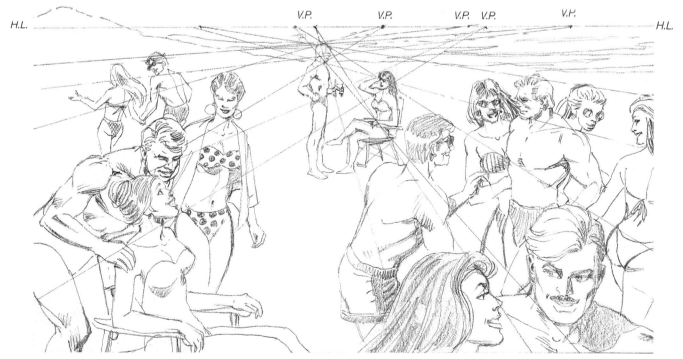

FUN ON THE BEACH

Here's another trick: After locating the horizon line, draw two "key" figures (one standing, one seated). Choosing vanishing points at random for subsequent figures, draw lines from a vanishing point through the top and bottom of the appropriate "key" figure's head to locate where other heads will be drawn. This can be done a bit more casually than with the hard-and-fast perspective rules.

hardware
DRAWING GUNS

I have suggested in previous chapters that you use geometric shapes to construct your drawings. It's no different when drawing weapons.

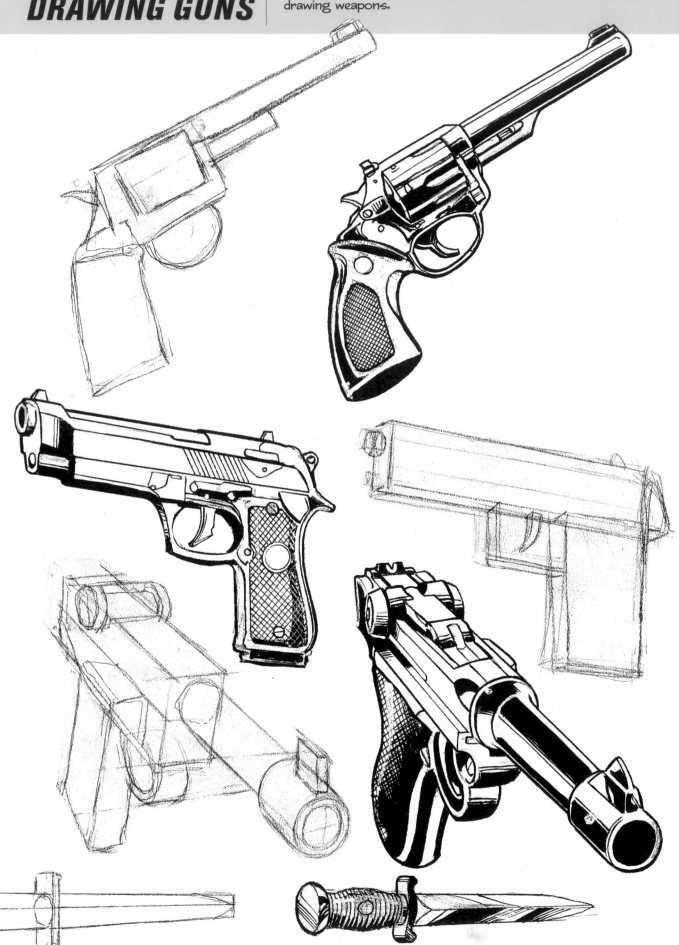

hardware
OTHER WEAPONS

Sometimes a fictional conflict will call for guns of an earlier time or more elegant weaponry. You may find yourself drawing a knife fight or sword battle. Some swords or knives are intended to cut, some to stab, others do both. You can't sever a limb with a foil or a stiletto. . . that's what broadswords are for!

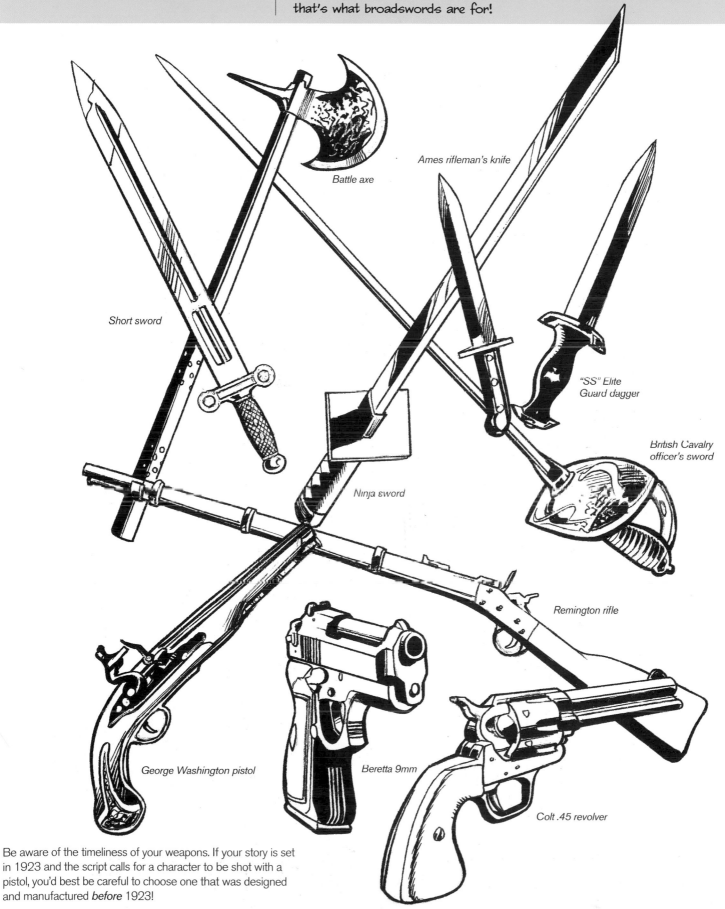

Battle axe

Ames rifleman's knife

Short sword

"SS" Elite Guard dagger

British Cavalry officer's sword

Ninja sword

Remington rifle

George Washington pistol

Beretta 9mm

Colt .45 revolver

Be aware of the timeliness of your weapons. If your story is set in 1923 and the script calls for a character to be shot with a pistol, you'd best be careful to choose one that was designed and manufactured *before* 1923!

hardware
GUN TYPES

The drama often found in comic stories usually involves conflicts that call for the use of weapons of various sorts. Guns are typically the weapon of choice—at least for the bad guys.

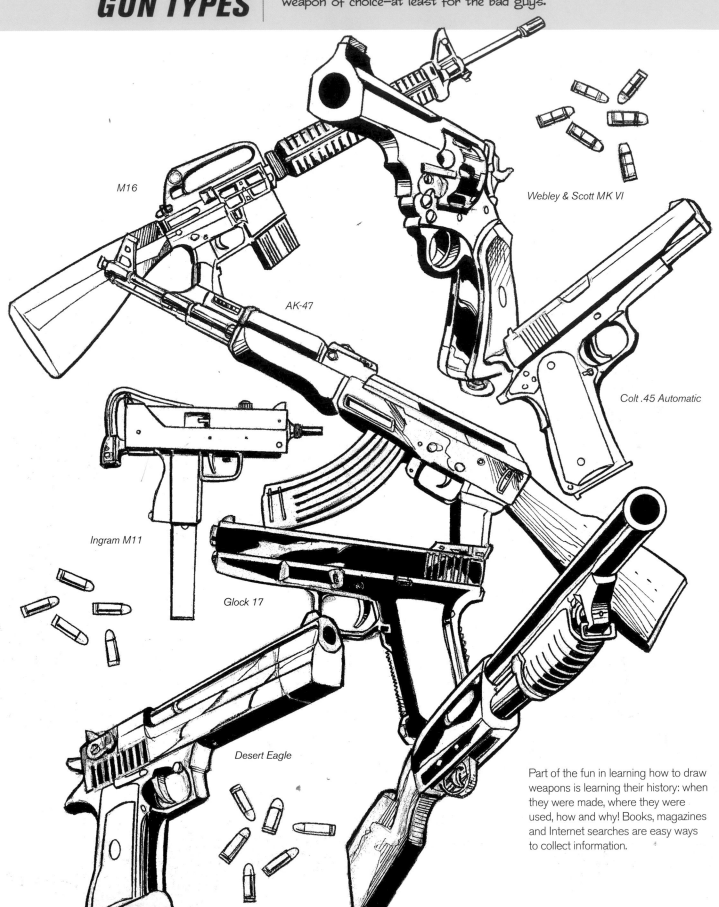

M16

Webley & Scott MK VI

AK-47

Colt .45 Automatic

Ingram M11

Glock 17

Desert Eagle

Remington M31
Riot Shotgun

Part of the fun in learning how to draw weapons is learning their history: when they were made, where they were used, how and why! Books, magazines and Internet searches are easy ways to collect information.

hardware
GUN HANDLING

Drawing the hardware is only half the battle... the other half is fitting it into the hands of characters.

Just as all swords and knives aren't used in the same way, so are there vast differences in firearms. A Flintlock and a Glock 9 are both pistols, but the resemblance ends there. They look, work and are used in completely different ways. When it comes to holding and firing guns—or handling any weapon, for that matter—it helps to observe. The reference that is readily available can show how, or you can rent some action movies and be ready to push "pause."

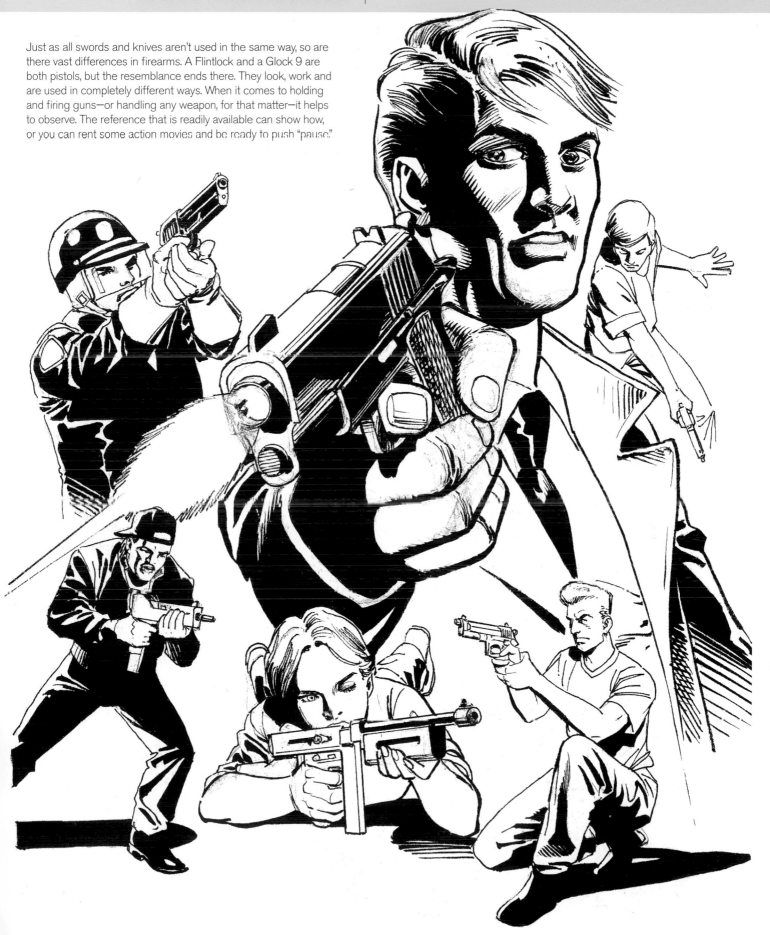

special effects
EXPLOSIONS AND GUNFIRE

When creating your stories, you are the special-effects supervisor. All gunfire and or explosions do not look exactly alike, but those shown here are a good place to start.

The muzzle flash from the single shot of a pistol is much different from the strobe-like flashes caused by the multiple shots of an automatic assault weapon.

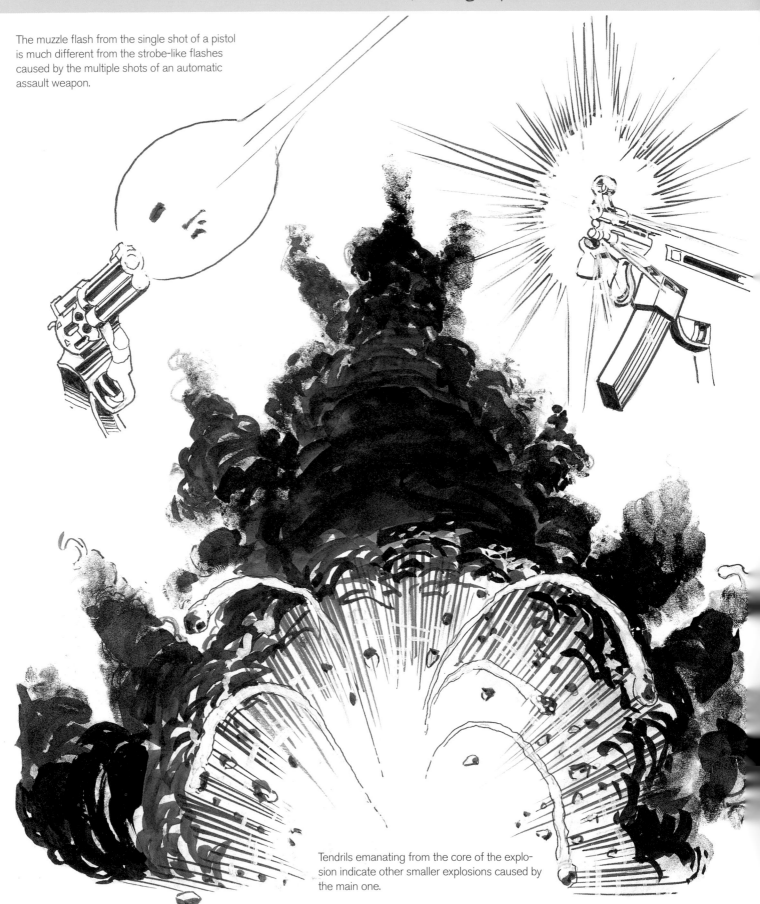

Tendrils emanating from the core of the explosion indicate other smaller explosions caused by the main one.

special effects
CREATIVE TOOLS

One of the many positive benefits of computer coloring comics is that a skillful color artist can create the special effects that were once the job of the story artist. The color artist can even take the effects that you have drawn and make them look infinitely better. When drawing special effects yourself, however, consider *anything* an art tool! Toothpicks, cotton swabs, cheesecloth. . .

CELLOPHANE

With a brush dipped in ink, draw lines on a piece of cellophane. The ink will separate into globules. Turn the cellophane over and press onto the paper. Voila! This could be gunshots hitting the ground, dirt thrown from horse hooves, etc. A little experimenting can lead to other results.

FINGERS

Not recommended for criminals! When inking blackish smoke (see previous page), ink the outer smoke edges, leaving a lot of wet ink. Spread the ink around with your fingertip (image on far left). Rub your finger away from the ink and you will leave a "trail" like an afterimage (image on near left).

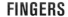

SPONGES

Cut some ordinary kitchen sponges in assorted shapes (cubes, wedges, etc.). Dip them into ink and dab onto paper for some very interesting effects that I'm sure you will find uses for. The amount of ink you put on the sponge and the shape of the sponge affect the results. The shapes shown here were created with different cuts of the same sponge.

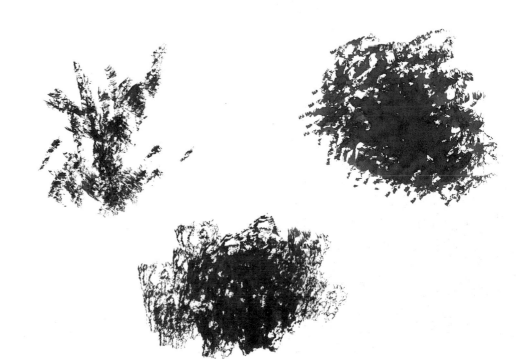

vehicles
CARS

The basic approach for drawing any wheeled vehicle is essentially the same: Start with basic geometric shapes (again!), "mold" the shapes and then finish with unique details.

1 Draw two rectangles in the proper perspective and proportion—one atop the other, representing the cockpit aboard the body. Add the wheels, also in perspective, as elliptical disks. Draw "through" all shapes so that you can "see" all four sides of the car.

2 Now start trimming the square corners to develop the actual shape of the car. Don't concern yourself with details at this stage; your goal is to attain the basic shape of the vehicle.

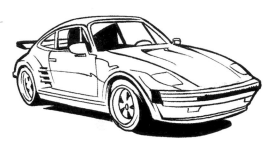

3 Detail time! Add molded body panels, alloy wheels, body, glass and tires. Work from references so your cars will have a realistic quality that will enhance your storytelling. Use references now and after awhile you'll be able to draw a credible car without them.

Follow the instructions above to draw a different sports car.

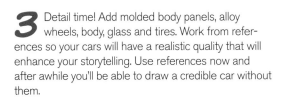

If you draw the upper rectangle larger, extending from the rear of the lower rectangle to a point further forward (shortening the hood), you will have the basic shape for an SUV or station wagon, or a Hummer!

vehicles
TRUCKS

Don't draw trucks, cars, airplanes and other vehicles freehand. Use rulers, French curves, circle templates and other guides in either the pencil or ink stages (or both stages, preferably). The result will be accurate and appealing drawings.

1 Follow the same method to draw a truck as you would a car—draw two rectangles in the proper perspective and proportion, add elliptical disks for wheels and draw "through" all shapes so that you can "see" all four sides of the truck.

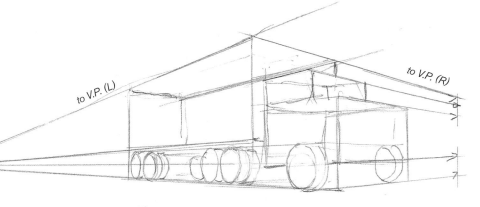

to V.P. (L)

to V.P. (R)

V.P. (L)

2 Start refining the truck to bring out its basic shape. Remember: Don't be obsessed with details at this point—focus on creating the truck's basic form.

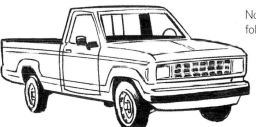

3 Add details and rendering to make the finished truck accurate and appealing. Again, good reference is the key to good drawings. Don't try to "wing it" until you've done quite a few from good reference.

Now try drawing a pickup truck, following the same steps.

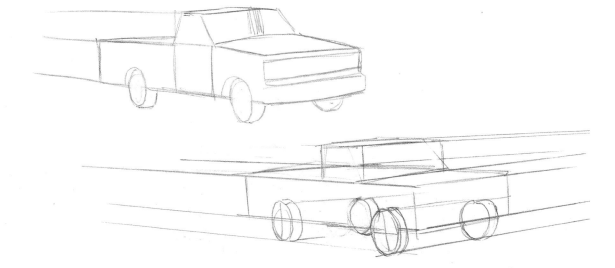

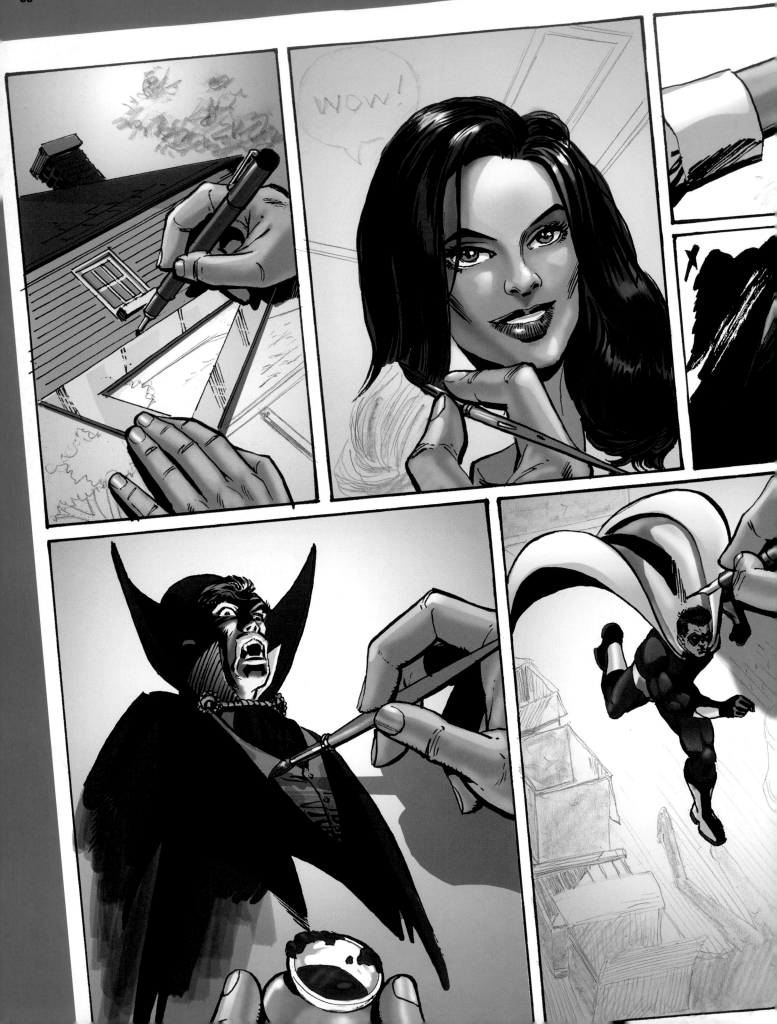

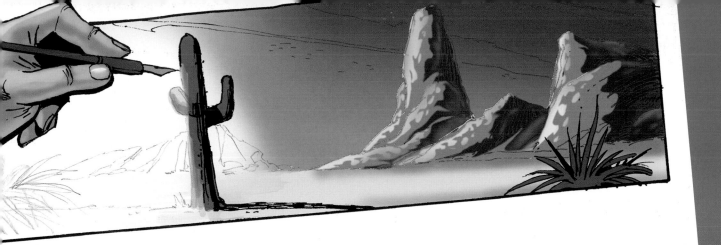

CHAPTER FOUR
THE ART OF INKING

Inking comic book pages was originally only intended to make pencil drawings reproducible, and was usually done by the artist who had penciled the page. At that time, the inking process did little to enhance the art; it was just a necessary step for production. As time passed, artists experimented with new inking techniques that brought the craft to another level, one where the art was enhanced by the inking process. As comic art matured and became more sophisticated, it began to take longer to complete a page, and the age of the inker—a specialist who inks over another artist's pencils—was born. Pairing excellent inkers with average pencillers improved the look of the work, and greater on-time performance was a residual benefit. The age of the "star" inker was born; those at the top of their game were in demand and had fan followings of their own.

Sadly, today's computers have made it possible to eliminate the inking process entirely. And when the work scanned is inked, the computer color artist can, with the click of a key, produce special effects, patterns or textures that were once the stock and trade of inkers past who had to work hard to develop the skills to produce similar results. Today, it is the computer color artists who are greatly in demand, and they are not always the best "inkers." Still, I believe that serious students of comic book art must learn as much as they can about inking to add to their resume of marketable skills. There remain several formats where computers are not used: newspaper strips, story boards, illustrations, and black and white comics.

inking basics
BRUSHWORK TOOLS

Inking with a brush can be very frustrating at first because it can take awhile to get a feel for the brush. But the effort you put into learning how to use this versatile tool can lead to great results.

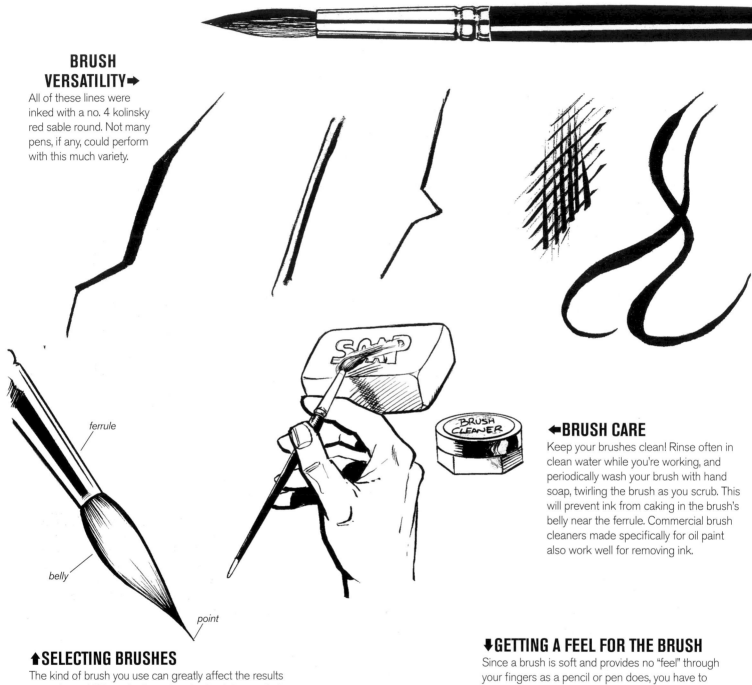

BRUSH VERSATILITY➡

All of these lines were inked with a no. 4 kolinsky red sable round. Not many pens, if any, could perform with this much variety.

ferrule

belly

point

⬅BRUSH CARE

Keep your brushes clean! Rinse often in clean water while you're working, and periodically wash your brush with hand soap, twirling the brush as you scrub. This will prevent ink from caking in the brush's belly near the ferrule. Commercial brush cleaners made specifically for oil paint also work well for removing ink.

⬆SELECTING BRUSHES

The kind of brush you use can greatly affect the results you achieve. When selecting a brush, check to see that:

• there are no "stragglers" (bristles that stick out at odd angles from the ferrule)

• the belly of the brush isn't bloated

• the brush comes to a nice point

⬇GETTING A FEEL FOR THE BRUSH

Since a brush is soft and provides no "feel" through your fingers as a pencil or pen does, you have to focus your eyes on the brush tip in order to determine the length and width of each brushstroke.

inking basics
BRUSHWORK TIPS

Chances are if you feel uncomfortable inking with a brush, it's because you can't seem to control the line weights. Here are a few methods that will help you work more confidently.

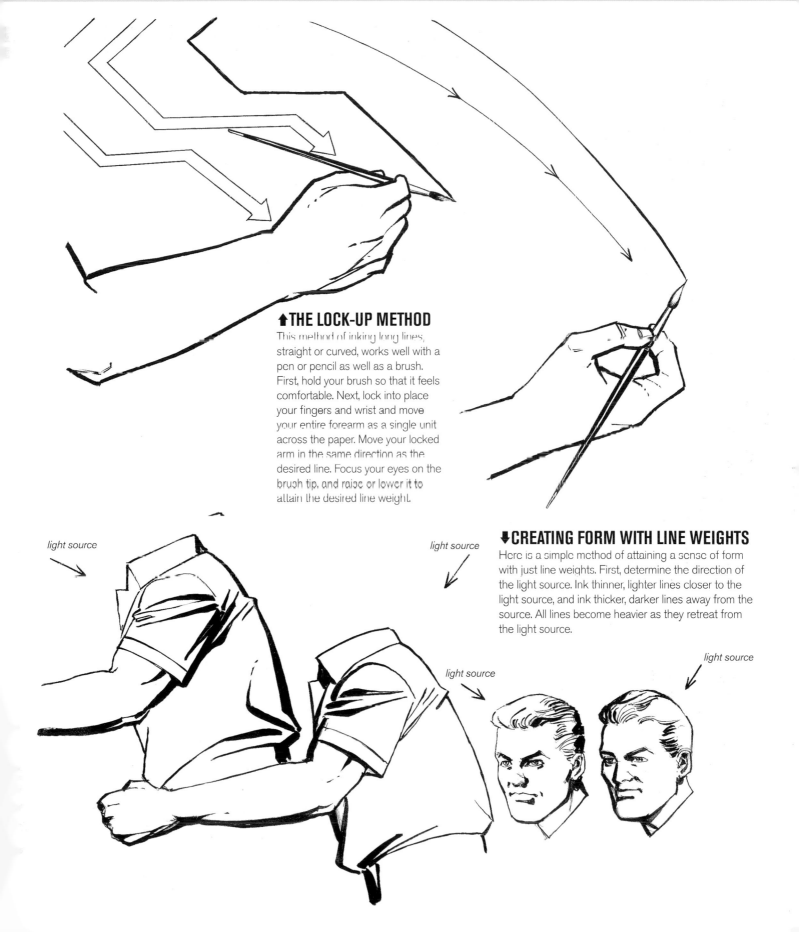

⬆THE LOCK-UP METHOD

This method of inking long lines, straight or curved, works well with a pen or pencil as well as a brush. First, hold your brush so that it feels comfortable. Next, lock into place your fingers and wrist and move your entire forearm as a single unit across the paper. Move your locked arm in the same direction as the desired line. Focus your eyes on the brush tip, and raise or lower it to attain the desired line weight.

⬇CREATING FORM WITH LINE WEIGHTS

Here is a simple method of attaining a sense of form with just line weights. First, determine the direction of the light source. Ink thinner, lighter lines closer to the light source, and ink thicker, darker lines away from the source. All lines become heavier as they retreat from the light source.

light source

light source

light source

light source

inking basics
PENWORK TOOLS

Although I don't use dip pens often (I find brushes more versatile), I do use them on work that needs to look more illustrative. Cartridge pens and pigment liners will give you even more control.

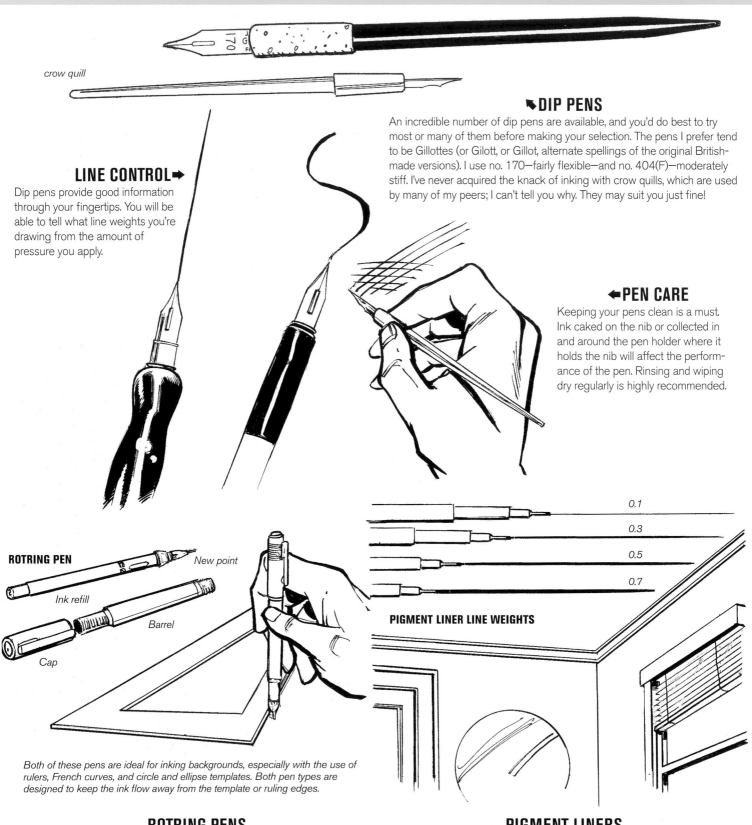

crow quill

↘DIP PENS

An incredible number of dip pens are available, and you'd do best to try most or many of them before making your selection. The pens I prefer tend to be Gillottes (or Gilott, or Gillot, alternate spellings of the original British-made versions). I use no. 170—fairly flexible—and no. 404(F)—moderately stiff. I've never acquired the knack of inking with crow quills, which are used by many of my peers; I can't tell you why. They may suit you just fine!

LINE CONTROL➡

Dip pens provide good information through your fingertips. You will be able to tell what line weights you're drawing from the amount of pressure you apply.

⬅PEN CARE

Keeping your pens clean is a must. Ink caked on the nib or collected in and around the pen holder where it holds the nib will affect the performance of the pen. Rinsing and wiping dry regularly is highly recommended.

0.1
0.3
0.5
0.7

ROTRING PEN

New point

Ink refill

Barrel

Cap

PIGMENT LINER LINE WEIGHTS

Both of these pens are ideal for inking backgrounds, especially with the use of rulers, French curves, and circle and ellipse templates. Both pen types are designed to keep the ink flow away from the template or ruling edges.

ROTRING PENS

I use Rotring pens, which are very similar to Rapidograph pens but don't clog as easily. In addition, when you replace the ink supply on a Rotring pen, you get a new point with the cartridge. Rotring 4-Pak sizes include .25, .35, .50 and .70.

PIGMENT LINERS

These are basically felt tips that use permanent ink so that corrections made with whiteout (which is water-based) won't cause underlying ink to bleed. Their line weights are compatible with those of Rotring pens.

inking basics
PENWORK TIPS

The techniques you use will depend somewhat on the type of pen you work with. Practice these strokes with different pens to get a feel for what they can do and what you are comfortable with.

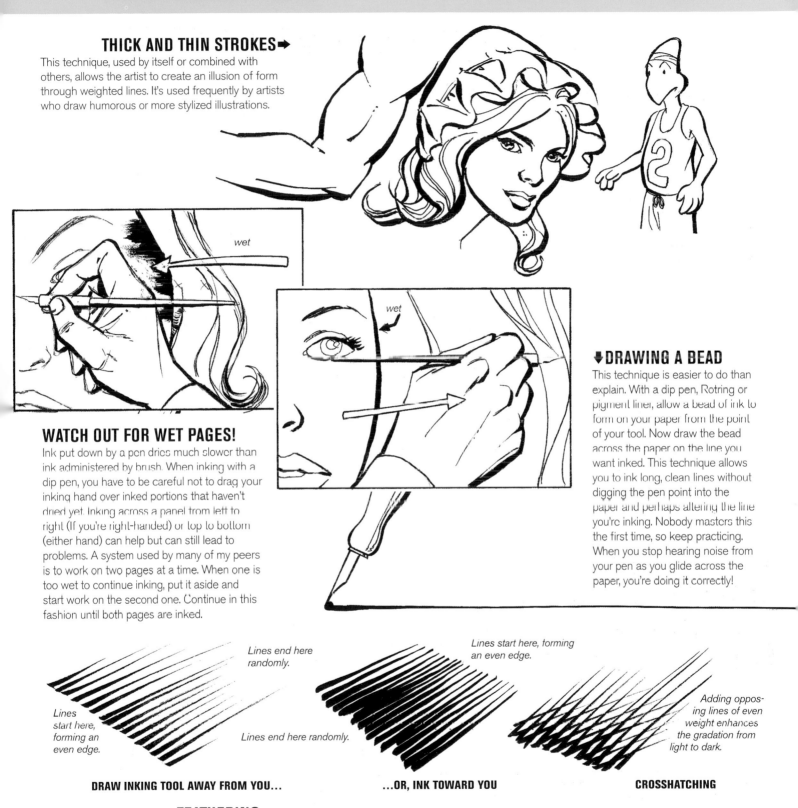

THICK AND THIN STROKES ➡

This technique, used by itself or combined with others, allows the artist to create an illusion of form through weighted lines. It's used frequently by artists who draw humorous or more stylized illustrations.

wet

wet

WATCH OUT FOR WET PAGES!

Ink put down by a pen dries much slower than ink administered by brush. When inking with a dip pen, you have to be careful not to drag your inking hand over inked portions that haven't dried yet. Inking across a panel from left to right (if you're right-handed) or top to bottom (either hand) can help but can still lead to problems. A system used by many of my peers is to work on two pages at a time. When one is too wet to continue inking, put it aside and start work on the second one. Continue in this fashion until both pages are inked.

⬇ DRAWING A BEAD

This technique is easier to do than explain. With a dip pen, Rotring or pigment liner, allow a bead of ink to form on your paper from the point of your tool. Now draw the bead across the paper on the line you want inked. This technique allows you to ink long, clean lines without digging the pen point into the paper and perhaps altering the line you're inking. Nobody masters this the first time, so keep practicing. When you stop hearing noise from your pen as you glide across the paper, you're doing it correctly!

Lines end here randomly.

Lines start here, forming an even edge.

Lines start here, forming an even edge.

Lines end here randomly.

Adding opposing lines of even weight enhances the gradation from light to dark.

DRAW INKING TOOL AWAY FROM YOU...

...OR, INK TOWARD YOU

CROSSHATCHING

FEATHERING

This is the art of inking lines from thin to thick (or thick to thin) to show the gradual transition from a white area to a dark area—in effect, a graded gray. As feathering is time-consuming and considered "old fashioned" by many, today's artists tend to avoid using it.

DEVELOPING A GAME PLAN

Although most of the following comments are intended to help you ink another artist's pencil work, much of it will apply to inking your own work as well.

First, some backstory on how I got involved with inking in the first place. My very first assignments when I started freelancing for Charlton (after a stint working at Jerry Iger's studio) were inking jobs, but in a short time I was given the opportunity to pencil and ink my own material. This soon led to being given pencilling assignments for others to ink and, for a while, that was fine. I wasn't sure of my pencilling skills and I was paired with pro inkers who took my "scribbles" and made fine pictures of them. As time went by, however, and I got better at what I was doing, I started to find fault with the inking work others were doing on my pencils. Lacking the power to do much about it, I just learned to live with it.

Later, when I joined the DC Comics staff as an editor in the late 1960s, I decided that it would be best to convince the people there that I was an inker, and I began to get inking assignments. You see, my editorial work was done in DC's office in Manhattan, and my freelance work was done in my home studio in Connecticut. Commuting presented a loss-of-time problem that I hoped would be overcome by my just inking. (You can jumpstart inking assignments easier than pencilling assignments.)

So I was now an inker! Job number one was to ensure that the pencillers I worked with wouldn't think of my inking efforts in the same rude manner that I thought of my former inkers' efforts. To that end, I developed the following game plan for completing my inking assignments:

1 READ THE STORY! This will help you familiarize yourself with the important pivotal scenes, times of day, lighting, etc. Perhaps it may even alert you to a continuity problem in the pencils that you can easily (and quietly) fix, like an unintentional midsequence change in clothing or costume.

2 STUDY THE PENCILS TO LEARN WHAT THE PENCILLER EXPECTS. The penciller has a right to expect that you ink his or her pencils in such a way that everything good in them is still present when you've finished your work. If you can improve the not-so-good pencils and *still* make it look like his or her work, then go to it—quietly! If the penciller has previously inked his or her own work, find copies of that and study it. You may not be able to match the style, but you can match the intent.

3 DECIDE ON AN APPROACH TO THE ACTUAL INKING. Will the story benefit from a looser, more organic inking style, or would a tighter, slick style work best? Choose the tools that will attain the desired result. (Incidentally, the next three pages show the same scene inked three different ways; note the differences.)

4 INK THE STORY IN SEQUENTIAL ORDER. This one is optional, but I prefer to work from panel one on the first page to the last panel on the last page. When I'm inking the story in the order that it is read, I feel I can be a help to the storytelling. I must point out that, on this practice, I am in the minority amongst my peers. Some inkers like to ink the fun stuff first (or last), or they may work on a new page while part of another one dries.

5 AND FINALLY, YOU CAN'T BLAME IT ON THE PENCILLER! When you are finished inking, your last act is to erase what pencil still exists... and all that is left is your ink lines. And, in a sense, you are left naked in the street!

inking styles
ALL PEN

My old friend Terry Austin, master of pen inking, inked this version (the published version) of this page, which was pencilled by me. Although an all-pen approach can be overly slick and rigidly controlled, Terry thought that the story would work better if the art was somewhat more organic and worked toward that end.

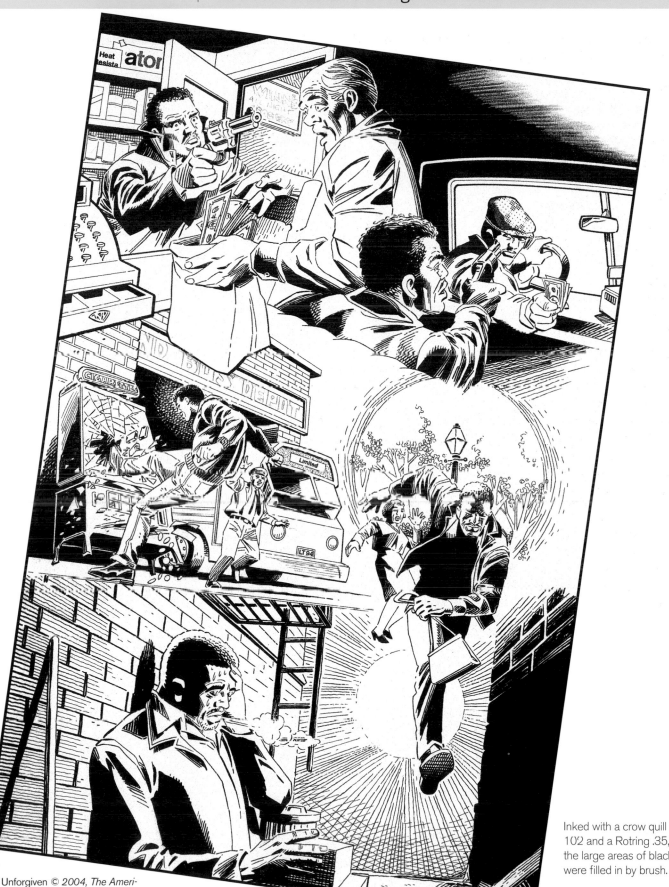

Inked with a crow quill Hunt no. 102 and a Rotring .35, except for the large areas of black which were filled in by brush.

inking styles
ALL BRUSH

Inking with a brush is the most organic method of inking a page because the tool will not allow you to get too sharp with your lines. Some pencillers and/or story lines can benefit from this looser ink style.

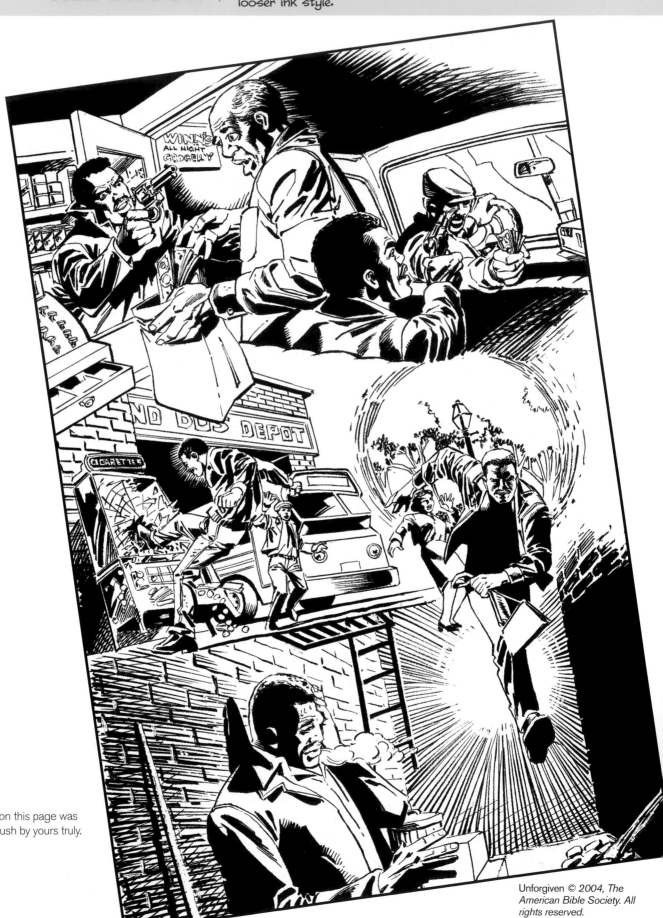

Yes, every line on this page was inked with a brush by yours truly.

inking styles
PEN AND BRUSH

Even though three different inking methods were used on these three pages, the results are similar because the pencil art directed the style and left not too much room for varied interpretation.

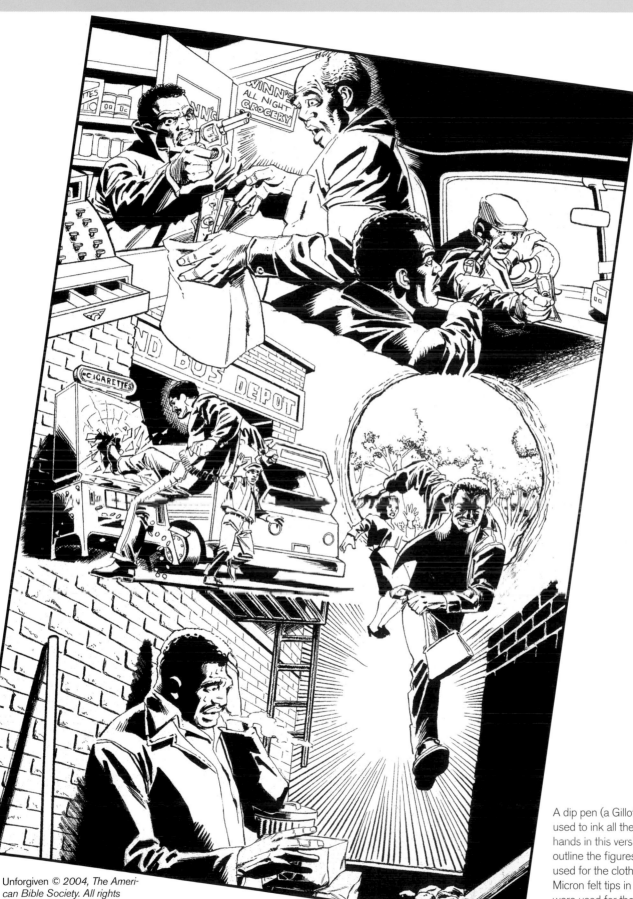

A dip pen (a Gillot no. 170) was used to ink all the heads and hands in this version, as well as to outline the figures. A brush was used for the clothing folds and Micron felt tips in sizes .3, .5 and .8 were used for the backgrounds.

inking textures
HAIR

Hair color, length and properties—curly or straight, thick or fine, coarse or shiny—vary from individual to individual, but the method we use to render them is the same.

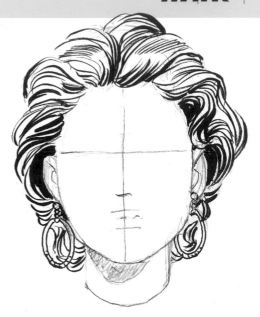

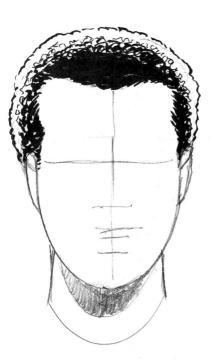

MASS CLUMPS, NOT SINGLE STRANDS

Determine the light source and the method you will use to transform the individual hairs into a mass (like a cap) that reflects the same light source that affects the head. Don't show every single strand, but for the strands and clumps you do show, you must be able to trace each hair in the mass back to its root—pun intended!

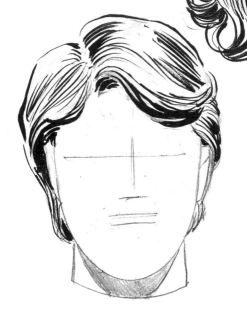

GRAVITY'S PULL

Each individual hair comes from some point on the skull and wants to fall down because of gravity.

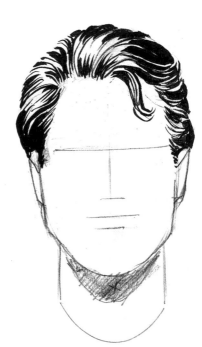

NO OUTLINING

In all of the examples shown here, you will note that there is not a clear outline for the hair, but rather an indication of where it (the cap) ends. Inking a hard line around the crown or at the roots of the hair will make it appear too mechanical and less natural—even wig-like.

inking textures
FABRIC

Each of the characters in your story will be wearing clothing. You must learn how to render not only the different textures of fabric, from shiny leather to nubby wool, but how it drapes and folds.

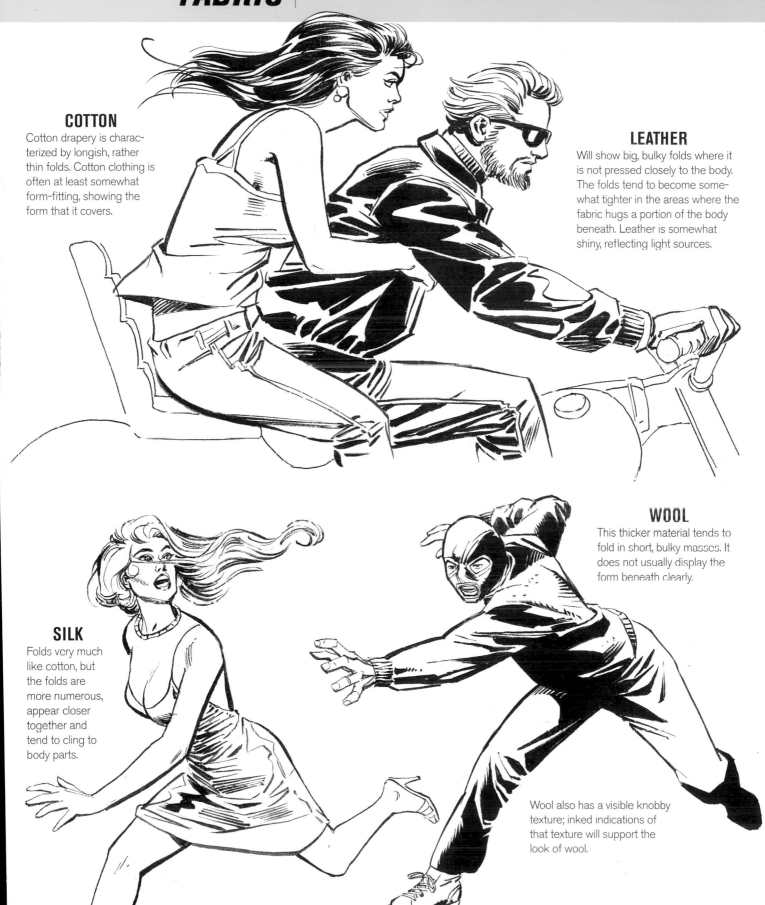

COTTON

Cotton drapery is characterized by longish, rather thin folds. Cotton clothing is often at least somewhat form-fitting, showing the form that it covers.

LEATHER

Will show big, bulky folds where it is not pressed closely to the body. The folds tend to become somewhat tighter in the areas where the fabric hugs a portion of the body beneath. Leather is somewhat shiny, reflecting light sources.

WOOL

This thicker material tends to fold in short, bulky masses. It does not usually display the form beneath clearly.

SILK

Folds very much like cotton, but the folds are more numerous, appear closer together and tend to cling to body parts.

Wool also has a visible knobby texture; inked indications of that texture will support the look of wool.

inking textures
BRICK

Bricks are made up of natural materials, with a texture similar to stone or concrete. What shows on buildings is generally a rectangle that is slightly projected.

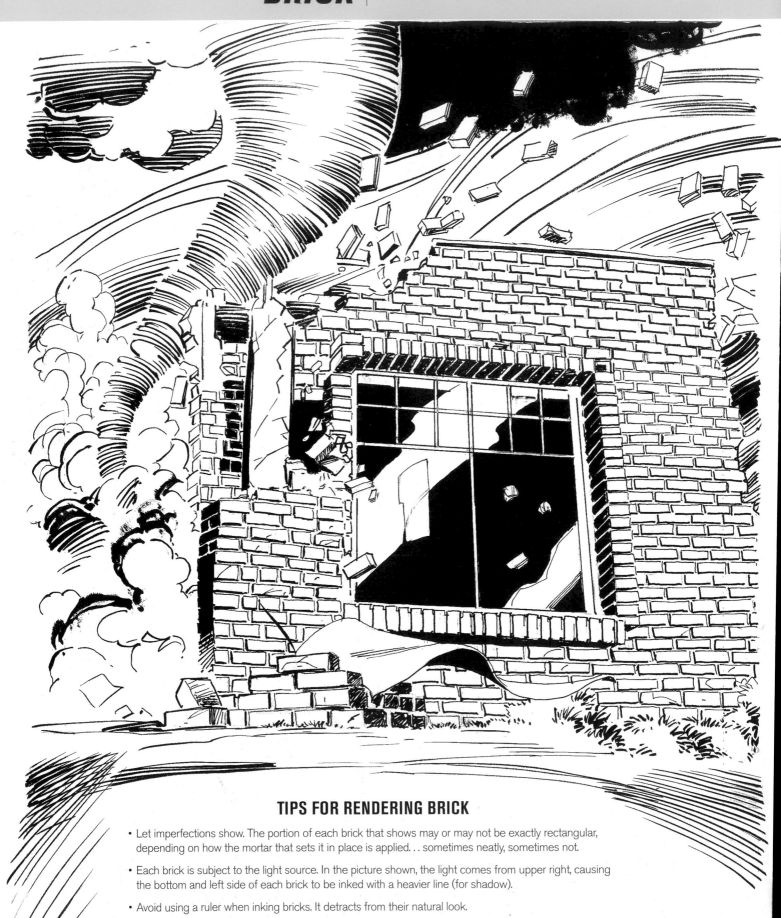

TIPS FOR RENDERING BRICK

- Let imperfections show. The portion of each brick that shows may or may not be exactly rectangular, depending on how the mortar that sets it in place is applied. . . sometimes neatly, sometimes not.

- Each brick is subject to the light source. In the picture shown, the light comes from upper right, causing the bottom and left side of each brick to be inked with a heavier line (for shadow).

- Avoid using a ruler when inking bricks. It detracts from their natural look.

inking textures
STONE

Stone is created by nature in a variety of sizes, shapes and textures. To render stone, you need to be aware of the light source and its effect on the stone mass.

ORGANIC LINES

Since there are no straight lines in nature, I've learned to hold my brush as far up the shaft as is comfortable to ensure a more organic line. The light source in this example comes from the right, and all the dark areas are, of course, away from the light.

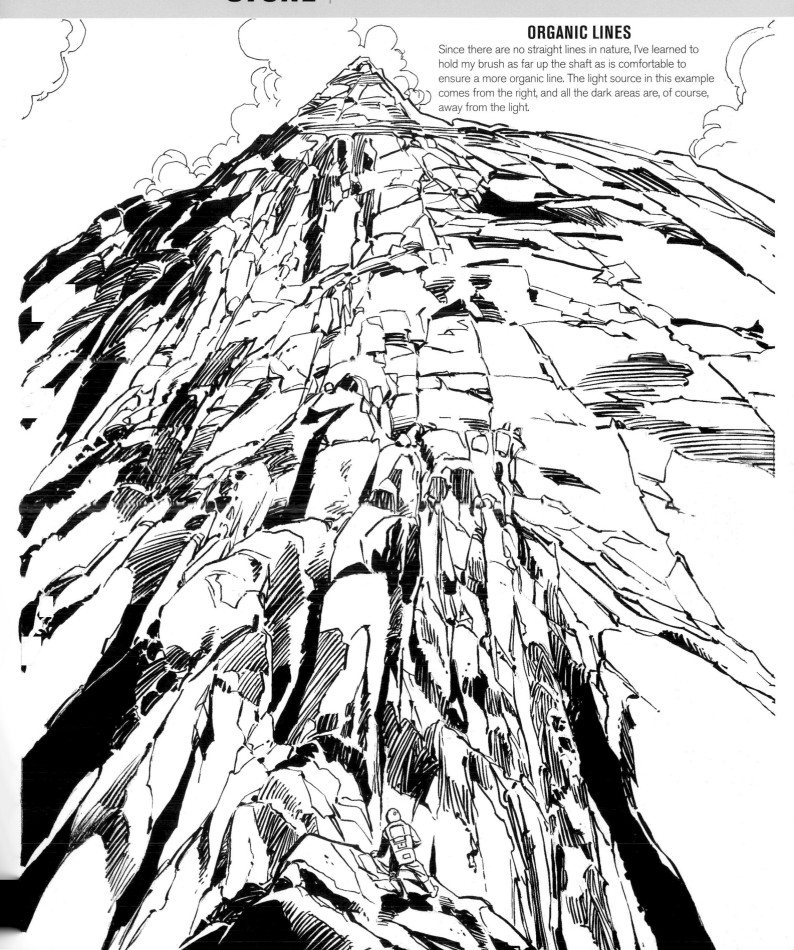

inking textures
SHINY METAL

Robots, cars, weapons and assorted hi-tech equipment are mainstays in adventure comics, so you need to be able to render metallic elements in an accurate and appealing manner.

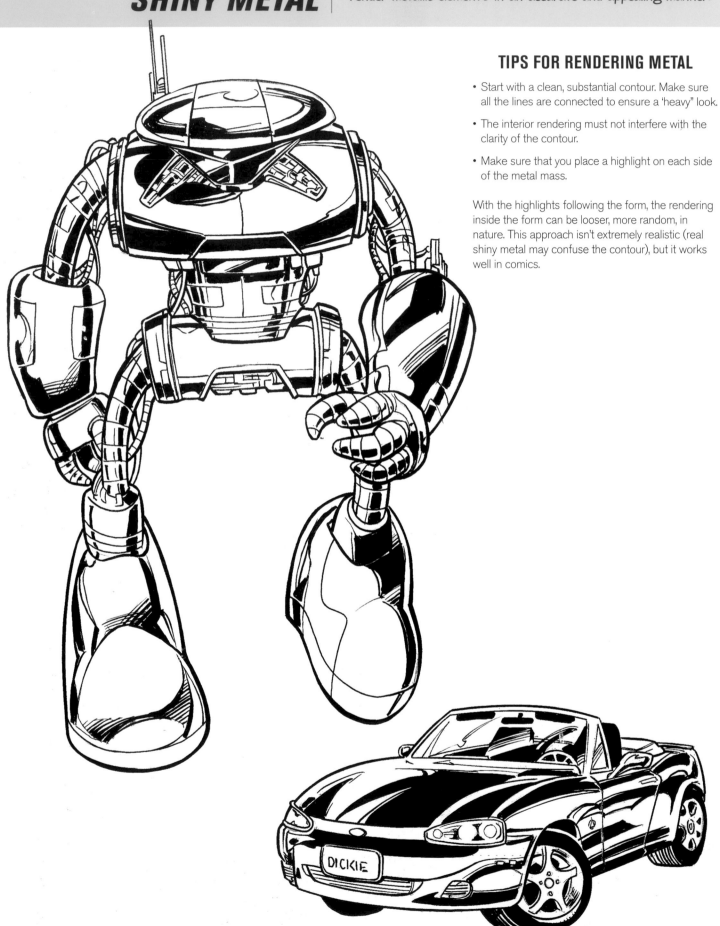

TIPS FOR RENDERING METAL

- Start with a clean, substantial contour. Make sure all the lines are connected to ensure a 'heavy' look.

- The interior rendering must not interfere with the clarity of the contour.

- Make sure that you place a highlight on each side of the metal mass.

With the highlights following the form, the rendering inside the form can be looser, more random, in nature. This approach isn't extremely realistic (real shiny metal may confuse the contour), but it works well in comics.

inking textures
TREES

Unless every scene of your comic takes place in the heart of the city, you'll need to know how to draw foliage. Trees can be as varied as your characters.

RECOGNIZE DIFFERENCES

Study the qualities of each tree type you wish to draw; their trunks, leaves, bark and overall shape are more different from each other than alike. And again, you must take the light source(s) into account in the rendering of the trees and the bark on their trunks... and remember that there are no perfectly straight lines in nature.

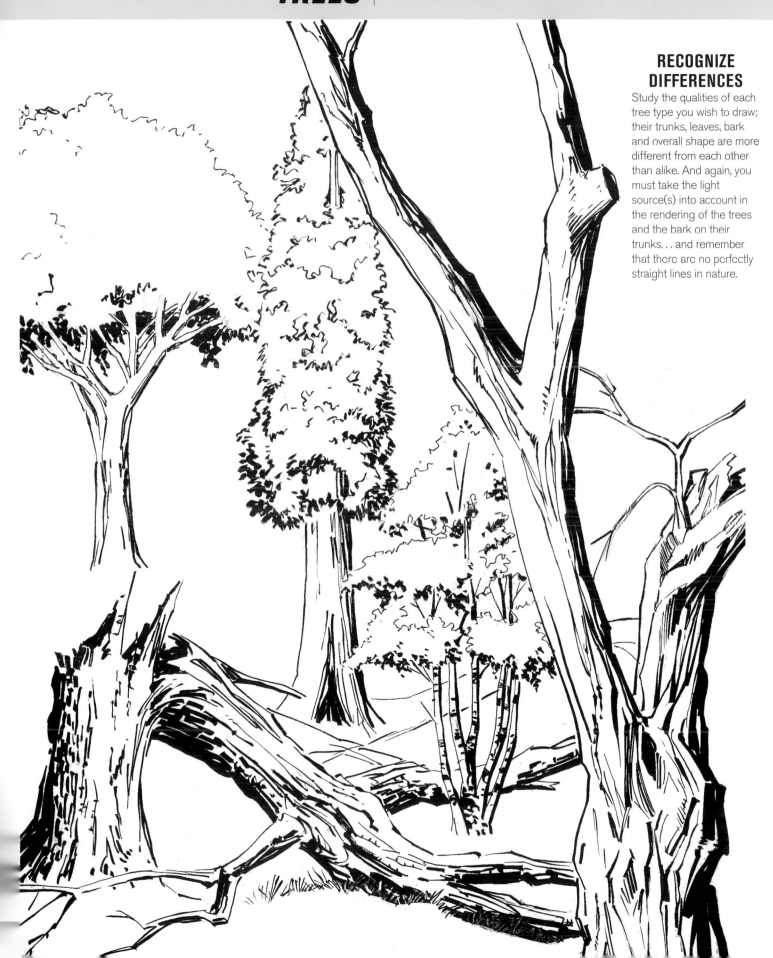

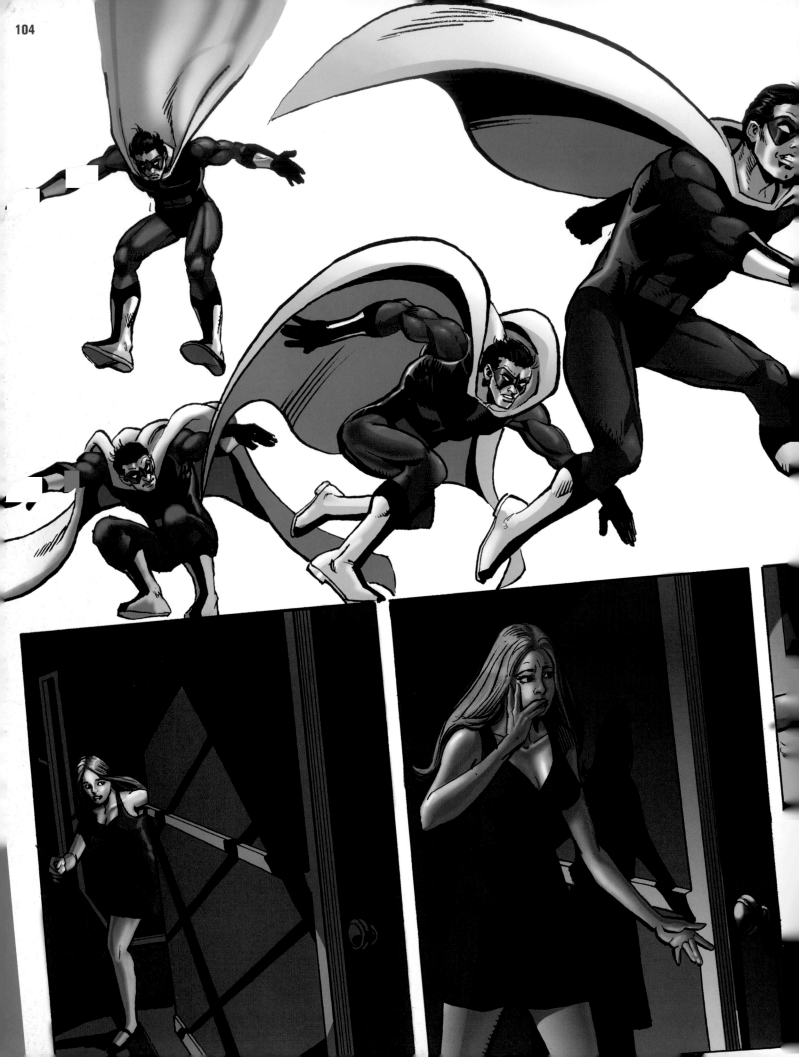

CHAPTER FIVE
SEQUENTIAL STORYTELLING

We come at last to the single most important job every comic artist must accomplish: the art of telling stories with pictures. Graphic storytelling is often a group effort, and at the same time, a very individualistic endeavor. It usually takes the collaboration of many (writer, editor, penciller, inker, letterer, colorist) for the story to come together; but, stylistically, you as an artist must go your own way. No matter what your artistic take on the story, it's crucial that you clearly illustrate story points and maintain reader involvement and interest.

There is, in my opinion, only one rule that must be observed in learning how to tell a story in pictures, and that rule is show the reader, don't tell him. In the pages that follow, I will attempt to illustrate how I approach the task of storytelling. My way is by no means the only way, and I would encourage you to find your own means of accomplishing the same goals. If you do your job well, nary a reader will consciously recognize your specific storytelling skills because your work will be a seamless blend of art, story and storytelling!

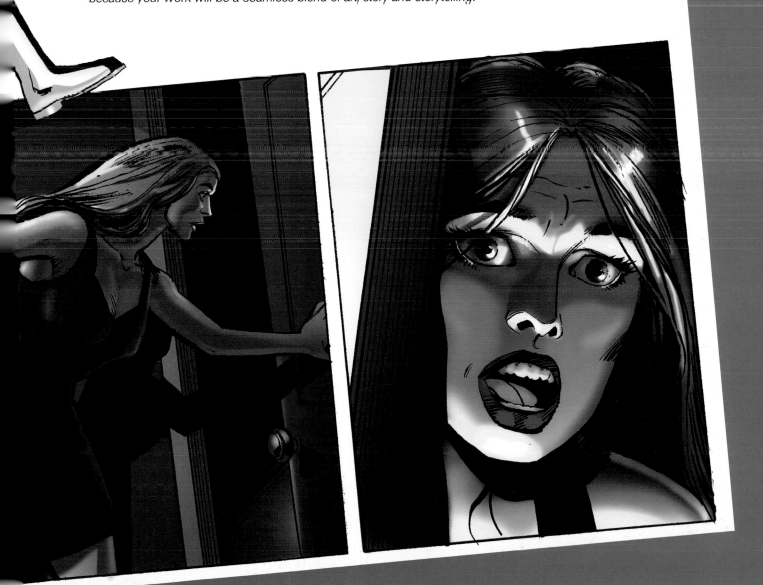

basic panels
THE CLOSE-UP

In my opinion, there are three valid reasons to choose a close-up over other shots: (1) to have a character clearly express an emotion, (2) to hide something that would be seen if you zoomed out and (3) to introduce variety to a page that has many long and middle shots.

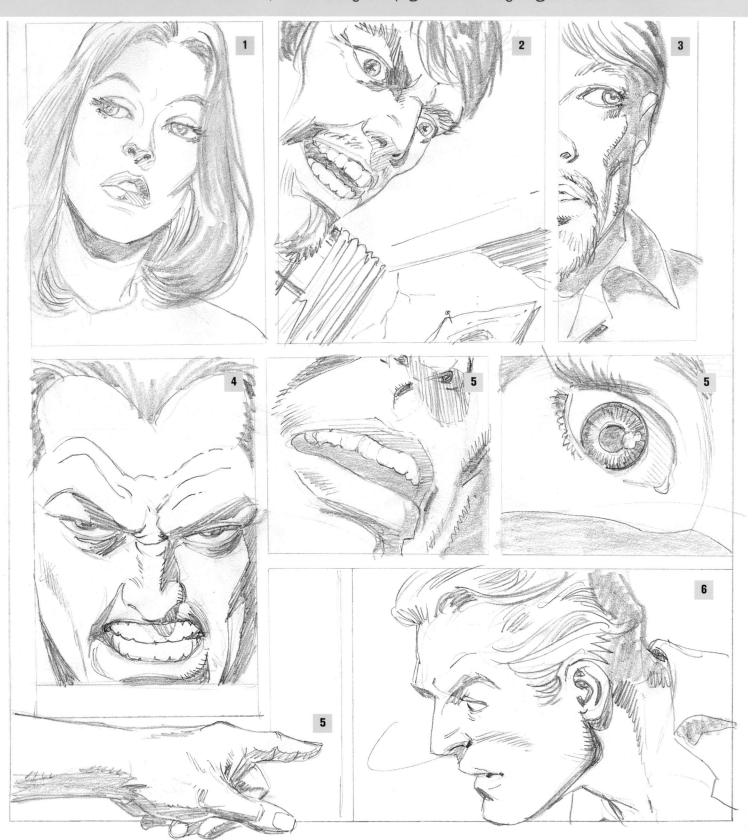

1 The full head close-up, the most conventional approach, works best for subtle expression and minimal drama.
2 The partial head close-up is a bit more dramatic and allows extra room for captions and/or backgrounds.
3 Half-head close-ups are great for the sideways glance or a thin panel.
4 Use extreme close-ups to show intense, in-your-face emotion.
5 The detail close-up zooms in on a hand or some other body part, or an item integral to the scene.
6 A close-up can draw attention to a specific action. He whirls to see. . .

basic panels
THE LONG SHOT

A long shot is one in which your "camera" is set far away from the focus of your picture. It typically includes background details that could become part of a closer shot as the story progresses. Long shots can establish a mood or, most often, the setting for a sequence.

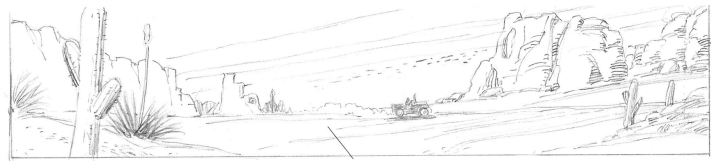

A pastoral panoramic shot can create a serene mood and establish the setting.

This vertical long shot is somewhat more energetic as the curved road and the vehicle create movement toward the distant city.

The chase is on! Simple one-point perspective accentuates the movement toward the reader. The foreground car enhances a feeling of deep space and directs the eye to the main action.

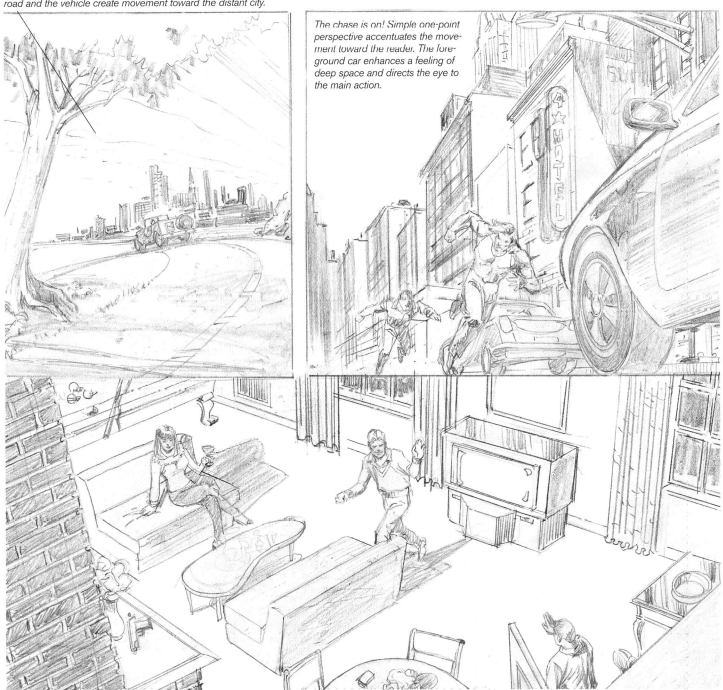

This classic overhead establishing shot quickly and efficiently answers the questions of who, what, where, when and how.

basic panels
THE "TWO" SHOT

The "two" shot is a visual device used when two or more characters are talking to each other in order to impart necessary information to the reader that is not or cannot be shown. The "camera" generally shoots past one character to the second to allow an action/reaction sequence.

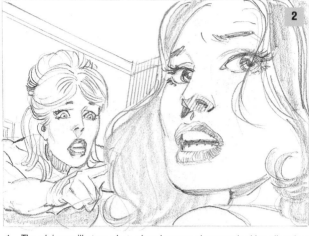

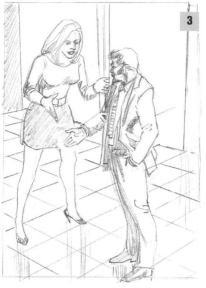

1 The plain-vanilla two shot—showing one character looking directly at another—often does the job.
2 This more complex shot shows a reaction to action off the panel. Don't you want to know what's happening off-panel? That's why readers will turn the page!
3 If a close-up of the characters' faces isn't necessary, a full-figure shot adds variety to your sequence.

THE MOB SCENE

Drawing a mob scene is time-consuming, but it can be a lot of fun!

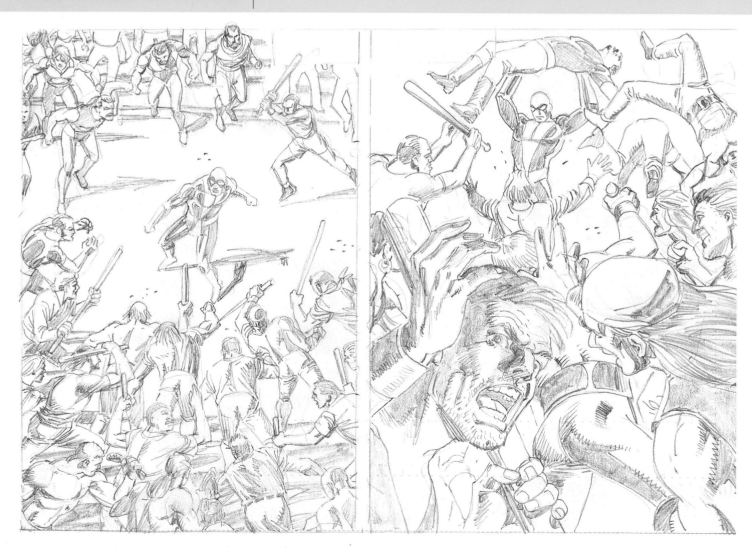

basic panels
THE TRICK SHOT

Trick shots show a unique or unconventional viewpoint. Although it is tempting to use this type of shot often—they look cool!—too many trick shots will impair good storytelling, which often requires multiple events in a panel. Trick shots are limited in how much depth of incidence they can convey. Use them sparingly as counterpoint to a page with other more conventional content or to accentuate a point of drama.

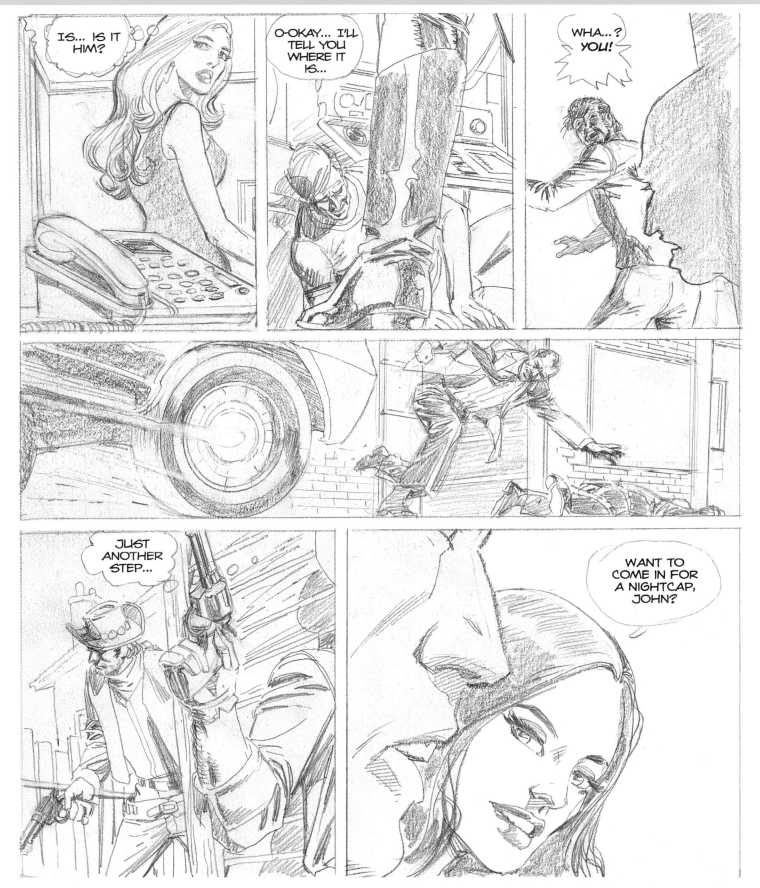

PANELING PAGES... THEN AND NOW

Today, comic artists have relatively free reign in designing the panel composition of their pages. This wasn't always the case.

TERMS TO KNOW

Panel—The drawn lines, generally rectangular, that enclose a drawing and text in a story. Represents one segment of the story.

Gutter—The space between panels.

Standard page format—An exact exterior page size, generally a 3:2 length-to-width ratio. In this traditional format the art may not extend beyond set margins within the exterior page lines. Used exclusively for comics up to about the 1980s.

Full-bleed page format—Allows art to "bleed" beyond the standard page margins to the edge of the paper.

I generally give a lot of thought to designing and sizing the panels on a page. It's important not only to help the reader move more effortlessly through the page (and thus through the story), but to best showcase the action contained within each panel.

I prefer to assign an odd number of panels (5, 7, 9) per page because this allows a greater variety of design opportunities. Also, odd numbers tend to be more pleasing to the eye.

With the advent of full-bleed pages, panel variety is almost limitless. This endless variety is not always to the betterment of the material, however. Some artists are often *too* creative in the panel composition of their pages, which can detract from the storytelling.

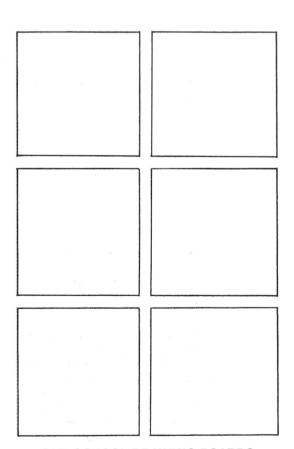

OLD-SCHOOL DRAWING BOARDS

Several decades ago, some publishers gave their artists boards pre-ruled in non-print blue that limited them to the same six-panel format for nearly every page. When a larger panel (or panels) was required, the editor or script would indicate which panels to combine vertically or horizontally to form the larger panel. The standard extra-wide gutters could not be made smaller.

MODERN-DAY FLEXIBILITY

More flexible division-marked boards, which offer guides for creating a couple of different panel sizes, are still used today. Marks printed on all four sides, dividing each page in half and in thirds, give artists the option of using a ruler to connect the marks and quickly create square panels.

PANEL FLEXIBILITY

Problem: A script calls for the second panel to be the largest on the page. Here are a few options. Make your choice based on the art that must appear in your panels.

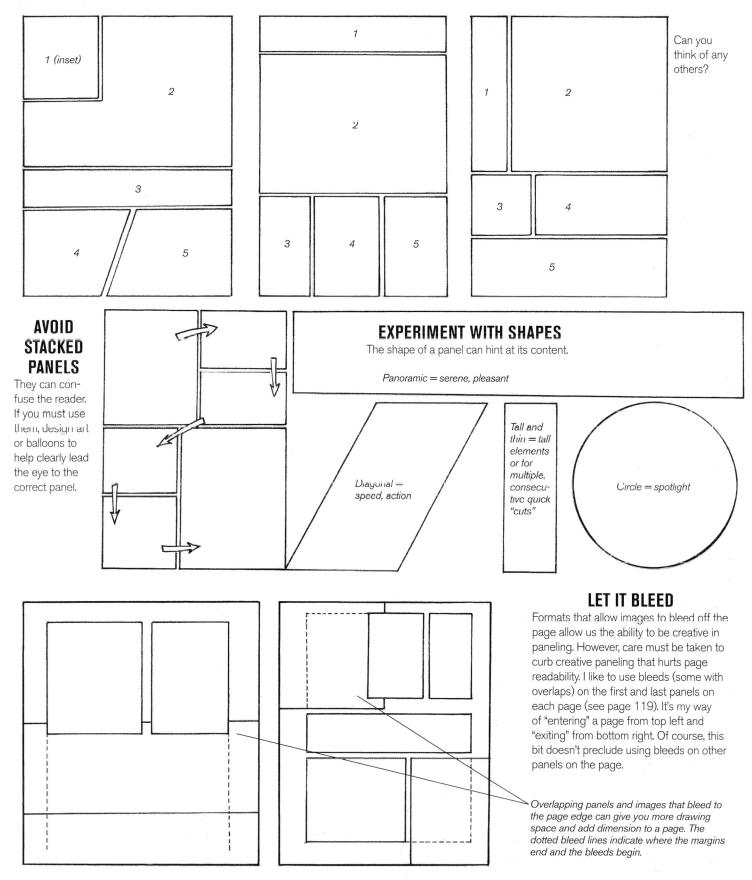

Can you think of any others?

AVOID STACKED PANELS

They can confuse the reader. If you must use them, design art or balloons to help clearly lead the eye to the correct panel.

EXPERIMENT WITH SHAPES

The shape of a panel can hint at its content.

Panoramic = serene, pleasant

Diagonal — speed, action

Tall and thin = tall elements or for multiple, consecutive quick "cuts"

Circle = spotlight

LET IT BLEED

Formats that allow images to bleed off the page allow us the ability to be creative in paneling. However, care must be taken to curb creative paneling that hurts page readability. I like to use bleeds (some with overlaps) on the first and last panels on each page (see page 119). It's my way of "entering" a page from top left and "exiting" from bottom right. Of course, this bit doesn't preclude using bleeds on other panels on the page.

Overlapping panels and images that bleed to the page edge can give you more drawing space and add dimension to a page. The dotted bleed lines indicate where the margins end and the bleeds begin.

storytelling 101
FROM WORDS TO PICTURES

"She moved silently through the dark, deserted street. She looked neither right nor left. She knew she would find the one she sought soon enough. Halfway down the street, a barely audible sound from behind and to her left stopped her in her tracks. She whirled around. And there, lunging at her from out of a pitch-black alley, was. . . "

TERMS TO KNOW

Caption—Boxed text that often provides information needed to change time and/or scene and mood. Narrator of captions can be a character in the story or an omniscient narrator.

Word balloon—Dialogue spoken by characters. Oval in shape.

Pointer/tail—The device extending from a balloon and pointing, or leading, to the character speaking.

Burst balloon—A loud exclamation. Jagged-edged.

Thought balloon— A series of connected partial bubble shapes containing the thoughts of characters.

Whisper balloon—Softly spoken words, indicated by dotted-line word balloons or small lettering in a big balloon.

The narrative above is similar to a "plot first" script. It simply and briefly details the action that is to appear on a particular page in a story, and contains only hints of what the dialogue will be. It is then the artist's job to turn the words into clear pictures; to create a graphic narrative. This plot-first method—often referred to as the Marvel method—gives artists more latitude in the layout and pacing of a story.

A writer, usually the one who wrote the plot, will then take the pencilled pages and create the word balloons and/or captions that complete the story. The writer generally indicates balloon and caption placements on an overlay.

This is an assignment I have given to many of my storytelling classes, and I've drawn it myself a number of times. Although the characters and minor details change from one attempt to the next, my approach remains constant: *Show* the readers, don't *tell* them. Strive for visual clarity.

With this in mind, let's compare this plot to the art on the facing page.

PANELS 1–3
"She moved silently through the dark, deserted street."
The wide-angle shot of the first panel shows the entire street so you can see it is dark and deserted. The next two panels follow the figure as she moves silently through the street. We can easily gauge her movement through space as she gradually approaches the reader.

PANELS 4–6
"She looked neither right nor left. She knew she would find the one she sought soon enough."
One drawing of the figure looking straight ahead doesn't mean she didn't look right or left before or after that one drawing. These three panels, with each shot moving in a bit closer on the character's face, are better than a single panel. A sense of movement is apparent because the background changes, as does the shadow pattern on her face.

PANEL 7
"Halfway down the street, a barely audible sound from behind and to her left stopped her in her tracks."
"Halfway down the street" is tough, but the art is designed so that we (and she) can "see" the sound that stops her.

PANEL 8
"She whirled around."
Where did the stake come from? Look closely at the previous panel—it's in her right hand.

PANEL 9
"And there, lunging at her from out of the pitch-black alley, was… "
Here, we have two schools of thought. Some artists and writers believe this last panel should be a cliff-hanger (we don't know who's lunging yet); others believe that a revelation is the best way to end a page.

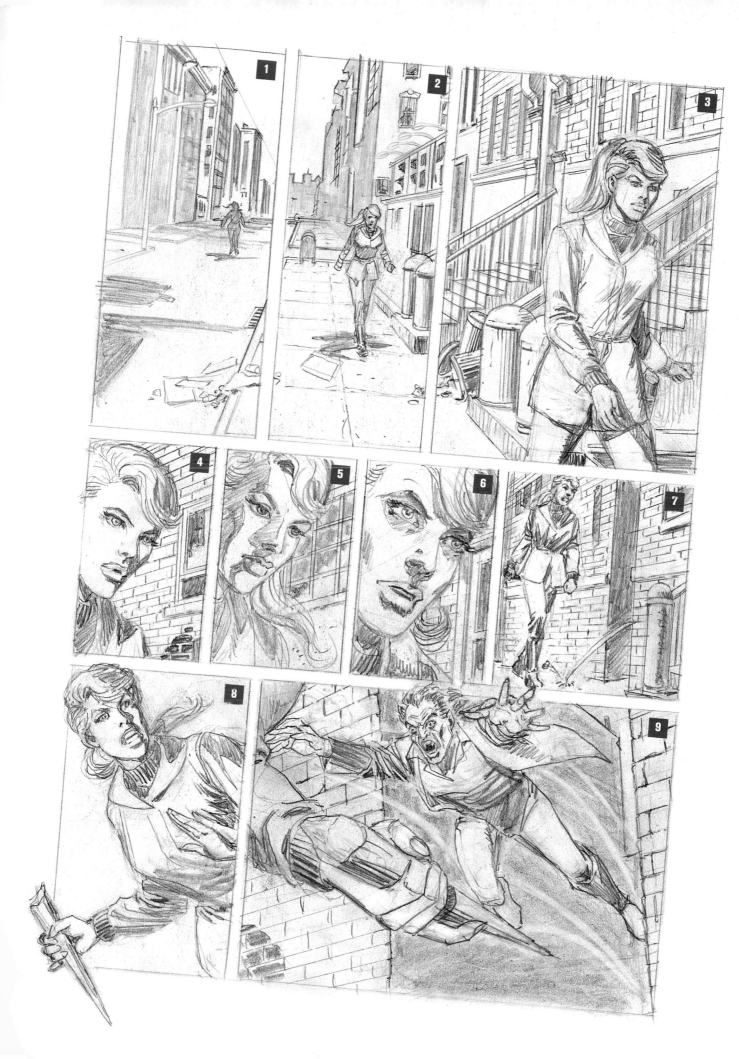

storytelling 101
CREATING A SENSE OF PLACE

Where the heck *are* we? Your reader is entitled to know where the action is taking place at all times in each story sequence.

The establishing shot (or long shot) should appear early in each sequence, preferably in the first or second panel. This shot shows where everything is relative to everything else. When subsequent panels are tighter on the action, you can select smaller portions of the "set" to show in the background to establish that we're still in the same place and to chart the movement of characters. Of course, you can leave backgrounds out of occasional panels altogether, so long as you regularly re-establish where we are.

It is relatively easy to tell where the action is taking place in each of the panels on this page. If I've done my job, you should be able to draw conclusions about the events that have taken and/or will take place. The sense of place now plays a role in the telling of the story.

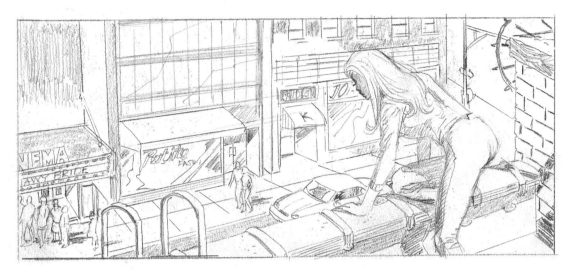

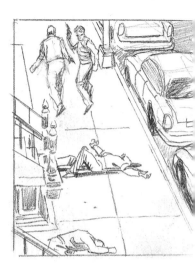

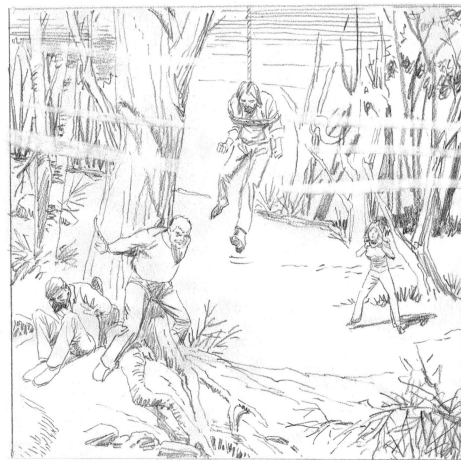

storytelling 101
DISTINGUISHING CHARACTERS

There's nothing duller than a story peopled by indistinguishable "nobodies." I like to create a life story in my mind for even minor characters. No one else needs to know this back story but me. It helps me believe these people are real so that maybe, just maybe, I can convince my readers that they are.

DESIGN BIG

Design characters based on basic shapes rather than small details. Small details are difficult to replicate time after time; distinctive shapes are not. Make characters easily recognizable from every angle, at every distance. It's easier to recognize someone as "the tall, thin guy" than as "the guy with blue eyes and a hook nose." A good test is: Would you be able to distinguish one character from another if both were drawn in silhouette?

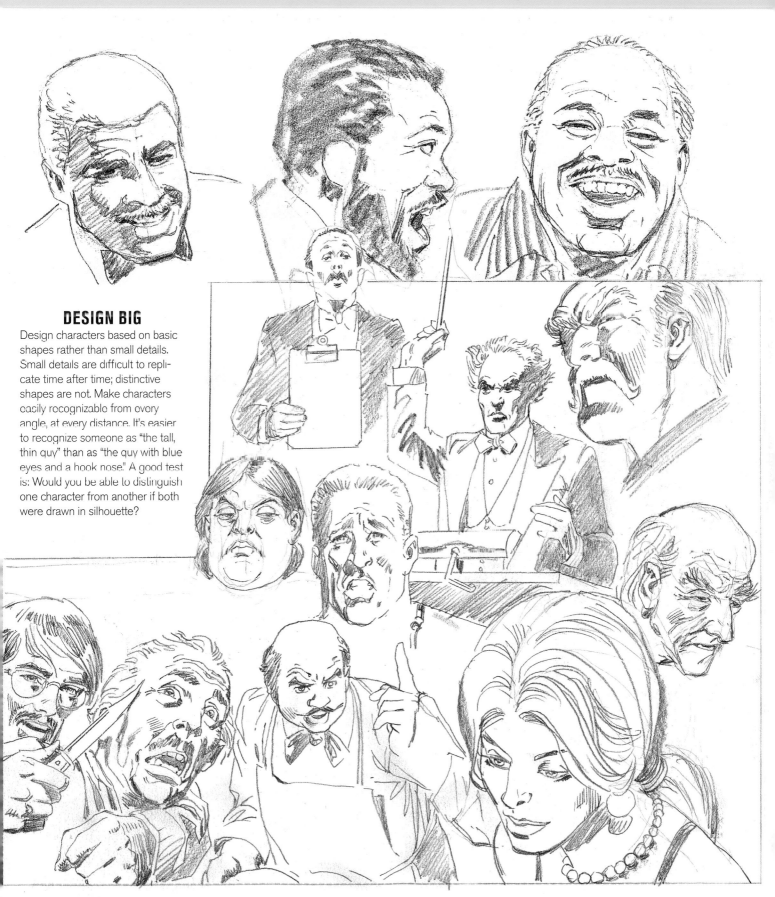

storytelling 101
PACING AND LEADING THE EYE

As your characters move through their story, the reader should be able to "read" their movements with ease and complete understanding. The reader should know exactly where to look next on a page *and* how quickly he should look there.

PANEL 1
A long shot leads the eye into the page. Who is this guy?

PANEL 2
A closer shot reviews a few more details—a gun, long hair. He's now walked up to the garbage bag established in panel 1.

PANEL 3
Zoomed in further, we can now see his face. He's made it as far as the tattered poster shown in panel 1.

PANELS 4–7
Scene change; the second character in four quick cuts leads us back to the first character. The "camera" pans out as the second character turns to see who is behind him. . .

PANEL 8
The first character lets us know what (and whom) the gun was for.

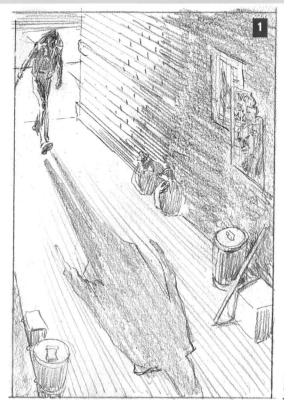

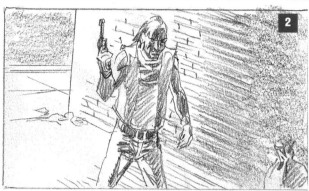

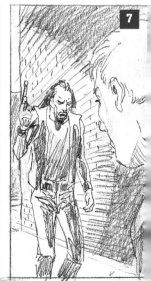

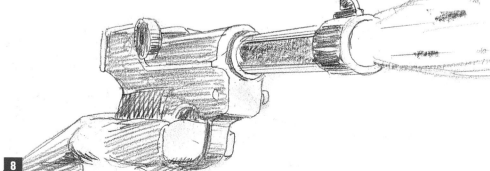

storytelling 101
DIRECTING TRAFFIC— AND THE EYE

I couldn't resist including this page from one of my favorite stories. It's called KYM, and it appeared in WITZEND #10. Since it was "silent," I had to draw on my story-telling skills to keep the reader involved.

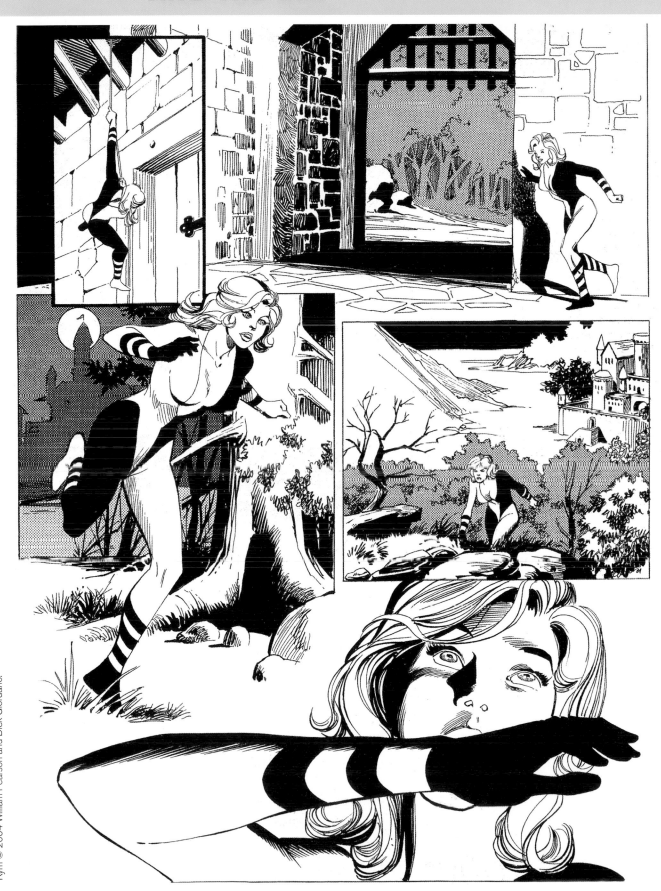

creating a comic
GETTING THE SCRIPT

This script was written by my old friend Brian Augustyn for *Unforgiven*, published by Metron Press. As you can see, a full script—as opposed to a plot-first script—gives the artist *all* the information needed to draw the pages. It is rather like a stage play script: It contains descriptions of character action, complete dialogue, sound effects and captions, if any.

This page of the story shows Nate, a burglar, going about his work silently and carefully.

UNFORGIVEN/METRON NOVELLA/SCRIPT FOR 36 PGS./AUGUSTYN/ Ms. 15

PAGE NINE

PANEL 1:
Nate backs through the glass front doors of the apartment building, as the doorman and the couple are distracted with the cab. Nate smiles at his own audacity.

1 CAP: Right in the front door! You can't get much bolder than that.

2 CAP: The man loved to take RISKS.

PANEL 2:
Nate slips silently through a door marked "STAIRWAY" in the well-appointed lobby. He wears a pair of leather driving gloves.

3 CAP: Made it SWEETER.

PANEL 3:
Nate peers out into a hallway through a door only inches ajar. He's making sure no one sees him. If we see any apartment doors, we should see that they are marked 6-c, 6-D, etc.

((NO COPY))

PANEL 4:
Nate stands at the door to 6-H. He's pressing the doorbell and looking around with studied calm.

4 CAP: Place was SUPPOSED to be empty, but he wouldn't risk THAT much.

5 SFX: BZZZT-BZZZT

PANEL 5:
In close-up, we see Nate's hands as he uses a thin tool to pick the door lock.

6 SFX: >SNAKKT<

creating a comic
THUMBNAILING

Working from the full script, I first produce a fairly comprehensive thumbnail or "comp" of the page at the size of a standard comic-book page. I feel that by doing this, I will see what the reader sees, and it helps me ensure that story points will be clear in the finished art. I use a template culled from an actual drawing board, indicating such details as bleeds and gutter widths.

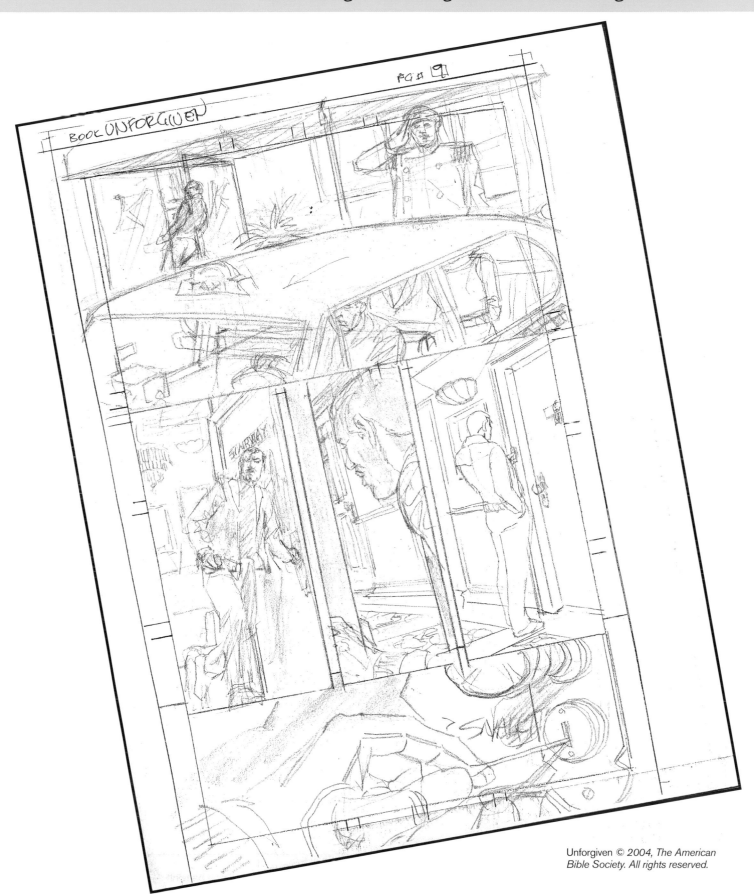

creating a comic
PENCILLING

To create a clean original to build upon, I make an enlarged photocopy of my comp, tape it to the back of a blank drawing board and make a tracing by using a light box. At this point I add details (i.e. the hotel front, the note about Nate's gloves) and lighting considerations, and I make important corrections as I work. (For instance, I turned Nate around in panel 1 so the reader can see his face.)

This procedure allows me to try resizing or repositioning individual elements or entire panels simply by making photocopies of the comp (reduced, enlarged or actual size) and moving them around.

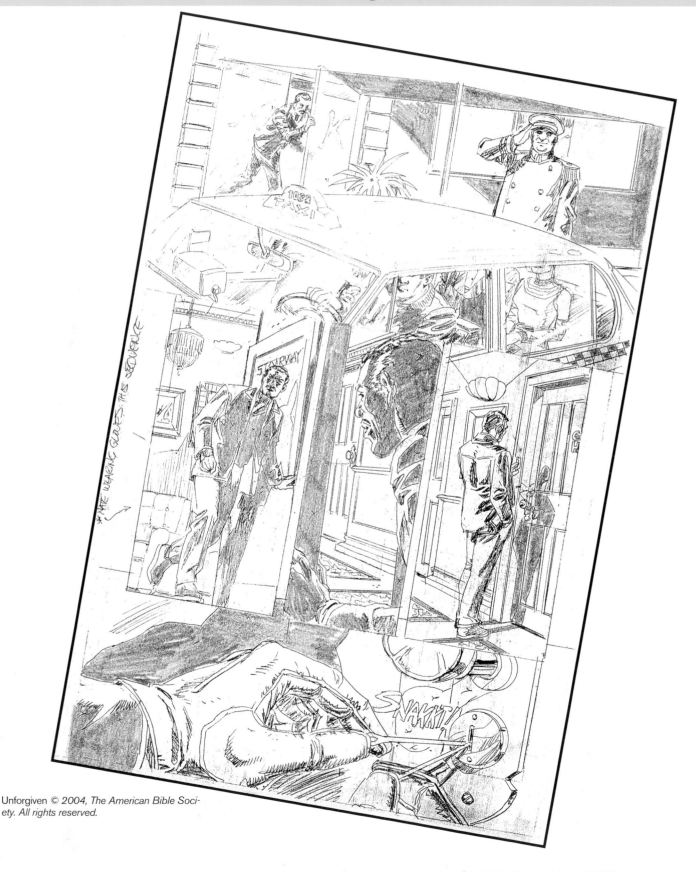

creating a comic
INKING

Terry Austin's inking magic completes the page, retaining all that was in the pencilled art and adding cool touches of his own including textures and lighting effects. Terry's careful rendering and attention to detail make the art cleaner and easier to understand. By slightly lowering the bottom edge of panel 1, he cleared up a paneling problem inadvertently left in the finished pencils. Also, he passed along my color note to the colorist.

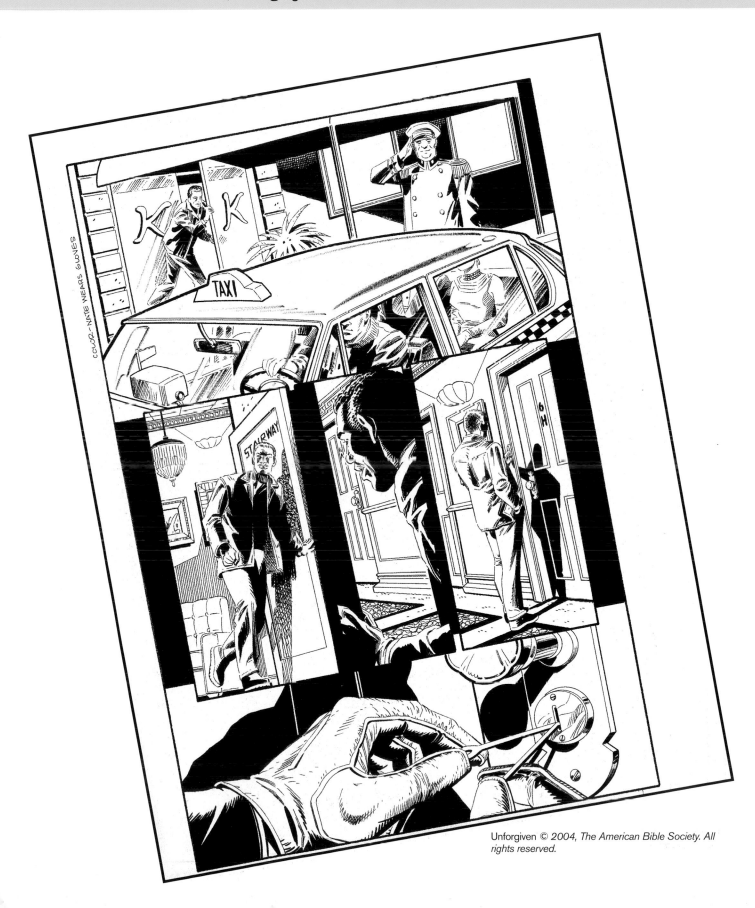

creating a comic
COLORING

If your art is destined to be colored, another collaborator enters the picture. My partners and I at Future Comics are fortunate to have worked with a great colorist, Brad Nault. Brad did the color for this book. Here, he explains the basics of the colorist's art.

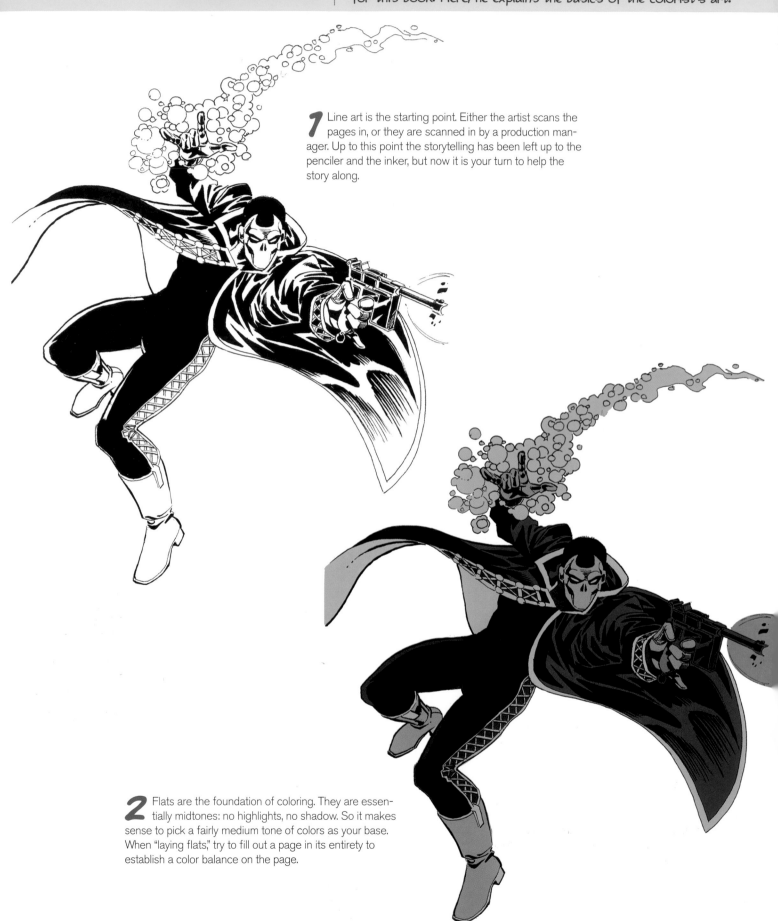

1 Line art is the starting point. Either the artist scans the pages in, or they are scanned in by a production manager. Up to this point the storytelling has been left up to the penciler and the inker, but now it is your turn to help the story along.

2 Flats are the foundation of coloring. They are essentially midtones: no highlights, no shadow. So it makes sense to pick a fairly medium tone of colors as your base. When "laying flats," try to fill out a page in its entirety to establish a color balance on the page.

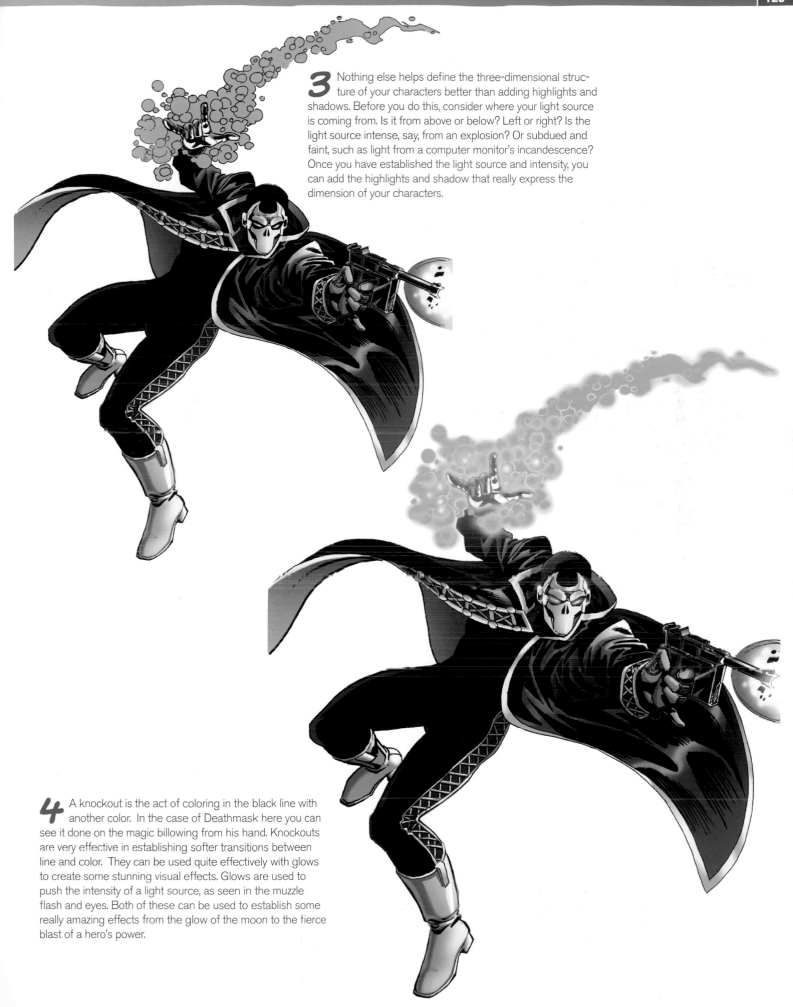

3 Nothing else helps define the three-dimensional structure of your characters better than adding highlights and shadows. Before you do this, consider where your light source is coming from. Is it from above or below? Left or right? Is the light source intense, say, from an explosion? Or subdued and faint, such as light from a computer monitor's incandescence? Once you have established the light source and intensity, you can add the highlights and shadow that really express the dimension of your characters.

4 A knockout is the act of coloring in the black line with another color. In the case of Deathmask here you can see it done on the magic billowing from his hand. Knockouts are very effective in establishing softer transitions between line and color. They can be used quite effectively with glows to create some stunning visual effects. Glows are used to push the intensity of a light source, as seen in the muzzle flash and eyes. Both of these can be used to establish some really amazing effects from the glow of the moon to the fierce blast of a hero's power.

What to Have in Your Portfolio

It is better to err on the side of too little than too much. Professionals who look at portfolios don't, for the most part, have the time or the attention span to look through tons of pages. Keep it lean, simple and neat.

The ideal portfolio is a binder with acetate sleeves that you can slip your samples into. Original samples, not photocopies, are best. Avoid loose pieces and small clippings. Also avoid pin-ups and covers; no matter how good you think they are, an editor will rarely risk using a newcomer on cover or pin-up assignments.

It's fine to include a very modest amount of samples that show all the skills you have (graphic design, coloring, lettering, etc.), but if your main goal is to pencil comics, include three to five consecutive pages from a single story. Editors want to see your consistency as a storyteller. If these pages represent the best you can do in the area you'd like to be active in, put them in the front of your portfolio. If the reviewer likes them, he or she may thumb through the rest of your portfolio to see what else you can do.

If your main goal is to become an inker, most of these suggestions apply to an inking portfolio as well. The main difference is that you must have photocopies of the penciled art that you used to produce the inked samples. This will help the reviewer ascertain what your contribution to the finished art was. As I said earlier, merely tracing penciled art isn't what the term "inking" implies to the professional reviewer. You need to *bring* something to the party!

Always have several sets of photocopied samples stashed in your portfolio for editors to take with them. Each page should have your contact information stamped or written on the back. (You'd be surprised how quickly pages get separated on an editor's desk.) Staple or clip the pages together and place them in an envelope that has all your contact information written on it. By the way, editors may not say it, but it's implied: Don't call me, I'll call you!

What to Say as Your Portfolio Is Being Reviewed

"Nothing" is good! Do not under any circumstances explain why you did what you did on a page—particularly if the reviewer is criticizing it. Never say, "Oh, I did it like that because. . ." My stock reply for this statement is, "That's an interesting explanation . . . and if you're willing to go along with every copy and explain it to the reader, we may publish it." Don't make excuses for your art. If the art doesn't speak for itself, your attempts to speak for it will fail. Take criticism for what it generally is: An attempt to let you know what the reviewer thinks is wrong with your work. You may not agree with him, but you should at least think about ways to address his concerns without giving up your integrity.

The person who buys your work always has the right to set standards that you must meet. An editor or art director tells you what she or the company she represents thinks is commercial. You don't have to go their route, but then you won't work for them, either. The only way to avoid some of this is to self-publish.

Do *not* compare yourself to other professionals. "Why is Artist A getting work and I can't? I'm at least as good!" First of all, that's *your* opinion. And even if it happens to be true, there is little point in them hiring an artist who is as good as Artist A when they already *have* Artist A. You will do better in marketing yourself if you can convince portfolio reviewers that you are a unique talent rather than as good as Artist A.

Finally, relax. Try to learn something from the experience, and be prepared to handle rejection. You expose yourself to it every time you turn in jobs. Use the criticism to motivate rather than depress you and you may find yourself in the reviewer's chair sometime down the road.

What to Do Afterwards

Shake off negative reviews and look for someone else to review your portfolio. What is drek to one may appear to be the Second Coming to another. In any case, don't be discouraged; pay attention to what others say (but you need not consider it gospel), and keep working at it. If you work hard enough and get better and your desire is great enough, you will not be denied. I graduated from my art school in the bottom half of my class, and so did my best buddy. Despite this, both of us have attained our life's goals, and we ran right past those in the top half of the class. Why? We *wanted* it more than they did. Proof that perspiration trumps inspiration!

And as all good things come to an end, we find ourselves at the end of this leg of your journey of discovery. My lasting regret is that there wasn't sufficient room to cover everything in greater depth. But I have touched on everything I feel you need to know to get started drawing comics.

If you've worked along with me on the pages in this book, you may have come to a conclusion as to whether you want to continue your comic art education or not. If you want to go on, the best way, of course, is to attend a good art school. If this isn't an option for you, you can still further your art education by yourself with a reasonably priced library of art instruction books. Some suggestions:

- Start by checking out IMPACT Books, a line of step-by-step instructional books focusing on comics.
- If you have access to the Internet, do a Google search on artist Will Eisner. You will be rewarded by a listing of his books (at reasonable prices) and a link to Comics Education that lists twenty-six books focusing on comic art. When you use that link, you'll be on Amazon.com. Eisner's classics *Comics and Sequential Art* and *Graphic Storytelling and Narrative* (both reprinted by IMPACT Books, 2004) are must-haves for every comic artist's library.
- In my opinion, the very best anatomy book for the comic artist is *Figure Drawing for All It's Worth* by Andrew Loomis (published by Viking Press in the 1940s). As good as it is, it's been out of print for a number of years, but you may be able to find a used copy if you're diligent enough. Trust me, it will be worth the effort! You might also want to seek out anatomy books by Burne Hogarth and George Bridgman. Both authors are still in print; check art store catalogs and art material websites.
- Another search worth the time is finding the three-volume set of *Famous Artists School* books. The school was originally located in Westport, Connecticut.

Of course, you may get lucky on eBay tracking down these hard-to-find gems, or at larger conventions where booksellers set up shop. Bud Plant's incredible catalog (www.budplant.com) offers a wide variety of art books. To round off your library, you should have at least one good book on perspective. Choose one that seems to fit comfortably into your current skill level. As your skills improve, you may want to purchase more complex perspective books.

Good luck on the next leg of your drawing journey. Thank you and good afternoon. P.S. Got a question? Ask me at dickgiordano@hotmail.com.

INDEX

LEARN TO DRAW COMICS WITH THESE OTHER FINE IMPACT BOOKS!

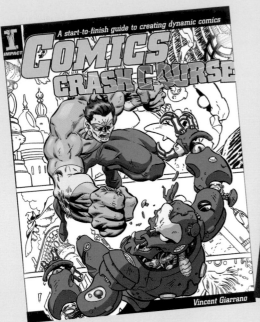

COMICS CRASH COURSE
by Vincent Giarrano
ISBN 1-58180-533-0, paperback, 128 pages, #32887-K

With the 20+ step-by-step demonstrations in this book, you can create amazing comic book art like an expert! Vincent Giarrano shows you how to draw eye-popping characters, poses, expressions, weapons and devices, and full comic book pages. Inside this start-to-finish guide, you'll also find valuable advice on how to publish your own comic book and make it as a professional comic artist.

GRAPHIC STORYTELLING AND VISUAL NARRATIVE
by Will Eisner
ISBN 0-9614728-2-0, paperback, 164 pages, #32095-K

In this companion to *Comics and Sequential Art*, Will Eisner shows comic artists, filmmakers and graphic designers how to craft stories in a visual medium. Eisner shows you how to use art as a narrative tool, write effective dialogue and develop ideas. These lessons and more are illustrated with storytelling examples from Eisner himself along with other comic book favorites, including Robert Crumb, Milton Caniff, Al Capp and Pulitzer Prize winner Art Spiegelman.

COMICS AND SEQUENTIAL ART
by Will Eisner
ISBN 0-9614728-1-2, paperback, 164 pages, #32094-K

Legendary comics creator Will Eisner turns a fine eye toward the principles of graphic storytelling in this extraordinary work, based on his popular Sequential Art course at New York's School of Visual Art. Learn the basic anatomy of sequential art, the fundamentals of crafting stories and how the medium works as a literary form.

These and other fine IMPACT books are available at your local art & craft retailer, bookstore, online supplier or by calling 1-800-448-0915.